A TOMMY'S LIFE IN THE TREN

A Soldier-Artist on the Western Front

PRIVATE FERGUS MACKAIN
edited by JOHN PLACE & WILLIAM MACKAIN-BREMNER

AMBERLEY

Page 1: 1. Fergus Mackain self-portrait. (Authors' collection)

Page 3: 2. Fergus Mackain. (Courtesy of Col Fergus Mackain-Bremner, ret'd)

First published 2016

Amberley Publishing
The Hill, Stroud
Gloucestershire, GL5 4EP

www.amberley-books.com

Copyright © Private Fergus Mackain, John Place and William Mackain-Bremner

The right of Private Fergus Mackain, John Place and William Mackain-Bremner to be identified as the Authors of this work has been asserted in accordance with the Copyrights, Designs and Patents Act 1988.

ISBN 978 1 4456 5829 2 (paperback)
ISBN 978 1 4456 2830 8 (ebook)

British Library Cataloguing in Publication Data.
A catalogue record for this book is available from the British Library.

Typesetting by Amberley Publishing.
Printed in the UK.

CONTENTS

CONCERNING THE MACKAINS

Fergus Herbert Elgin Mackain's family is very ancient indeed. The first clan chief was Ian Sprangaich (the Bold) who was settled in Ardnamurchan, Argyllshire, Scotland, in the late thirteenth century by his father Angus Mor, 4th Lord of the Isles, and chief of Clan Donald. The Mackains were an eminent Scottish clan, one member becoming Baron of the Exchequer. Many others were slain in battle, mainly in the 1500s and later, all concerning major clan issues. The family had to give up their rights to the castle and the land in 1625. They emigrated to Elgin, hence Mackain's third name (the first, Fergus, going back to Fergus Mor in the later part of AD 400).

The family thrived in Elgin, and in 1776 James, the seventeenth clan chief, moved to Suffolk, England. One of his sons was William Fergus, the grandfather of the subject of this book. After the end of the Great War, Fergus Mackain spent some time with his cousins in England, to whom he was devoted. He was a man of intense attention to detail as both a writer and an artist, as were many of the family in the 1900s to come.

FIRST WORLD WAR COMIC POSTCARDS

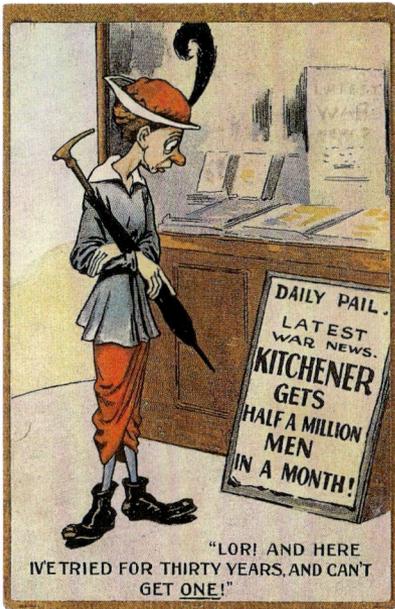

"LOR! AND HERE
I'VE TRIED FOR THIRTY YEARS, AND CAN'T
GET ONE!"

3. A humorous poster about enlistment. (Authors' collection)

A brief introduction such as this cannot hope to match the vast amount of writing on First World War postcards that is available. Excellent books on this subject have been written by, among others, John Laffin (*World War I in Postcards*); Tonie and Valmai Holt (*Till the Boys Come Home*) and Peter Doyle (*British Postcards of the First World War*). The interested reader is advised to buy these books!

Some postcard artists seem to have concentrated solely on the Great War; others, longer established in postcard design, such as Donald McGill, produced a large number of cards from the safer distance of home. Somehow, these do not have the same resonance or pathos as those drawn by the artists who had been through the nightmare that was 'the Front'. Fergus Mackain, as will be read, fought on the front line and was wounded in battle, thereafter becoming a well-known Great War postcard artist. He had joined up in 1915, having travelled from New York to London, signing up as soon as he arrived in London.

Artists were already busy creating the posters that encouraged young men to sign up:

'Lads, you're wanted, go and help,'
On the railway carriage wall
Stuck the poster, and I thought
Of the hands that penned the call.

wrote E. A. Mackintosh, a First World War poet who fought and was wounded in 1915, and the

propaganda machine was quickly meeting the demand increasingly imposed upon it by a war which was taking longer to complete than was first expected.

Postcards were soon readily available, at first encouraging enlistment, and soon turning to criticism of those who had not joined up.

Postcard artists followed different styles and approaches. Some represented cheerfully (albeit laconically) the life of the 'Tommy' (the most famous of these being perhaps Captain Bruce Bairnsfather); others avoided the difficulty of representing front-line reality and produced cards which tended more towards propaganda.

Postcards and magazines became a huge industry in the First World War. Lucinda Gosling, in *Brushstrokes and Bayonets*, describes this very succinctly:

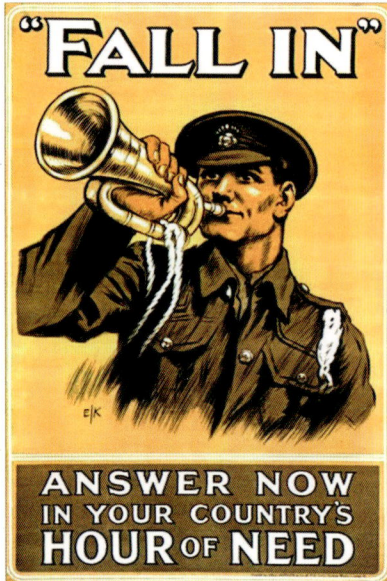

Magazines sent to the Front were greatly enjoyed, passed around and eventually cut up to decorate the walls of dug-outs. In particular, 'The Sketch' and 'The Bystander' were popular, combining gossip and humour with a whiff of glamour to brighten a Tommy's day ... It was through the most popular magazines that spirits were lifted, and soldiers were touchingly reminded that those at home had not forgotten them. 'The Bystander' in particular encouraged soldier-artists, amateur or otherwise, to send

Left: 4. Fall in! (Imperial War Museum)

Right: 5. Designed by Savile Lumley, this was a 1915 poster commissioned by the British Parliamentary Recruiting Committee. (Library of Congress)

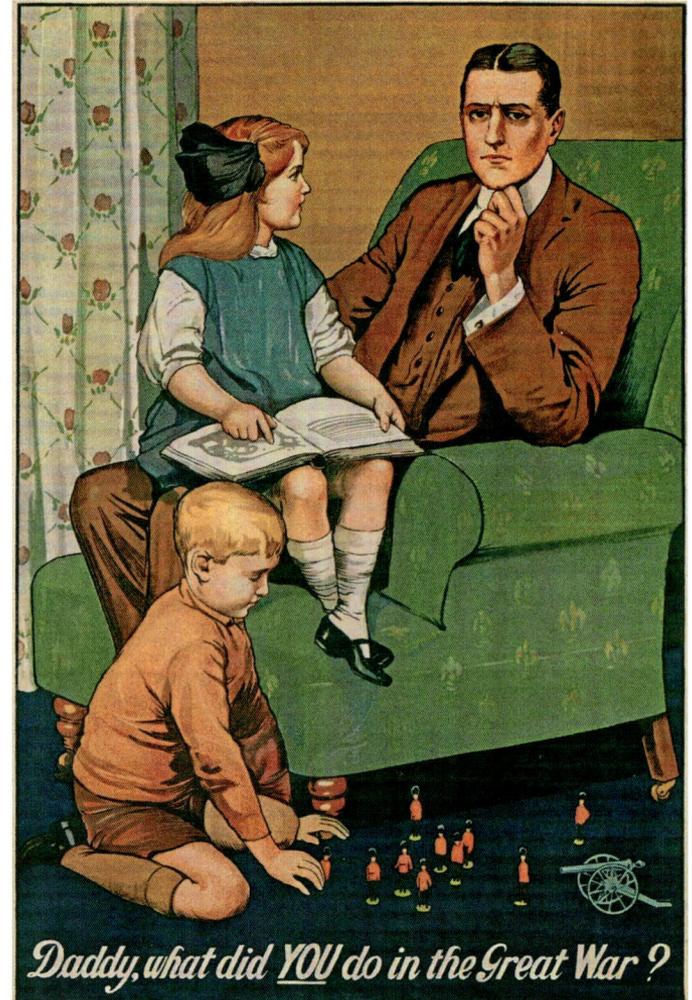

in their work for publication. Any artist who had a perceptive knack for recreating Tommy's experiences and depicting his humour would rarely be short of commissions. The trick was to find comedy in even the bleakest moments, without belittling those involved, a skill Bairnsfather pulled off deftly, receiving floods of letters from soldier fans, who recognised either themselves or their comrades in his creations.

The Wipers Times, the magazine printed, published and distributed by soldiers serving on the Western Front from 1916 to 1918, begun by Captain (later Colonel) F. J. 'Fred' Roberts and Lieutenant (later Major) J. H. Pearson, opined that perhaps the industry had developed too far (as the satiric advertisement to the right shows).

Captain Bairnsfather, together with several other artists, had studied art under John Hassall in London, and was turning his hand to playwriting towards the end of the war; he contributed much to the *Bystander* magazine.

Censorship had been imposed from 15 September 1916, and all 'pictorial representations, including picture postcards' which contained military or war material had to be submitted to the Press Bureau for censorship before publication. Many cigarette cards and postcards contain, therefore, very fanciful 'representations' of new machines of war such as the tank.

It is interesting to note that there are few postcards which celebrate officially or otherwise the ending of the Great War in terms of a victory; the cost had been too great. Peace was not officially declared until June 1919 and the great parades in London took place the following month, the Cenotaph still unfinished.

6. Can you sketch? (Author's collection)

7. Bruce Bairnsfather postcard. (Author's collection)

FERGUS HERBERT ELGIN MACKAIN

Fergus Herbert Elgin Mackain was born on 28 March 1886, the son of Fergus Henry Mackain and Georgie (or Annie) Smith. His father was a civil engineer and architect who had worked in Stoughton, Massachusetts designing schools and public buildings. Fergus H. E. Mackain himself had been born in New Brunswick, the father having emigrated from Alverstoke, Gosport, Hampshire in the early 1870s. On the death of his father in 1896, Fergus Mackain and his family (he had two brothers and four sisters) moved to the Swannanoa Township, North Carolina. The 1900 census return lists him as 'Elgin H. McCane'; such variations in the spelling of the name and the usage of either 'Fergus' or 'Elgin' as the first name were to be repeated throughout Fergus Mackain's life.

It is likely that the young boy then attended school in Asheville, North Carolina, as the family were resident in the Asheville area from 1906 to about 1914 (Fergus Mackain was to be buried in 1924 in the Asheville Riverside Cemetery).

Fergus Mackain next appears some ten years later in the North Carolina city directories in 1906–07 as an artist, living with his now widowed mother (Georgina) Annie McKain in Biltmore Road, Biltmore (the village built by the Vanderbilts as adjunct to the famous Biltmore Estate). On 24 March 1910 he married Louise Joan Beers, whom he may have met at the Pratt Art Institute in Brooklyn, New York, where she was then living and studying. In the 1910 census records (15 April), he has moved to Manhattan Ward 9, New York (318 West 14th St). Here he is described as an 'illustrator' in the advertising business and working on his own account in rented accommodation.

On the birth of his first son, Fergus, in 1911, he was living in Asheville, North Carolina, with the rest of the family. *The Telegram*, an Elmira, New York newspaper, announced

the birth of a son to Mr & Mrs Elgin Fergus Mackain of New York City at Asheville, N.C. The young mother was Miss Louise R Beers, formerly of this city.

A second son, Lindsey (also known as 'Linsley' or 'Lindsay'), followed in 1912.

From New York to London!

A ship's crew manifest shows that Mackain left New York on 13 October 1915, on one of the regular runs of the SS *Lancastrian*, a converted horse transport which plied between America (New York) and England. He worked his passage as a 'Horseman', according to the ship's crew list. Horses were extremely vital to the war effort, and had been since the day that war was declared. John Fairley (*Horses of the Great War: The Story in Art*) writes that 'Southampton, of all the English channel ports, became the great hub for transport to Le Havre and Boulogne. More than a dozen ships a day made the crossing. At the beginning of the war in August, the minutely planned operation to take the requisitioned horses to France swung into operation. Eighty trains arrived in one day in Southampton. Less than a fortnight after the declaration of war, more than nine thousand horses had been delivered to the British Expeditionary Force.'

Mackain worked his way on the two-week outward voyage, being paid £1. His job included 'to feed and water livestock and clean out stalls, to assist in loading and discharging livestock, also to assist in cleaning out cattle sheds and whitewashing same after discharging livestock as required. Sum of ten shillings to be paid for this work.'

It would have been an arduous two weeks (the *Lancastrian* arrived at Tilbury on 29 October). Basil Clarke, in his book *The Story of the British War Horse*, describes such work:

On the voyage the animals were under the charge of a 'conductor', who, if not actually a veterinary surgeon by academic qualification, had nevertheless a complete knowledge of horses and their ways and ailments. Under him were some forty horsemen – a crew of tough Americans, some black, some white, who made the round trip out and home with the boat. They were split up into gangs and squads under foremen, and each gang was responsible to the 'conductor' for watering, feeding, and otherwise caring for the horses in certain stalls every day. The conductor, in turn, was responsible to the shipping company and the Government, and his earnings depended on his success in bringing over horses without sickness or injury. Every horse lost meant a loss to him. He saw to it that horses were well fed and watered, and were given as good a voyage as might be.

At feeding-time the 'horse boys' filled portable iron troughs with 'feed' and squeezed their way along the alley-ways, fixing a trough on the wooden bar under each horse's head. Water had next to be carried round, and each horse watered individually. To water a horse in a rolling ship, standing in a narrow alley, with horses' heads all around one, each trying to force its mouth into your bucket, was no easy task.

Why Fergus Mackain left his wife and two young sons to 'join up' so far from home will probably never be known. Was he simply restless, like his father had been at that age? Or was he really fired up by the international appeals for able-bodied young men to go and fight, to answer England's call to arms? It is possible that his marriage had already failed: the address he gives in the ship's log is not that given by his wife in the state census some four months earlier.

He was clearly attracted to the idea of joining the Sportsman's Battalion of the 23rd Royal Fusiliers (a first cousin, Henry

Mackain, joined the 3rd/28th Artists Rifles in Romford soon after). Not all who wished to join this battalion could, though – one Harvey Barr Child, a naturalised American, writes,

> I went up to London, and tried my best to join the Sportsman's Batt which was then being raised by Lady Cunliffe Owen, and I got turned down for two reasons, First, Because I was American, 2nd Because of too old, plenty of younger men, being available at that time, I went around and tried my best, until finally I went down to Bedford, boxed up my Name, said I was from Canada, and joined the Royal Bedfords.

Arriving in England on 29 October 1915, within four days Mackain had signed up with the 30th Royal Fusiliers, the reserve unit of the Sportsman's Battalion.

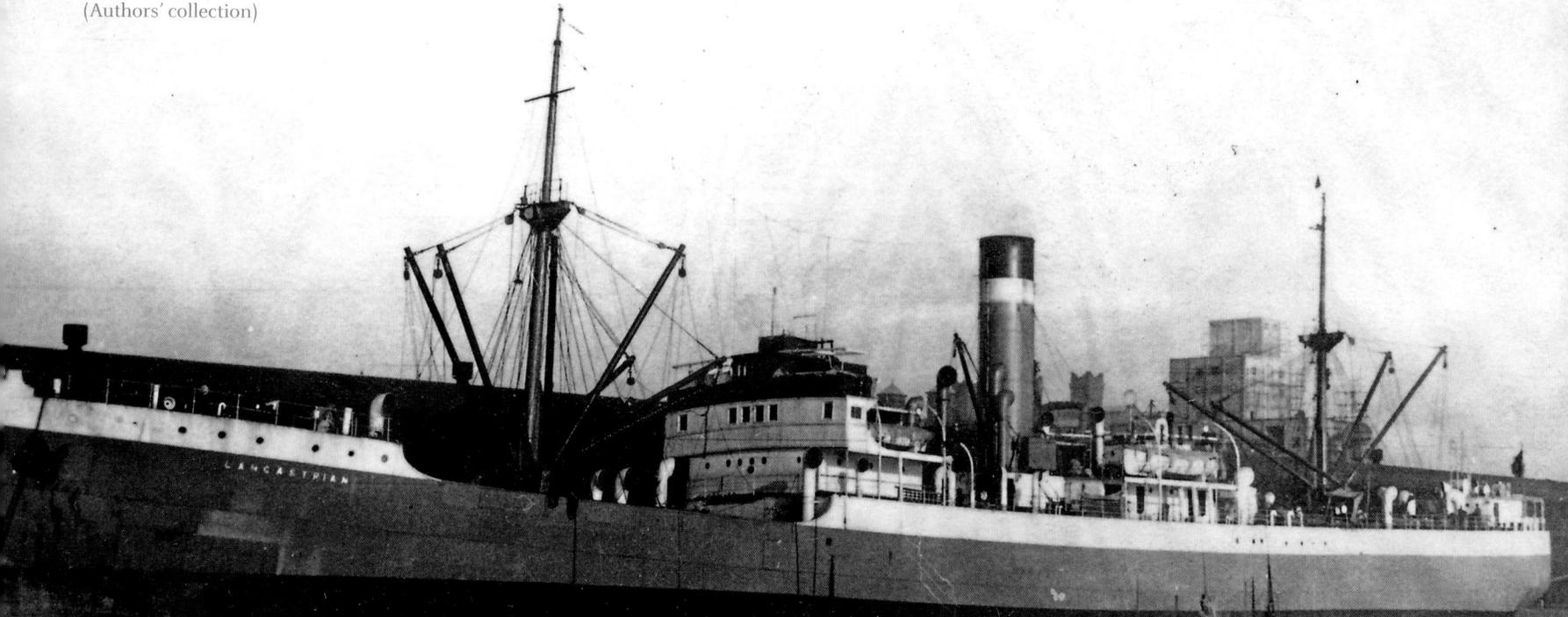

8. Horse transport, the SS *Lancastrian*. (Authors' collection)

1914–1917: The Sportsman's Battalion

The Sportsman's Battalion, later part of the Royal Fusiliers, was privately raised in early September 1914 by Mrs Emily Cunliffe-Owen, a society lady sufficiently well connected to be able to telegraph Lord Kitchener with the question, 'Will you accept complete battalion of upper- and middle-class men, physically fit, able to shoot and ride, up to the age of forty-five?' She was to receive the answer, 'Lord Kitchener gratefully accepts complete battalion.' To begin with, the recruits were enrolled at the Hotel Cecil in the Strand and the battalion handed over to the Army in April 1915. It took some time to gather the uniforms for the volunteers:

Enlist in the
SPORTSMAN'S BATTALION

A SPECIAL COMPLETE INFANTRY BATTALION for active service sanctioned by Lord Kitchener is now being recruited from sportsmen up to 45 YEARS OF AGE. Only those used to outdoor sport, who are thoroughly sound and fit, need apply. Now is the opportunity for the RIGHT MAN to join a sportsman's corps.

PAY AT ARMY RATES.
JOIN TO-DAY!

Write or call Chief Recruiting Officer,
Indian Room, Hotel Cecil, Strand, W.C.
Hours: Daily, 10 to 6.

9. (Authors' collection)

Perhaps we had a pair of army trousers and a sports-coat. Perhaps we had a pair of puttees, and the rest of the costume was our own. It didn't matter. It was good enough to parade in off the Embankment Gardens. (Ward)

The 1st Sportsman's Battalion, later the 23rd Royal Fusiliers, was practically complete within four weeks: Raymond Skeen describes how 'Mrs Cunliffe Owen bullied contractors into having a proper hutted camp ready for them at Hornchurch a week before that'. He adds that 'to avoid accusations of unwomanliness she prepared their menus herself in the intervals between personally conducted drill parades'. No soldier, apparently, was allowed to apply for a commission until he had found two suitable replacements, this to prevent the battalion becoming merely 'officer-producing units'.

Taken over by the War Office on 1 July 1915, they then moved to Kandahar Barracks, Tidworth, in August 1915 and landed at Boulogne on 17 November 1915. On 25 November 1915, they moved with the 99th Brigade to 2nd Division. The 23rd Battalion was to serve in the 99th Brigade throughout the war, with 4,987 officers and men serving, and 3,241 as casualties – killed, wounded and missing. The *London Evening News* coined the phrase 'hard as nails' for these men, and the battalion tried to live up to this with honour.

Fred Ward's book, *The 23rd (Service) Battalion Royal Fusiliers (First Sportsman's) During the First World War 1914–1918*, covers the various campaigns in some detail, together with the history of the battalion. Acknowledgements here go to the author for this summary of the battalion's fighting until the end of 1917. *Hard as Nails*, the story of the battalion, by Michael Foley, is also an essential read for the military historian.

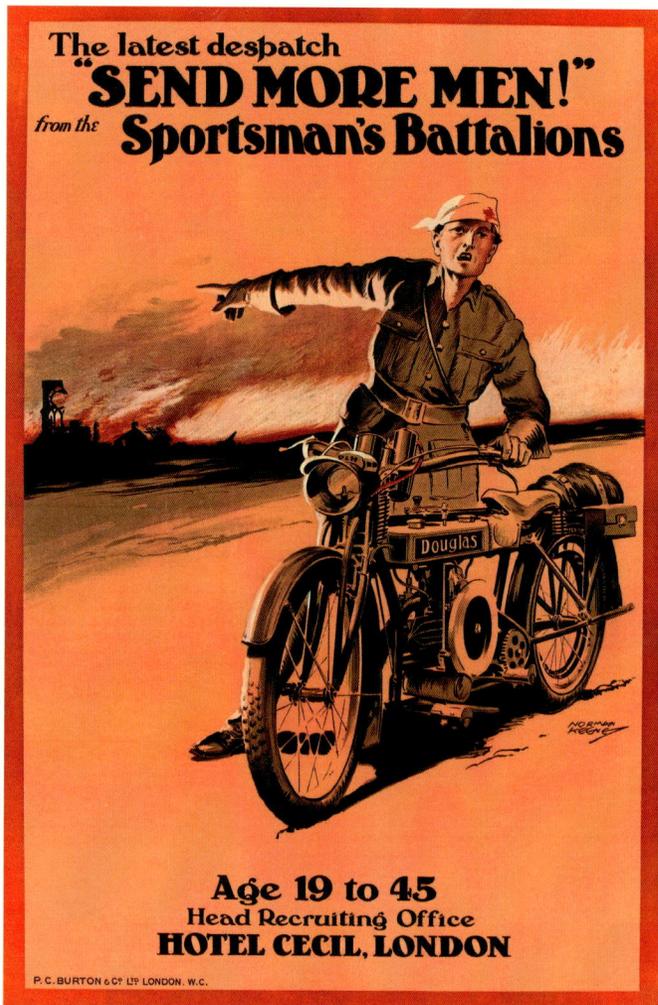

The latest despatch
"SEND MORE MEN!"
from the Sportsman's Battalions

Age 19 to 45
Head Recruiting Office
HOTEL CECIL, LONDON

P. C. BURTON & Cº Lᵀᴰ LONDON. W.C.

10. (National Army Museum)

Mackain's regimental number SPTS/4299 and the war records confirm his enlistment date of 2 November 1915. Mackain was placed into the 30th Royal Fusiliers, a reserve unit formed in July 1915 from depot companies of the 1st and 2nd Sportsman's which had not relocated to Clipstone Camp with 99th Brigade. He was therefore based briefly at Romford and then Leamington Spa for about three months, and then billeted during training in Oxford (February 1917) and Kingsbury (near Tamworth) in March, where the 30th had 'musketry practice' (*Tamworth Herald*), after which the battalion moved to Edinburgh in May for the duration of the war. Some five to six months after enlisting, training completed, Mackain would have been drafted overseas and would have crossed to France and been assigned to the 23rd. Mackain's own letter to his wife, probably written in early July 1916, describes how he is now 'up the line' and serving in the 23rd rather than the 30th. The 23rd were by then fighting in the Somme region, an area that was to see particularly heavy fighting.

The 23rd (Service) Battalion Royal Fusiliers (First Sportsman's) and the 30th Reserve, 1915–1917: A Summary of Key Dates, Events and Personnel

1915

July – Remaining depot companies of 1st and 2nd Sportsman's are formed into a 30th Reserve Battalion of the Royal Fusiliers (rather than a 3rd Battalion) in Romford Hall Camp. Then moved to Gidea Park (grounds of Gidea Hall, close to Hare Hall). Some 'bad feeling' among soldiers reported due to being left behind; a number of men arrested after 'riotous behaviour'. King's Royal Rifle Corps also stationed at Gidea Park.

2 November – Enlistment of Fergus Mackain into the 30th Royal Fusiliers. His regimental number is SPTS/4299.

November 1915–May 1916 – 30th Battalion are in training, moving from Romford (until November 11th), Leamington Spa (until January 30th),

Oxford (until March); Tamworth (until early April) and then to Leith Fort in Scotland and Edinburgh.

14–16 November – 23rd Battalion leaves Tidworth for Folkestone and then to Boulogne-sur-Mer, Ostrohove Rest Camp, entraining at Pont-de-Briques to billets at Steenbecque.

23 November – 23rd moves to Busnes (Nord Pas-de-Calais), 11½ miles from Steenbecque. 99th Brigade moved to 2nd Division; 23rd separated from the 24th, which was replaced in the 99th Brigade by the King's Royal Rifle Corps (also previously stationed at Gidea Park).

25 November – 23rd training at Béthune (Nord Pas-de-Calais). Inspection by General Walker and staff of 2nd Division.

19 December – 23rd Battalion's first experience of front-line duty at Cambrin (five miles east of Béthune) with the 7th Royal Berkshires and 5th Liverpool.

26 December – Colonel Viscount Maitland (Batt'n CO) wounded in the knee by high-explosive shell shrapnel.

1916

7–11 January – Exchange of officers with King's Royal Rifle Corps.

14 January – 99th Brigade takes on sector C at Festubert (five miles NE of Béthune).

31 January – Lt Colonel H. Vernon of the King's Royal Rifle Corps assumes command of the battalion.

February – 30th Battalion stationed in Oxford.

3 February – 23rd Battalion moves to region of Le Quesnoy to relieve Royal Berkshires.

22 February – Lt Colonel Vernon awarded Croix de Chevalier.

10 March – Draft sent to join 23rd Battalion in France.

18–25 March – 30th billeted at Kingsbury (near Tamworth, Warwickshire) for 'musketry practice' (*Tamworth Herald*). Gives concerts and holds a boxing contest with the 27th (Reserve) Battalion.

March–May – 23rd Battalion at Souchez north, Villers au Bois, Carency, Somme.

1 May – 30th in training at Olympia, Edinburgh.

1 June – A number of 30th Battalion soldiers are transferred from Folkestone to Boulogne. Given the known movements of other soldiers in his unit, it is likely that Mackain was based around this time at Étaples, joining 33 Infantry Base Depot for three weeks' additional training in preparation for the Somme offensive, then possibly joining the 3rd Entrenching Battalion for one to three weeks before going out to join the 23rd Battalion. He would be kitted out for the front and given a new BEF (British Expeditionary Force) address with the 23rd. The 23rd received reinforcements on 10, 17, and 27 June. This period of time forms the experiences in his second 'Sketches of Tommy's Life' series of cards 'At the Base'.

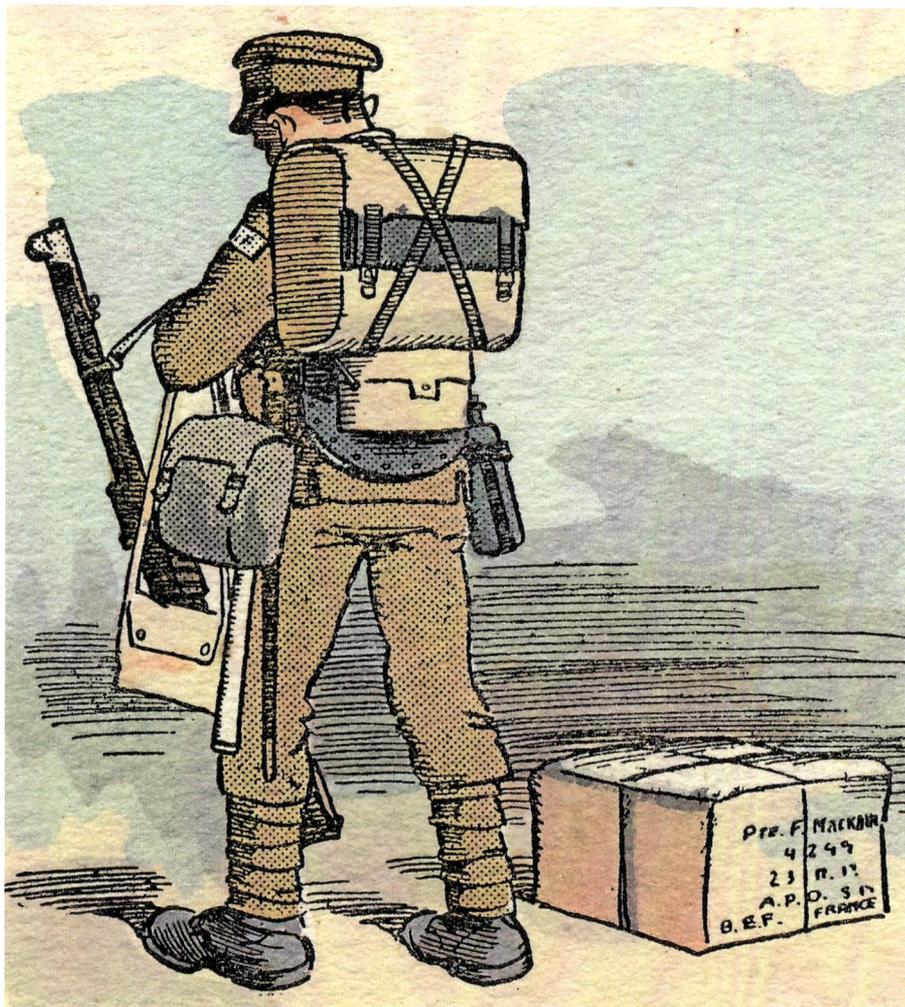

In the 23rd Royal Fusiliers!

Fergus Mackain later followed the 23rd Battalion to the front as part of reinforcements 'to replace wastage'. In Fred Ward's book, the transport train goes as far as Steenbecque (northern France, in the Dunkerque arrondissement), which is where they hear artillery for the first time (see first card in the 'Up the Line' series). *Scribner's* records that he writes to his wife for the first time, 'just a bit of a note' to tell her that he is 'now in the 23rd'.

June–July – 23rd at Bernefay Wood.

21 June – Lt Colonel Vernon wounded; Major H. Pirie takes temporary command.

July – Move to the Somme. Reinforcements from England thrown straight into the front line. Heavy casualties.

27 July – Battle of Delville Wood. Heavy casualties. Mackain fights with the 23rd and is wounded by shell fire. He is sent to Rouen Hospital for recovery, and draws a picture of himself fleeing the pursuing shell for the nurse who tends him. During this time, he may have returned to England 'with a blighty'.

11. Enlarged detail from At the Base 9 showing Mackain having put his own details on the packet: Pte. F. Mackain 4299 23 RF A.P.O. S17 B.E.F. France. (Authors' collection)

The Battle of Delville Wood – 27 July 1916

The Battle of Delville Wood (the 'bois d'Elville', but more commonly known as 'Devil's Wood' to the soldiers), to the east of Longueval, was one of a protracted series of engagements fought as part of the Somme offensive. The chance finding of a VAD nurse's autograph diary, with a signed picture by Fergus Mackain, places him in the thick of the action on 27 July, which was to see him wounded and withdrawn from frontline action.

The battle began on 15 July. The attrition rate of this particular battle can be seen by the opening casualties, as described by Michael Foley:

> The Sportsman's Battalion played a big part in the battle for Delville Wood although it was the South Africans who got most of the credit for taking the wood. The 2nd South African Regiment had numbered over 3,000 men when they went into the wood on 15 July. They held it for a few days, while the front line was nothing more than connected shell holes. Only just over 700 came out again when they were relieved on 19 and 20 July.

The difficulty in holding this position was that when captured, the wood and the village of Bazentin le Petit formed a salient which could be fired upon by German artillery from three sides. Neither the wood nor the village could be held without control of the other. High casualty rates, poor weather conditions and ammunition difficulties reduced the fighting to piecemeal attacks.

12. 'Final barrage'? There was no final barrage. In the Fourth Army sector, from 15 July to 14 September, the British launched no fewer than ninety attacks for little or no gain, many in the Delville wood area. (Royal Fusiliers war diaries)

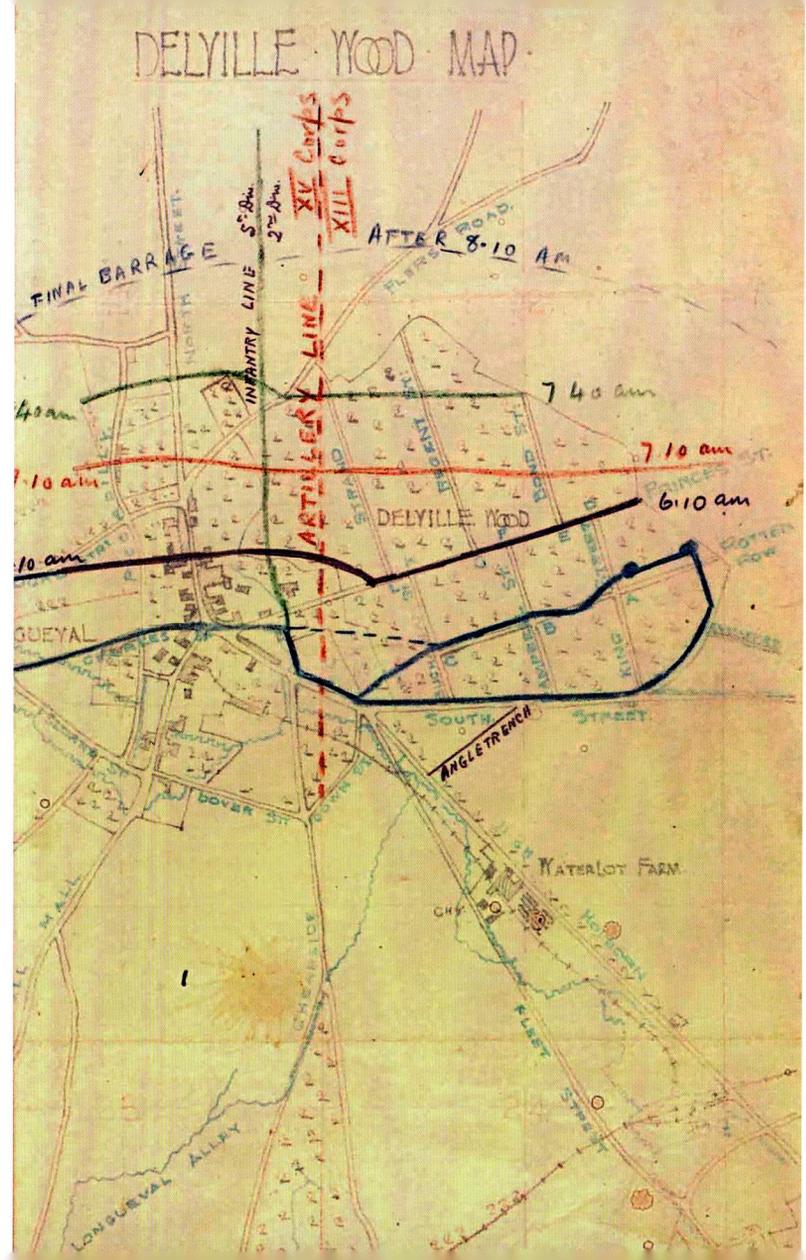

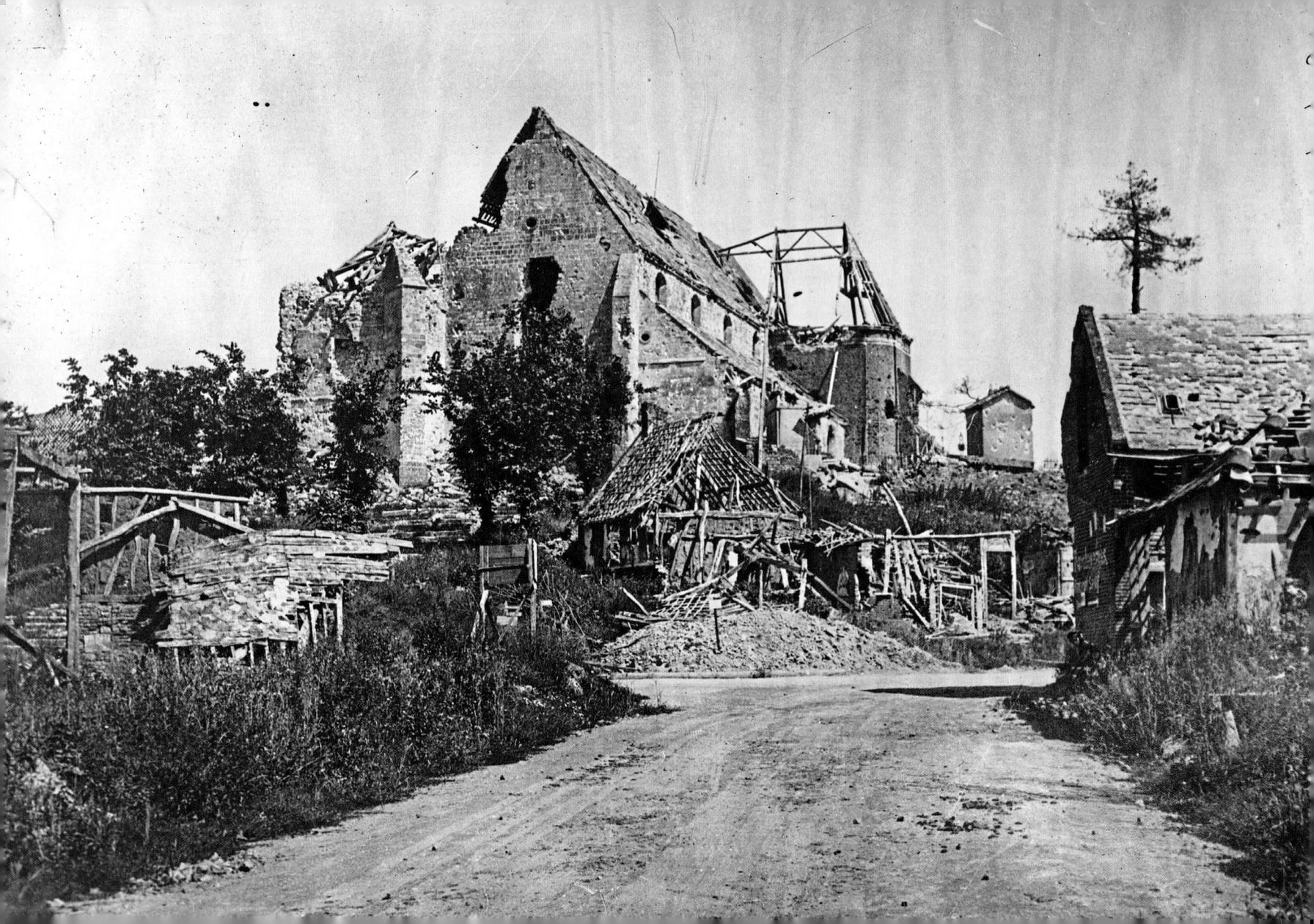

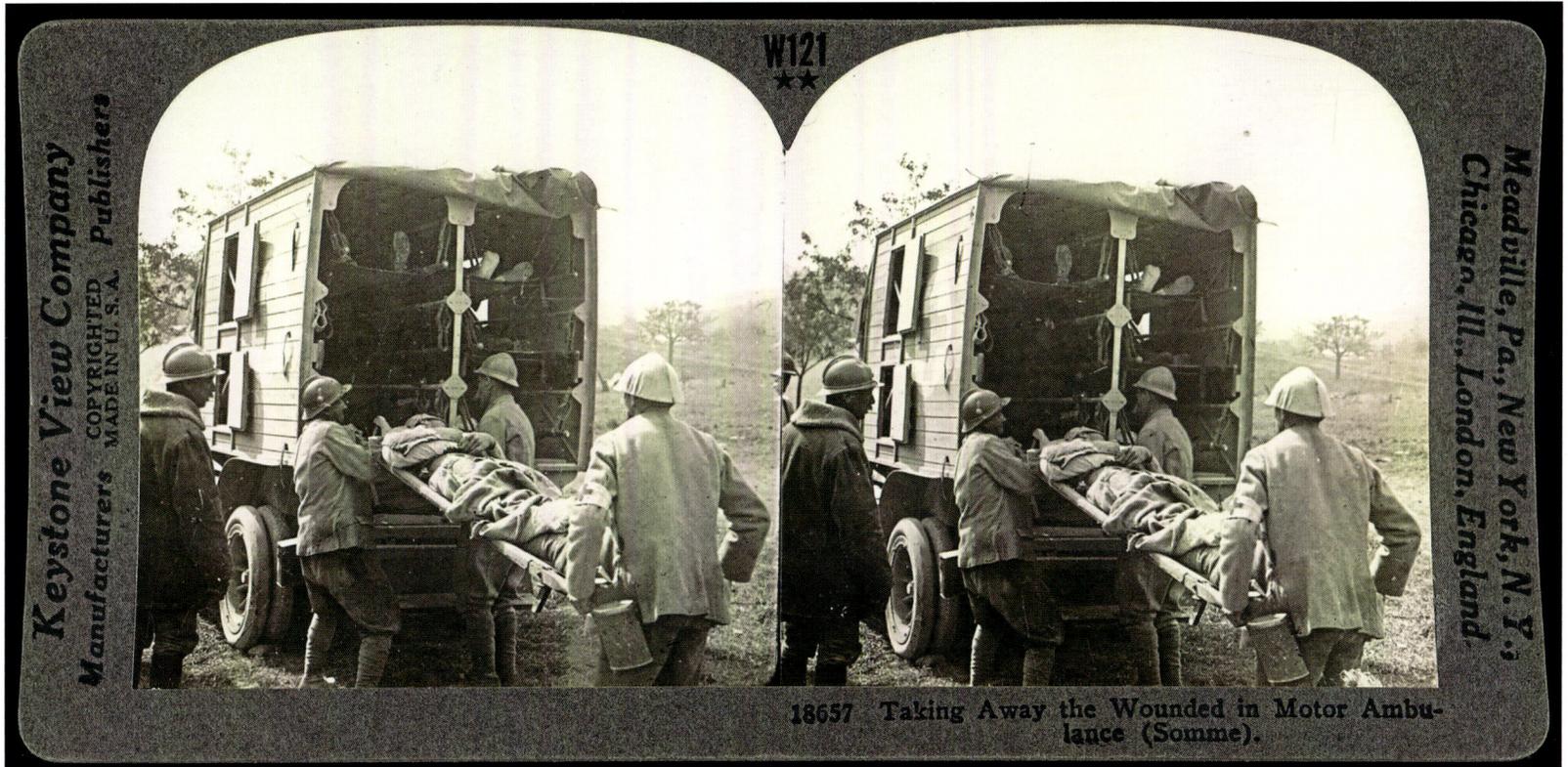

18657 Taking Away the Wounded in Motor Ambulance (Somme).

The conditions must have been horrifying as the Sportsman's Battalion arrived up the communication trenches, with many of the dead unburied because of the fierce fighting and recent hot weather leaving 'a terrible atmosphere'. On 27 July the 23rd Battalion was involved in an attack against the German attempt to recapture Delville Wood. They captured a trench in the middle of the wood, holding it against artillery barrages and counter-attacks that continued through the day. Most of the casualties suffered by the 23rd were in the defence of the right flank of the wood from 11 a.m., when the enemy bombarded the whole of the wood for most of the day.

Fergus Mackain's later drawing of this part of his fighting (the below is a reconstruction of the original seen by the author) is ironically entitled by him 'The Last Lap'. Pursued by a shell round a tree, it is Mackain's last lap before he is wounded; it is also the last lap of his fighting in this particular battle.

Rouen Stationary Hospital No. 12, July – November 1916

Fergus Mackain was transferred to Rouen Stationary Hospital No. 12, where the young nurse Olive Swanzy was working. The hospital was established on the racecourse on the outskirts of Rouen in 1914. No. 12 hospital was a 1,350-bed hospital, almost completely made up of tents. American medical staff replaced the British medical staff on 12 June 1917. The city of Rouen was safely behind the lines and became an important logistics centre comprising several base hospitals. Rouen was also situated on the River Seine, which facilitated the movement of wounded soldiers (and possibly Mackain) to England. Commonwealth camps and hospitals were also positioned on the southern outskirts of the city.

Olive Swanzy (1881–1974) was an Irish girl from Newry, although she was born in Cannes. She would have immediately found an interest in common with the wounded Fergus Mackain, as she was herself a talented watercolourist. She painted several scenes of the tented accommodation that the nurses lived in while working at the hospitals.

Mackain was not to rejoin his battalion until later in the year, sometime around November 1916.

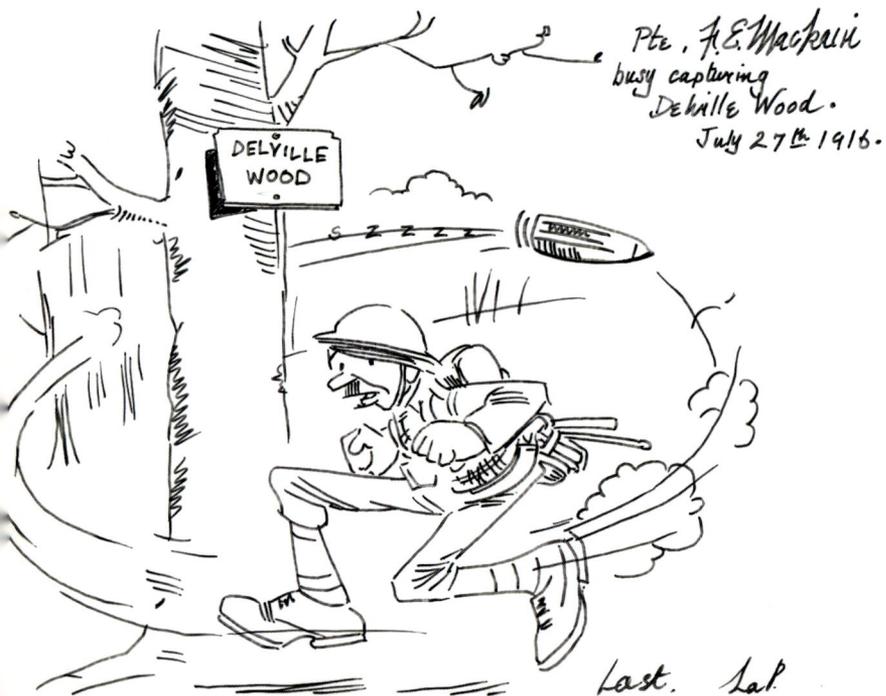

Pte. F.E. Mackain busy capturing Delville Wood. July 27th 1916.

DELVILLE WOOD

Last. Lap.

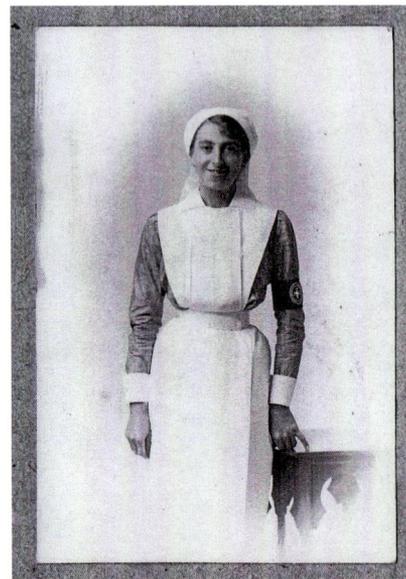

Previous spread, left: 13. Ruins on the Somme. (Library of Congress)

Previous spread, right: 14. Stereoscopic card of wounded being taken away from the Somme offensive in an ambulance. (Library of Congress)

Far left: 15. Fergus Mackain's last lap. (Original by Fergus Mackain)

Left: 16. Olive Swanzy. (anurseatthefront.org.uk)

August – Reinforcements arrive at Thiepval.

September – Hébuterne sector.

October – Coieneux (Basin Wood), Redan, Mailly-Millet, Raincheval.

22 October – Lt Colonel Vernon awarded DSO.

November – Beaumont Hamel; Redan Ridge. Mackain returns to the Front to fight with the 23rd again. Is billeted in various villages. He is in 'D' company. In mid-November Mackain is hospitalised again, this time with diarrhoea.

December – Battalion at rest.

1917

1 January – Major E. A. Winter awarded Military Cross (and, on 1 January 1918, the DSO). Courcellette (Somme département).

1 February – Ovillers la Boiselle (Somme département).

17 February – Battalion suffers heavy casualties in front-line fighting.

5 March – Courcellette; Grevillers Trench and Lady's Leg Ravine.

April – Vimy Ridge. Capture of Bailleul; Oppy.

6 April – The USA enters the war.

April – Mackain hospitalised.

27 April – Mackain's illustrated letter dated. In the letter he tells how he has just recovered from another bout of intestinal illness.

1 May – Composite battalion formed of two companies of the 23rd and two companies of the 1st Royal Berkshires to attack Oppy–Fresnoy line.

3-4 May – Battalion withdraws, relieved by 15th Warwickshires. Heavy casualties suffered.

5 May – Major E. A. Winter assumes command of battalion (promoted to Lt Colonel on 24 May). Battalion back to front-line duty.

May – Battle for and capture of Oppy–Fresnoy line.

June – Cambrin sector.

4 June – Mackain is transferred to the ASC (Army Service Corps) at Boulogne-sur-Mer, service number S/343429.

October – Mackain's first postcards published.

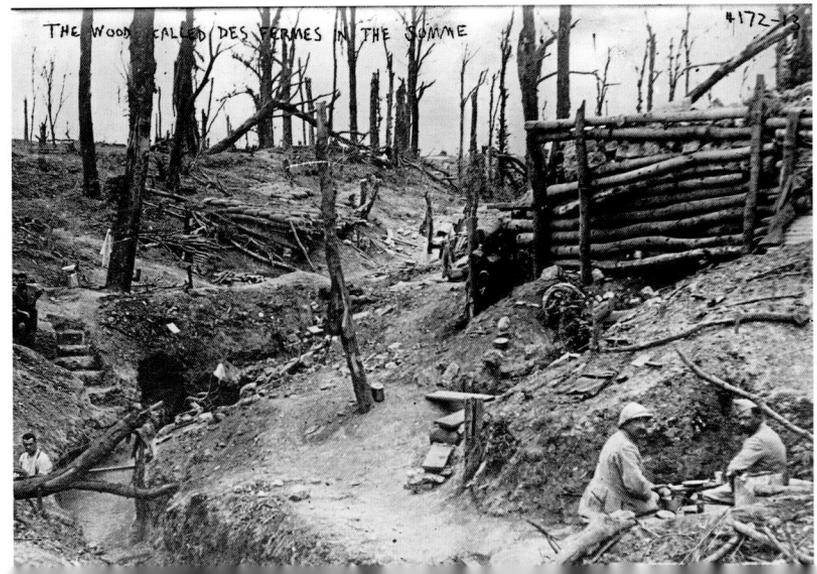

17. The wood called Des Fermes in the Somme. (Library of Congress)

An Illustrated Letter

Published by the American magazine *Scribner's* in 1917, this letter, sent by Mackain on 27 April, describes how he had been 'rushed to hospital' (probably with dysentery or some similar complaint) but had then (so he wrote) recovered by the time of writing. The magazine adds detail from an earlier letter he had written 'just before the artist was wounded (27 July 1916), and sent back to the base hospital':

Just a bit of a note to tell you where I am. I have been 'up the line' for the past few days; and it's rather nice, too. There's a thundering big battle raging not far from here, and last night and three nights ago, we were within less than a mile of it, on a working party. I am sure that when the World was Created, the spectacle was nothing compared to what I saw, and heard, these last two nights. There's nothing to frighten a fellow – it's all far too big and splendid for that. I wish you could experience it for a few minutes. This Man-made storm surpasses Nature's feeble efforts to such an extent you would laugh at anything she does in the way of a disturbance afterward, I fancy. As I mentioned in my last letter, I expect to return to England shortly - if I don't go to Heaven, or some other place, before. How are you and the boys? Write to me at the following address ... You see, of course, I'm now out of the 30th and in the 23rd. 'B.E.F.' means, as I suppose you know, British Expeditionary Force ...

18. *Scribner's Magazine.* After the Americans entered the war in 1917, the magazine usually had four to six articles covering different aspects of the war. The magazine ceased publication in May 1939. (Charles Scribner & Sons)

It is the fighting on the Somme and in Delville Wood that Mackain had witnessed when he described 'this man-made storm' surpassing 'Nature's feeble efforts'.

The illustrated letter was addressed to his young son, 'My Dear Little Mackie' (also called Fergus). It describes how his life has been in the trenches, but no doubt conceals various harder truths. *Scribner's* describes how this illustrated letter 'was written by a soldier-artist who worked his passage to England on a horse-transport and enlisted in London at the beginning of the war'.

His illustrated letter adds that 'Little Mackie' should 'show these pictures to dear little brother and dear Mamma'. It is worth noting that the original drawings were printed at Boulogne, where a majority of Mackain's cards were later to be produced. One of the pictures shows Mackain wearing the regulation blue suit and red tie ('hospital blues') that marked a military hospital patient.

During the Great War Boulogne-sur-Mer was one of three important base ports for the British Army. The coast between the British General Headquarters in Montreuil and the Port of Calais was an immense logistics zone comprising Army camps, munitions depots and hospitals (the war poet John McCrae, who wrote 'In Flanders Fields', was in command of a hospital in Boulogne-sur-Mer). For the most part, these were supplied with men and equipment through the port of Boulogne. Boulogne was essentially an enormous barracks and hospital complex. Public buildings, such as schools and the casino, were requisitioned to house the wounded who had been evacuated from the front.

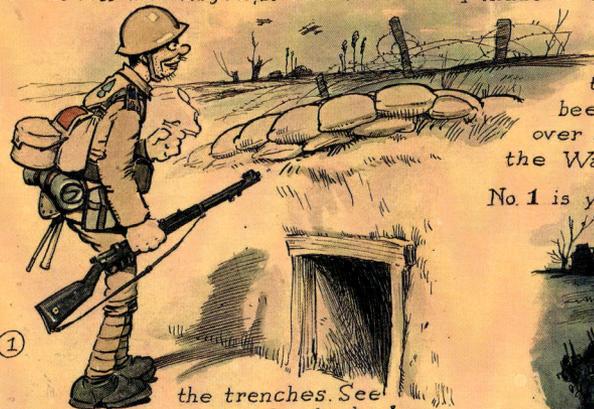
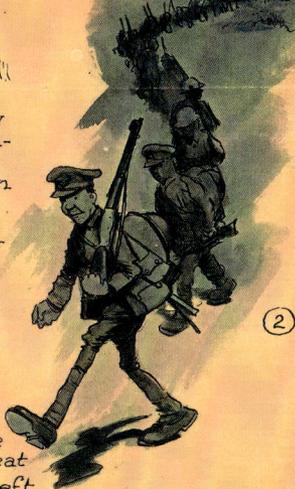
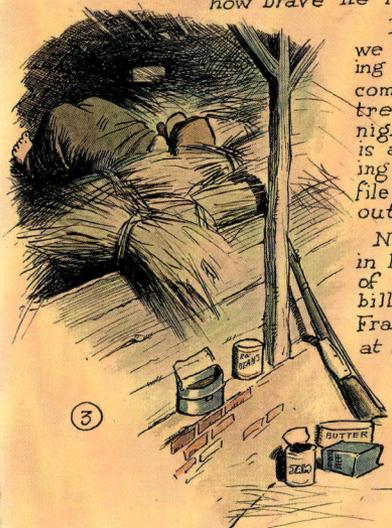
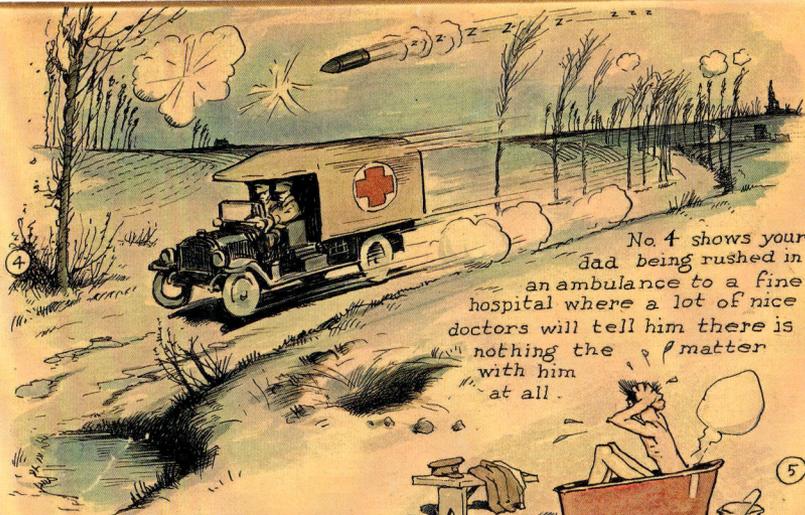
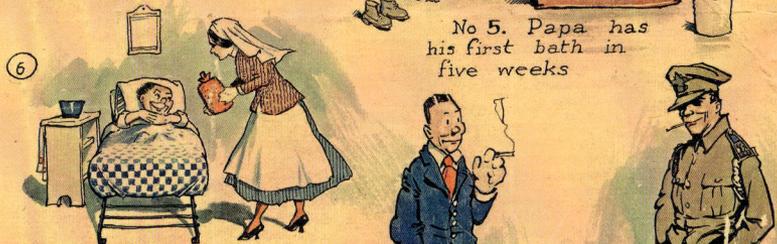
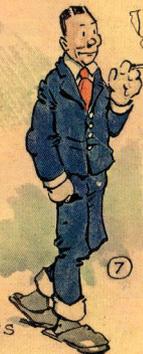
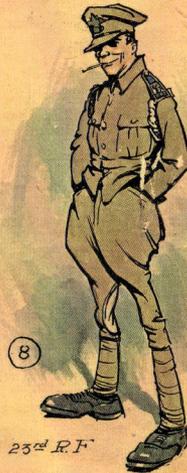

19 & 20. (Alan Wagner)

It was in Boulogne-sur-Mer that the printing firm of Gaultier started producing Mackain's postcards in October 1917.

On 4 June 1917, after leaving front-line duty, Mackain was transferred to the (Royal) Army Service Corps – usual with men who had suffered wounds and illness (RASC S/343429). Mackain's 'War Badge' record lists the reason for discharge as 'sickness' rather than 'wounds', however, and confirms his date of enlistment as 2 November 1915 and discharge as 31 December 1918.

The 'Dear Mackie' illustrations and letters comprise almost the only surviving personal writing of Fergus Mackain and are currently in the possession of Fergus Mackain's great-grandchildren. These original sketches were drawn on brown paper and coloured (unlike the copies shown in 1917 in *Scribner's*). They detail this otherwise unknown part of Mackain's life when, having been ill and in hospital, he was soon injured and no longer fit to undertake front-line service.

The illustrations had been folded and at some time later stuck onto thin cardboard for mounting. The rear of the cardboard bears the name and address in 1917 of his wife: Mrs F. Mackain, 58 W85th Street. This is in Manhattan, New York. Mackain's great-grandson recalls, 'I do remember my grandmother (Clara) telling me that they were sent to my grandfather when he was very young while his father was still in the war.'

The chain of events which led from this illustration being sent to Fergus Mackain's eldest son Fergus (here addressed by the family nickname of 'Mackie') to *Scribner's* later publication of them (in September 1917) and Mackain's first postcards appearing in October 1917 would be of huge interest to know, but it is a story which can only be surmised. At some point, Fergus Mackain's abilities were recognised and the suggestion made that, once he was in the ASC, it would be a good idea to publish such postcard sketches for sale to soldiers fighting on the front line.

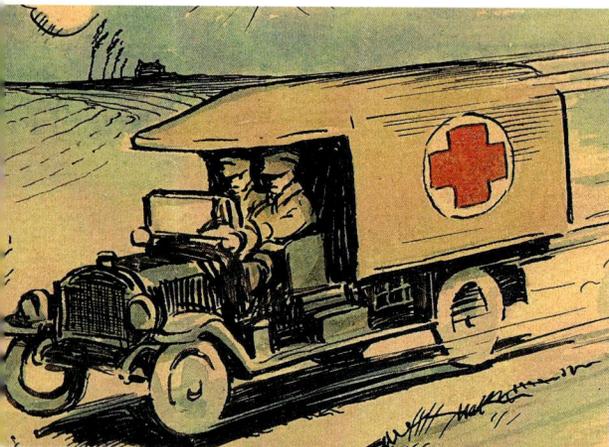

Far left: 21. Detail from the illustrated letter. (Alan Wagner)

Left: 22. Fergus Mackain's War Medal Card. Details explained: Corps – R Fus = Royal Fusiliers; Rank Private; Regimental number 4299; ASC = Auxiliary Service Corps, regimental Number S-343429 ('S' indicates working with supplies). (Authors' collection)

ENTERING THE POSTCARD MARKET: NOVEMBER 1917

Postcard Production in France

Postcard production was enormous during the war. Pierre Brouland, in his article 'Les cartes postales satiriques pendant la Premiere Guerre Mondiale', describes how the war, rather than slowing down postcard production from its peak in the early 1900s, served only to massively increase the number of postcards published. In Germany alone, some six to seven billion were produced. This was easily matched by the cards from the allied countries, mostly portraying pictures of generals and important figures of the war, views of destroyed towns, villages and buildings, comic and satirical cards and patriotic and sentimental cards. Included within the latter are the famous 'silk cards', the manufacture of which became almost a cottage industry in France. Brouland writes how the mood of cards changed through the war years, a certain 'triumphalism' disappearing after the end of 1915 as the war took a more sombre direction and trench warfare replaced older, traditional means of combat.

The number of postcard editors was similarly huge. Brouland relates how almost any local trader could style himself as an 'editor' and have thousands of postcards printed at the nearest press. As early as 1914, there were over 700 such postcard editors, this excluding the major printing companies such as LL (Léon & Levy) and Neurdein (brothers Etienne and Antonin) and others. One such, Bergeret, alone produced over 150 million cards in 1914. The numbers are staggering. Fergus Mackain's first postcards were produced in Boulogne-sur-Mer, with the editor a Pierre Isoré in Bresles (near Beauvais, to the north of Paris). A more local editor, Paul Gaultier, then took over.

Fergus Mackain began producing postcards from October 1917. He joined a rather elite group of soldier-artists who were already quite established, particularly G. M. Payne, Lawson Wood, Fred Spurgin, G. A. Stevens ('G.A.S.'), Reg Carter and Captain Bruce Bairnsfather. Of these, it is Bairnsfather who is probably the best known, through his series of 'Fragments from France' Old Bill cards and magazines. These extended

to several series, cards being available in wrapped sets of six cards. Bairnsfather's magazines appeared from January 1916, and the postcards from May 1916. These were instantly popular; as Peter Doyle writes, 'old Bill's unique brand of humour typified that of the British soldier himself'. Similarly, Bairnsfather also began his drawing after being wounded and hospitalized.

While Bairnsfather applied a caricaturist's cynical sense of humour to his postcard illustrations, which focused largely on the many ironies and hardships of the soldier's experiences, Mackain generally offered a much gentler and more observational first-person narrative view of the everyday life of British soldiers in France during the war. Mackain's cards were also coloured in gentler pastel tones as against Bairnsfather's

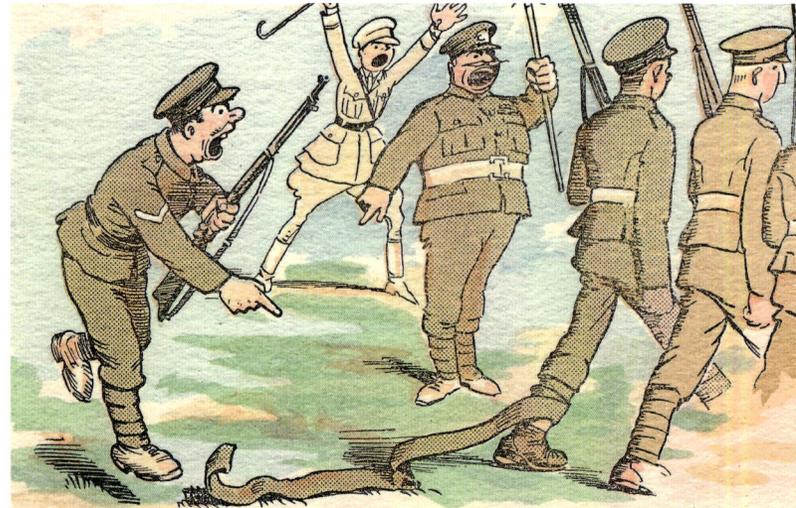

23. Detail from No. 6 from In Training, Mackain's first series. (Authors' collection)

rather dark sepia pictures, thus rendering them softer in impact. The artist narrator becomes the reassuring voice of the writer to the recipient rather than the overheard comment of soldier to soldier.

Mackain's officers, for example, are variously shown as hectoring, supercilious, mean-spirited and grudging or downright sneaky, and the men as being more able to take whatever came their way, whereas Bairnsfather's, as described by First World War poet Wilfred Owen, are more bleak: 'On all the officers' faces there is a harassed look that I have never ever seen before, and which in England, never will be seen – out of jails. The men are just as Bairnsfather has them – expressionless lumps.' Such Wilfred Owen wrote to his mother (4 January 1917). Mackain would not have wanted to convey this in his cards.

Mackain captured accurate depictions of the soldier's lot in the series of postcards entitled 'Sketches of Tommy's Life' that were published from October 1917 in Boulogne and Paris. Although these cards were intended to be humorous, they reflected a deep understanding of what it was like to be a soldier on the Western Front, derived from Mackain's own first-hand experience in the Royal Fusiliers. These series followed the different stages of wartime experience: training, transfer to the overseas base, on the front line and on rest.

As has been described, Mackain had had experience as a commercial artist/illustrator before the war in New York. The picture postcard industry had peaked somewhat in popularity from about 1908 to the start of the war and the Great War was

to be the last war where picture postcards were an important method of communication as well as collectables in their own time (many messages on the cards refer to the sending of a full set for the recipient to collect). Interest in postcards would gradually decline after the war (postal rates for them doubling to 1*d* in 1918 and 1½*d* in 1921).

These postcards were published in France for sale to British soldiers on active service and issued in four sets of ten. The cards were printed by G. Savigny of 80, Rue de Cléry, Paris, or Paul Gaultier of Boulogne-sur-Mer (Paul Gaultier's typographical printing company was taken over by Laurent de Prat in 1929 and still exists as 'Cartonnages Gaultier'). The cards were tissue wrapped in their sets of ten, the wrapping reading, 'There will come a time when you may be glad to have something of this sort to remind you of the bright or funny side of the war,' followed by, 'Take this opportunity to secure the balance of the series.'

The *Daily Mail* series of official war postcards had come to an end on 9 May 1917, and the newspaper similarly told its readers that the postcards 'will in years to come to form an interesting and historical record of the conditions under which our army fought'. Many were clearly now looking towards the end of the war and the time when it would all be over.

A paper shortage in mid-1918 led to the Savigny printers taking the decision to issue the four sets of 'Sketches of Tommy's Life in France' in sets of only eight cards (the price remaining the same at 1f 50). Many of these cards are also issued on noticeably thinner card.

The notice at the bottom of the wrapper highlights that not only was paper in short supply, but ink shortages were also causing printers difficulties, and prices were rising sharply. *The Times* of 1918 reported that 'the paper question has affected us most seriously … and has cost us thousands of pounds extra'. 'The Illustrated War News failed to survive the last months of the war.' as Lucinda Gosling writes (*Brushes and Bayonets*) 'as imports of raw materials and paper from overseas were restricted and soon … became a scarce commodity'.

24. Wrapper for the sketches. (Authors' collection)

Postcard Production Begins in Boulogne-sur-Mer

Mackain's First World War 'Sketches of Tommy's Life' series totals forty different cards or ten per series, these series following the path of the typical soldier during wartime: (1) In Training; (2) At the Base; (3) Up the Line; and (4) Out on Rest. These sold initially at 10*d* (or 1f) per set. Additional postcards were produced strictly as greeting cards and (possibly) not part of a series. There were at least four such sets of six to ten cards. In what order these cards were produced has yet to be discovered (but see conjectures below). A later series called 'Sketches of Sammy's Life in France' began in September 1918 and was designed to appeal to the newer American market. Other known cards seem to belong to different series and show Mackain experimenting with different designs and ideas.

All cards have divided backs; paper thickness and colour depth vary, and the typeset for the captions varies with different printings (some including typographical errors – e.g. Tomm'ys Life).

It seems a reasonable conjecture that Mackain began producing drawings for his postcard series after he was taken ill and transferred to the ASC, these perhaps based on sketches he had created while in the trenches. It is certainly the case that none of the sets he produced appeared before October 1917. It is likely that his first cards were those captioned 'Pierre Isoré éditeur à Bresles (Oise)' and printed in Boulogne-sur-Mer by Gaultier; thereafter, the editor and the printer become the same Paul Gaultier. Gaultier's typographical imprimerie continued until 1929.

Although all the cards were coloured (and available in packs which advertised this), one early set of black-and-white cards exists under the editorship of Pierre Isoré in Bresles. Perhaps these were the first trial cards. The firm of Savigny in Paris also began printing the cards soon after.

Cards depicting the realities of war were not suitable for sending home. The Mackain cards occasionally touched on these realities, but the overall theme was light-hearted, jovial in tone and more reassuring for sending to concerned families. Many of the scenes on the cards had relevance to the men at war – the petty little jobs at base camp, billets, Army food, the rum ration ('One of the bright spots in our life' – Up the Line, No. 7), the officious officers, etc. There are some particularly powerful cards that touch on some of the real scenes of war, but with little comment. Most researchers agree that the postcard publishers were not ordered to produce propaganda, it was more of a case of '… giving the public what they thought they wanted'.

Mackain's cards follow four stages of a soldier's experience. They are written in the first person as though reflecting that soldier's own experiences in 'sketches'. The sketches themselves may well be based upon a sketchbook Mackain himself kept throughout the war, as they do include caricatures of officers of the Royal Fusiliers, together with some personal connections such as the package bearing his own name that the Quartermaster gives him. How many of the illustrated events were from Mackain's own experiences is, of course, open to conjecture.

'In Training' reflects the training of recruits in England in the many camps which attempted to prepare these young men for a type of war which had yet to develop. Problems with uniforms, learning how to deal with officers, becoming familiar with rifle

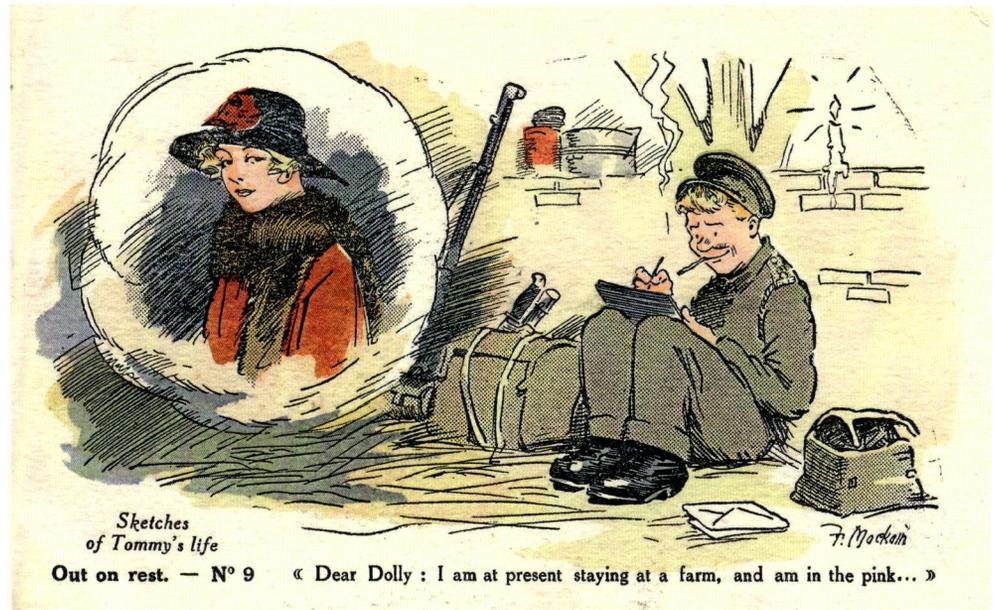

Sketches
of Tommy's life

Out on rest. — N° 9 « Dear Dolly : I am at present staying at a farm, and am in the pink... »

25. Such a letter Mackain wrote to his own wife and children, a letter which worked hard to conceal a darker reality. (Authors' collection)

and weapons and learning how to parade correctly were all part of this new way of life for these young men. Considerable moral pressure had been exerted through propaganda and the press to make signing up the 'right thing to do':

> Girls with feathers, vulgar songs –
> Washy verse on England's need ...

All these contributed to that first burst of patriotism, as the poet A. E. Mackintosh was to write.

'At the Base' then sees the soldier travelling overseas to France. For most this was their first time in a different country. It could seem a long way from home for these inexperienced men, and there was much to learn as they set to prepare for fighting in the front line. A new 'Franglais appeared', as Tommies turned French words and places into recognisable English terms. Mackain's final card in this series tells how, at the end of their final training and preparation at the base, they 'left the Base in great style and cattle trucks', an oxymoron and zeugma with which Alexander Pope would have been pleased! This undercutting of statement is a particular strength of Mackain's cards.

'Up the Line' is, in general, more serious, touching on the difficult conditions that existed there. Night-time patrols; duties; barrages; finding shell holes for cover under heavy fire and the

constantly flooded trenches are shown with a lightness of touch under which one can often feel a current of sadness.

The final series, 'Out on Rest', reflects something of the relief with which men welcomed their turn to be rotated out of front-line duty. The routines of trench life duties saw soldiers in the front line for up to seven days before they withdrew to the support trenches for a week and were then 'out on rest' for a third week, at which point the cycle commenced again. Simple daily routines (washing, eating properly) became a great pleasure simply because they could be done again. Soldiers would frequently be billeted in farms or nearby towns, many of which would bear the scars of a war which was never far away.

Postcards formally came under censorship in Great Britain on 15 September 1916 and from this date the cards had to be submitted to the Press Bureau for censorship. This would not affect Mackain's cards as they were published in France (although they did seem to have to be registered, the word 'Vise', endorsed, appearing on most). In most cases there was self-censorship. Card designs also catered to the market: men would not want to appear to be complaining about their circumstances, and they would also not want to worry those waiting at home. On the other hand, they did want to give the 'folks at home' some idea of their new life, especially if it could be done in a humorous format. These cards acceptably fit those demands.

Opposite: 26. Mackain's most sombre card, evoking the grim landscape of the trenches. (Authors' collection)

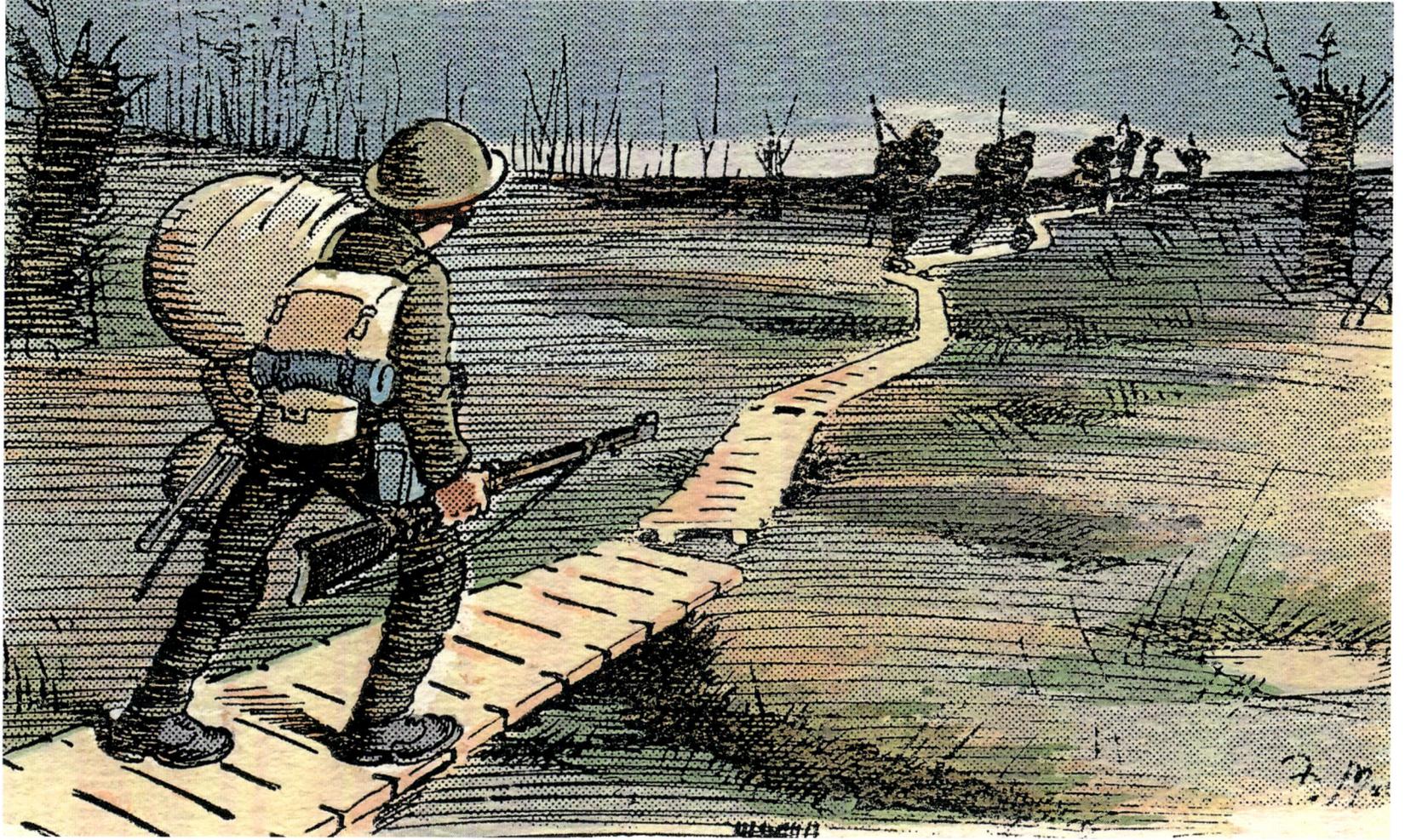

THE CARDS: SKETCHES OF TOMMY'S LIFE

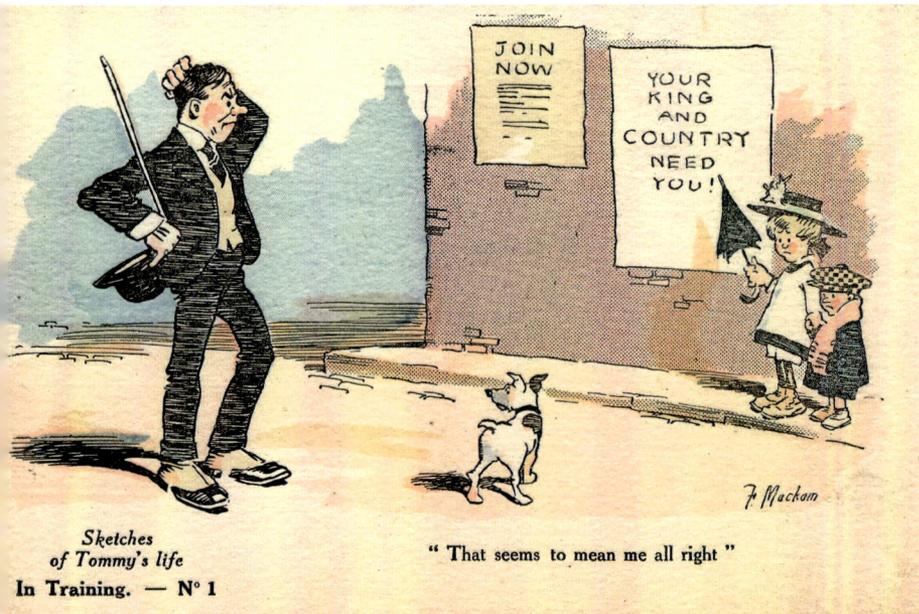

Sketches
of Tommy's life
In Training. — Nº 1

" That seems to mean me all right "

In Training (Set 1)

Young Englishmen answered the call, for King and Country, and voluntarily joined the British Army. By early 1915 losses in the regular army had become heavy and numbers were now replaced by the part-time volunteers of the Territorial Force and Kitchener's new volunteer army. The Kitchener recruitment campaign had proved to be very successful, as on 1 September 1914 over 30,000 men had enlisted. With each day passing, thousands more were clamouring to be taken. Eventually, in January 1916, well before the Tommy's Life cards were produced, conscription was introduced.

27 & 28. In Training No. 1, 'That seems to mean me all right'. (Authors' collection)

At the start of the First World War there was a shortage of khaki uniforms, and most new army units had to instead wear 'Kitchener blue', which was deeply unpopular (not least because it made new recruits look like bus drivers).

Some men spent hard-earned money in order to look extra smart. Soldiers would purchase special material that would be cut by a local tailor to their specific dimensions.

The difficulties with equipping so many men with the appropriate uniforms were, in the beginning, insuperable. Fred Ward writes how for the Royal Fusiliers volunteers 'the stock sizes could be secured, but stock sizes were at a discount with the majority of the men who first joined up. They wanted outside sizes, and very considerable outside sizes, too, for the average height was a little over six feet, and the chest measurements in proportion.'

Early-morning tea was important: drink would be an important issue throughout the war. Ward writes, 'If we were fortunate, we might be able to purchase beer at a local hostelry, or Oxo at a village shop. If not so fortunate, the water bottle or, if again lucky, a pocket-flask was brought into service.' Later, on the front line, it would be the rum ration that became indispensable.

Top right: 29. In Training No. 2, 'It's funny how rotten your uniform looks on you. You wonder how the other chaps manage to appear so smart'. (Authors' collection)

Bottom right: 30. In Training No. 3, 'Getting your cup of tea in the morning was as exciting as battle'. (Authors' collection)

Overleaf: 31. In Training No. 4, 'First time you got out on the parade grounds and forgot to say 'Sir' to the Sergt-Major, the one with the big silver-headed stick'. (Authors' collection)

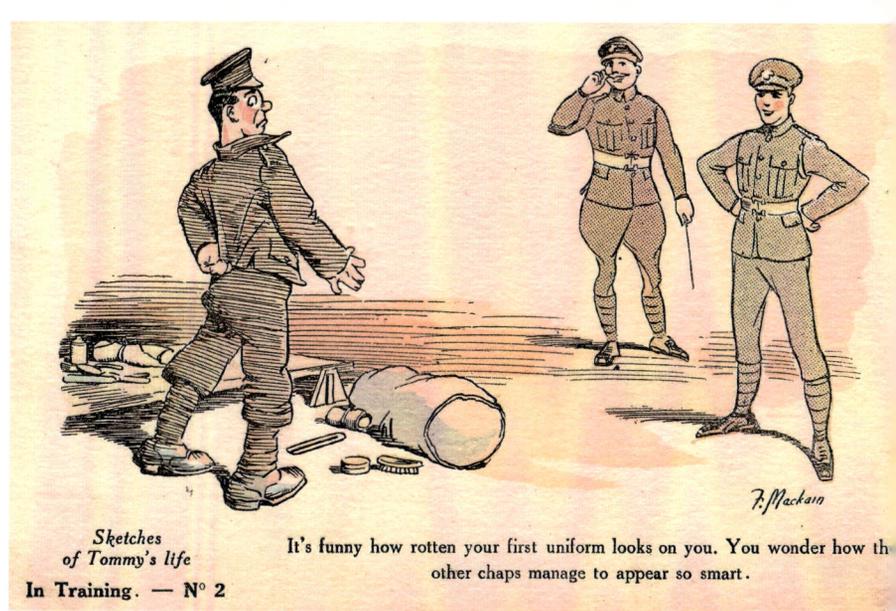

Sketches of Tommy's life
In Training. — Nº 2
It's funny how rotten your first uniform looks on you. You wonder how the other chaps manage to appear so smart.

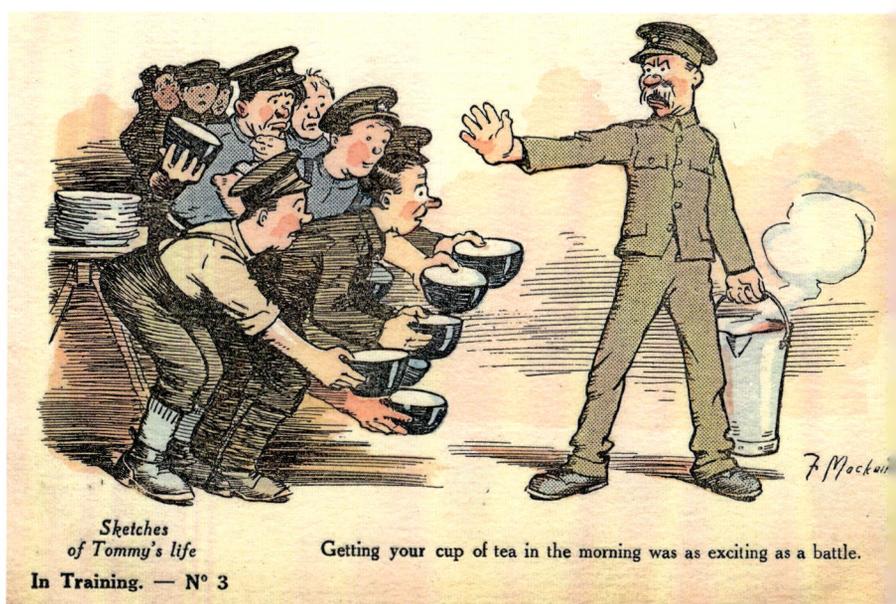

Sketches of Tommy's life
In Training. — Nº 3
Getting your cup of tea in the morning was as exciting as a battle.

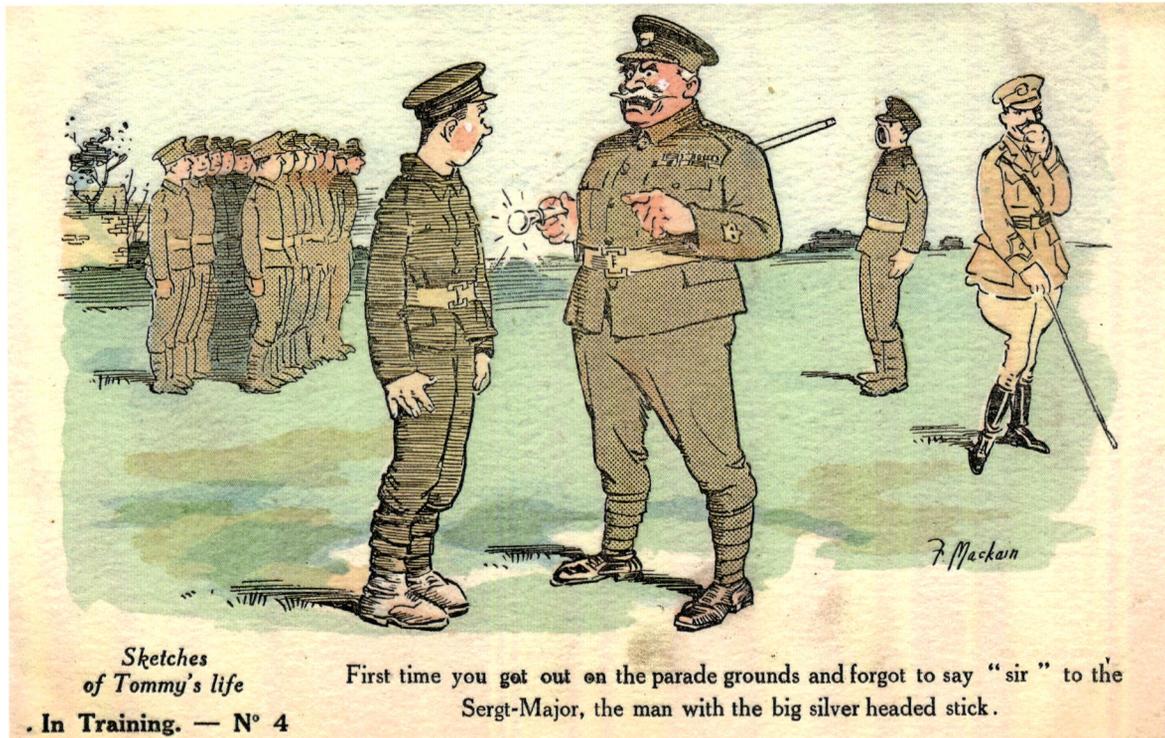

Sketches
of Tommy's life

In Training. — N° 4

First time you got out on the parade grounds and forgot to say "sir" to the
Sergt-Major, the man with the big silver headed stick.

Swagger sticks were most familiarly carried by military officers or more senior non-commissioned officers (in this case, a company sergeant major as signified by 'the Crown' on his sleeve). Some commissioned officers would carry swagger sticks when in uniform, while some warrant officers and senior NCOs carried pace sticks instead.

The officers and all their well-loved (and hated) rituals come into this series, here the hectoring sergeant-major, 'the one with the big silver-headed swagger stick'. As one regimental sergeant-major briefed new officers: 'Now gentlemen, the swagger stick is not for rattling along railings, cleaning out drains at home, or swiping the heads of poor innocent little flowers. Nor is it for poking into stomachs or for fencing duels in the mess line. No, gentlemen, it is to make you walk like officers and above all to keep your hands out of your pockets.'

The rifle in question is the standard Short-Magazine Lee-Enfield (SMLE Mk III and Mk III*). Adopted by the British Army in 1907, this rifle would still be in use until 1957. The rifle had a ten-round magazine (.303 cartridge) and a 'soldier-proof reputation', as Andrew Robertshaw describes it in *24 Hr Trench*.

The puttee was a standard item of dress for British soldiers from the 1880s. Derived from the Hindustani word for 'bandages', they were nine-foot-long strips of cloth wound up the leg and fastened off with a tape just below the knee. The spiral had to be even and similar on both legs. The puttee was designed to support the soldier's calves, protect the top of the boots from mud and damp in the trenches and prevent the trousers from becoming torn.

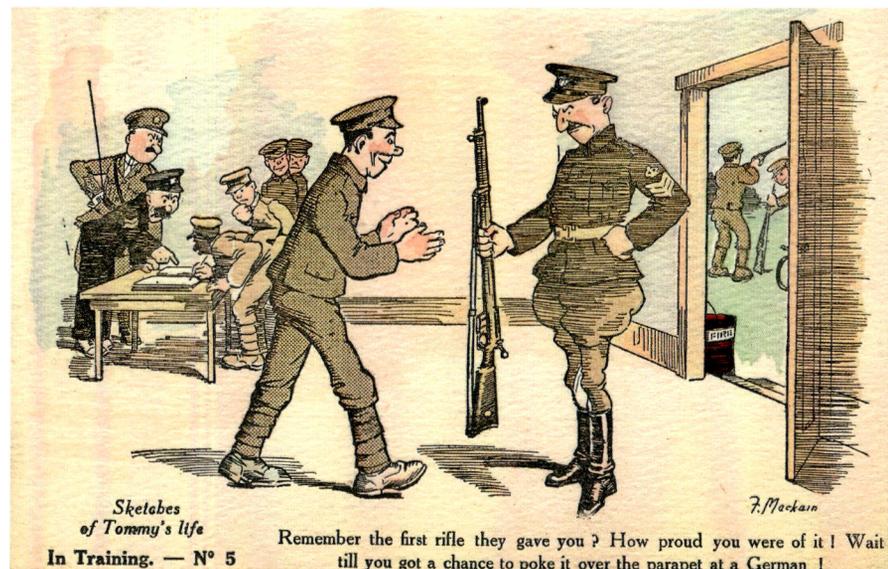

Sketches of Tommy's life

In Training. — N° 5

Remember the first rifle they gave you? How proud you were of it! Wait till you got a chance to poke it over the parapet at a German!

Top right: 32. In Training No. 5, 'Remember the first rifle they gave you? How proud you were of it? Till you got a chance to poke it over the parapet at a German!'. (Authors' collection)

Bottom right: 33. In Training No. 6, 'One time, just as I thought I was getting good at the game, my puttee became undone on parade. They made such a fuss about it I was afraid I would be ordered to be shot at dawn!'. (Authors' collection)

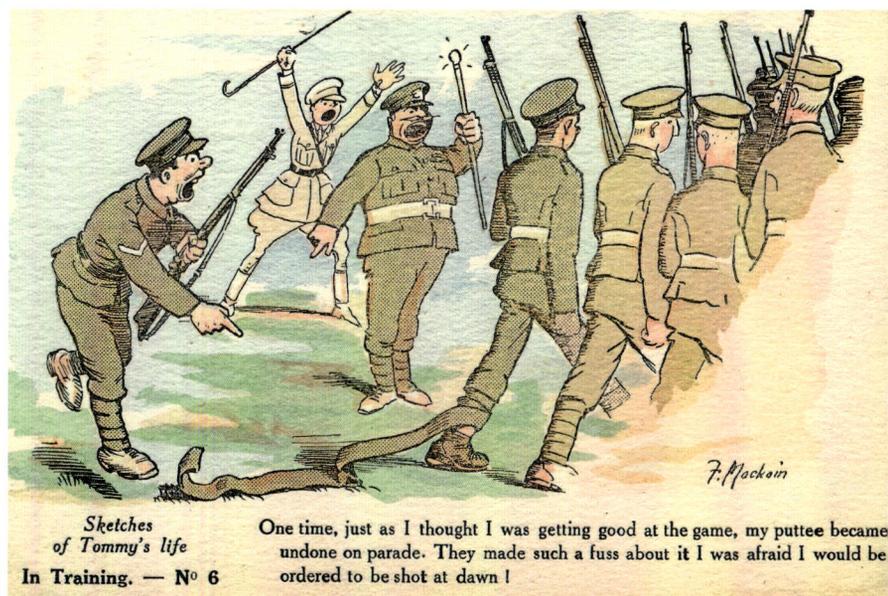

Sketches of Tommy's life

In Training. — N° 6

One time, just as I thought I was getting good at the game, my puttee became undone on parade. They made such a fuss about it I was afraid I would be ordered to be shot at dawn!

Soldiers were paid once a week, usually on a Friday afternoon. Basic infantry pay started for a private started at about 1s 1d per day, with other increments possible for length of service and proficiency qualification (e.g. best shot in the company). To give an idea, the exchange rate was 9½d for a franc; two packs of cigarettes would cost 15 centimes, a box of matches 60 centimes, a packet of biscuits 20 centimes, a pack of OXO cubes 75 centimes and a pint of beer would set you back 1 franc.

Where conditions permitted, troops attended a Pay Parade, presided over by the unit commander, at platoon or company level. Pay parades often had a lieutenant or captain in charge, assisted by one or two NCOs of the unit. Each soldier's name would be called out in alphabetical order along with his regimental number: 'Mackain, 4299!' The soldier would stamp his heel and shout back, 'Sir!' or 'Present!' then march smartly forward to the pay-table, salute, have his pay-book marked in the correct amount, receive his pay in cash handed from the NCO, salute again, and march back to his place.

Also noticeable here is the officer behind the desk: this seems very likely to be a caricature of Lt Colonel E. A. Winter (DSO and Bar; MC). Winter joined the Royal Fusiliers as a lieutenant in 1914 (on the nominal roll) and rose to the rank of lieutenant colonel and commanding officer on 18 May 1917, gazetted from the rank of temporary major.

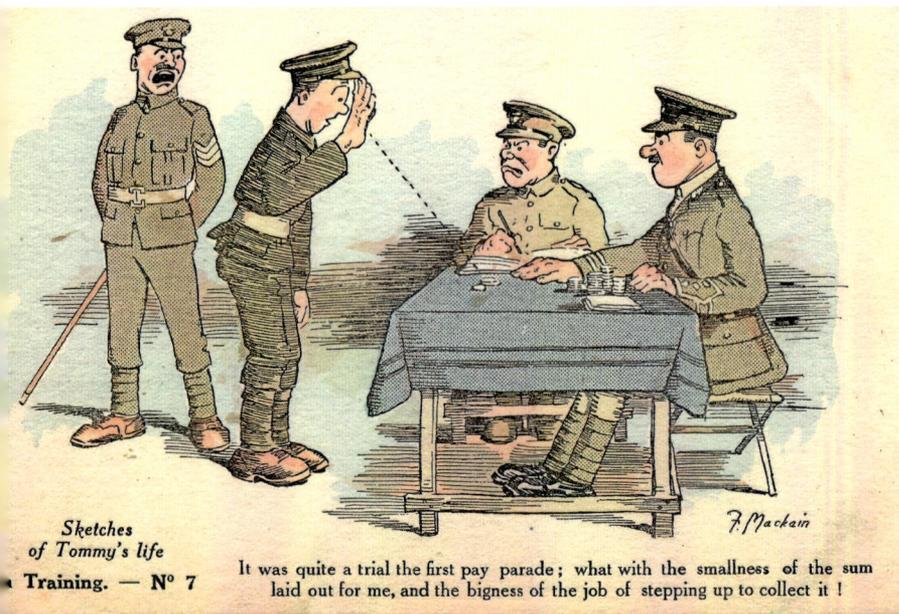

Sketches of Tommy's life
Training. — Nº 7

It was quite a trial the first pay parade; what with the smallness of the sum laid out for me, and the bigness of the job of stepping up to collect it !

F. Mackain

34 & 35. In Training No. 7, 'It was quite a trial the first pay parade; what with the smallness of the sum laid out for me and he bigness of the job of stepping up to collect it!' (Authors' collection)

Before the peak of the war, no man could be sent to the front until he had taken a marksmanship test that required the soldier to fire fifteen rounds at a target at 300 yards. The results of this test were used to determine whether a soldier was a first- or second-class shot. Ammunition was in short supply so the men only got a few chances to practice beforehand, however.

Average training started at approximately twelve weeks, and by 1918 was down to about six weeks. Training was basic as most people already accepted orders, routine, manual labour and so on as the norm. The main areas of training were rifle and bayonet drill, small-unit tactics and understanding the basics of trench warfare.

Right: 36. In Training No. 8, 'You are a Trained Soldier as soon as you finish your firing course. It's hard to shoot well at this time, on account of having so many to help you hit the bull's eye.' (Authors' collection)

Overleaf, left: 37. In Training No. 9, 'It was a thrilling moment that day, at tea time, when our lot were told off for the Overseas draft.' (Authors' collection)

Overleaf, right: 38. In Training No. 10, 'Naturally, one writes a good many letters describing the many adventures one is shortly to experience.' (Authors' collection)

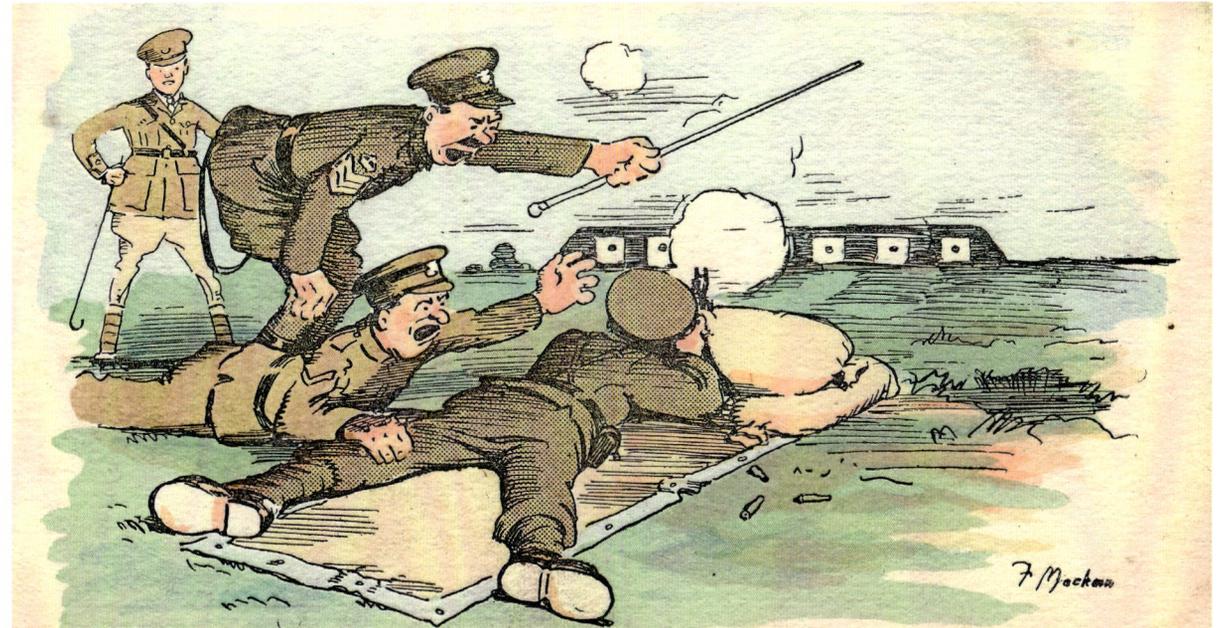

Sketches of Tommy's life
In Training. — N° 8

You are a Trained Soldier as soon as you finish your firing course. It's hard to shoot well at this time, on account of having so many to help you hit the bulls eye.

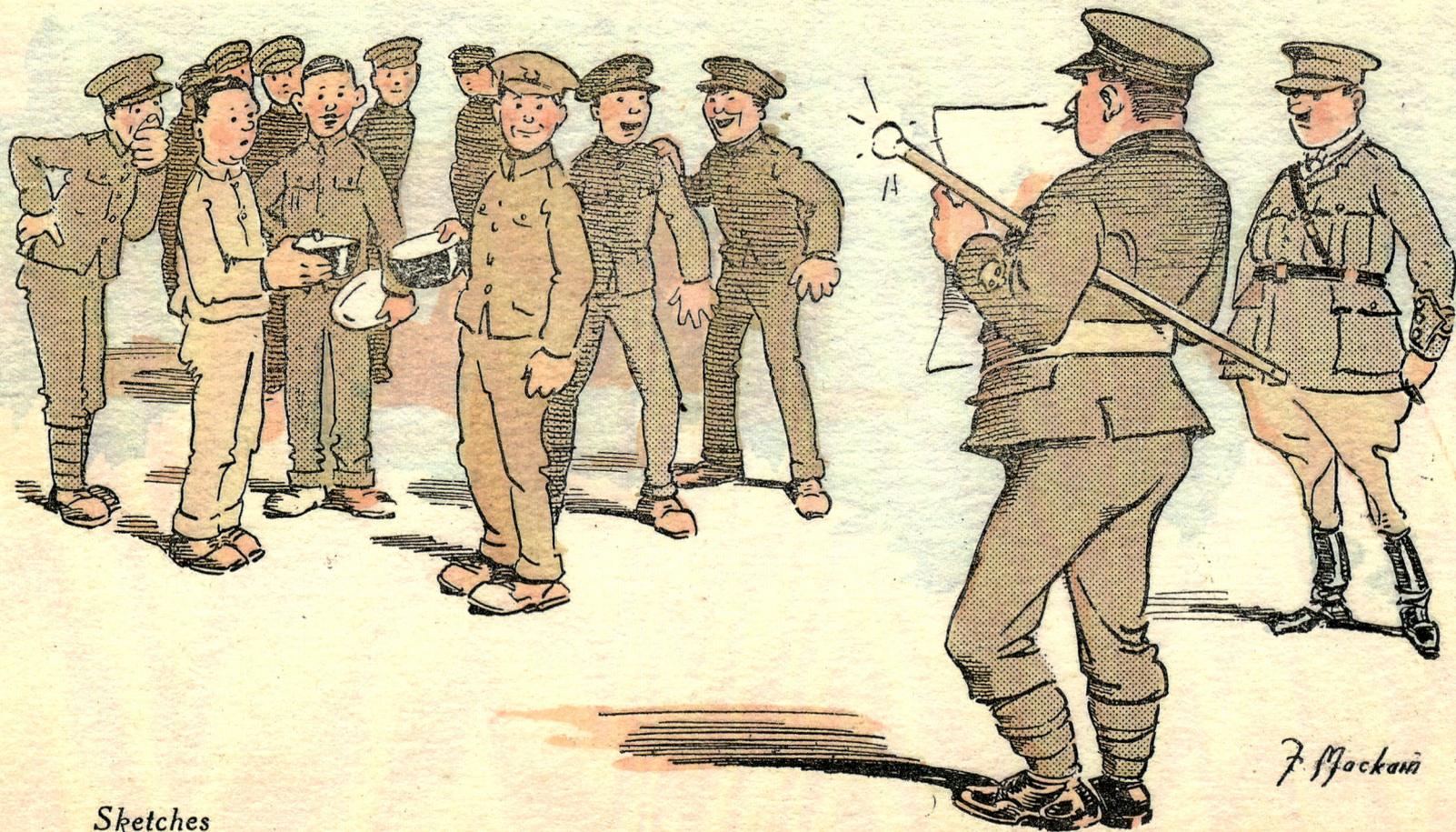

*Sketches
of Tommy's life*

In Training. — Nº 9

It was a thrilling moment that day, at tea time, when our lot were told off
for the Overseas draft.

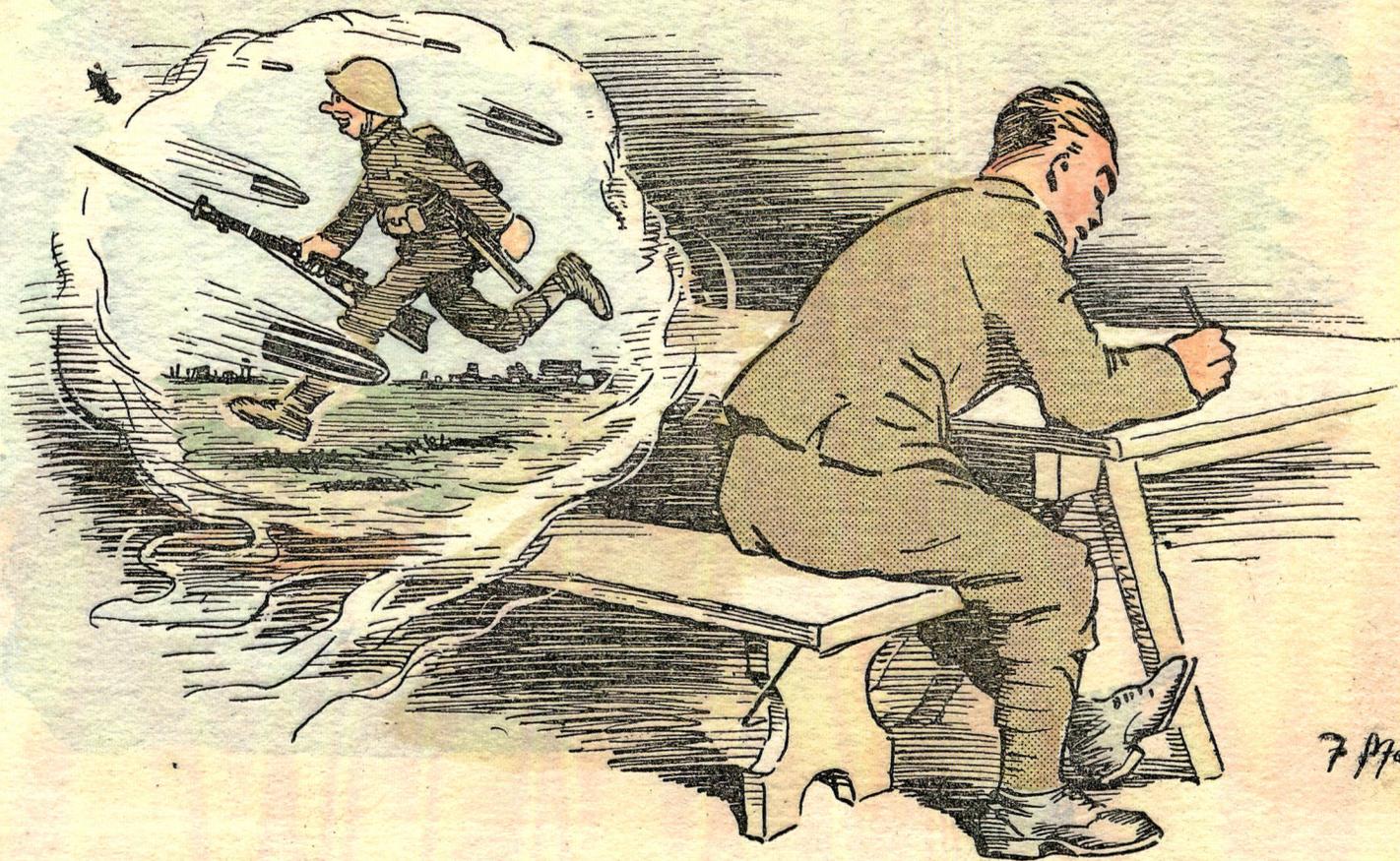

Sketches of Tommy's life

In Training. — Nº 10

Naturally, one writes a good many letters describing the many adventures one is shortly to experience.

At the Base (Set 2)

The term BEF (British Expeditionary Force) is often used to refer only to the forces present in France prior to the end of the First Battle of Ypres on 22 November 1914. By the end of 1914 – after the battles of Mons, Le Cateau, the Aisne and First Ypres – the old regular British Army had been effectively wiped out, although it managed to help stop the German advance. An alternative endpoint of the BEF was 26 December 1914, when it was divided into the First and Second Armies. BEF remained the official name of the British Army in France and Flanders throughout the First World War.

Contrasts of experience must have been extreme, as new and no doubt naive and excited young men met older hands who had seen it all before. Robert Cedric Sherriff's play *Journey's End* deals with this idea in the characters of the experienced and bitter Captain Stanhope and the young Second Lieutenant Raleigh.

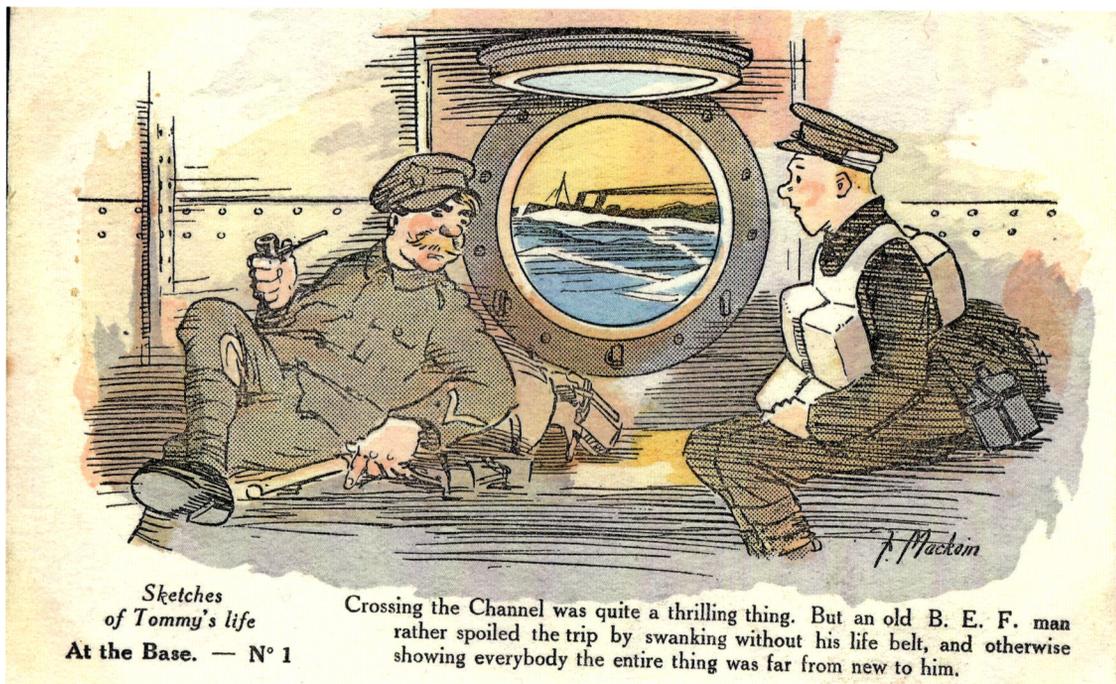

Sketches of Tommy's life
At the Base. — N° 1

Crossing the Channel was quite a thrilling thing. But an old B. E. F. man rather spoiled the trip by swanking without his life belt, and otherwise showing everybody the entire thing was far from new to him.

39. At the Base No. 1, 'Crossing the Channel was quite a thrilling thing. But an old B.E.F. man rather spoiled the trip by swanking without his life belt, and otherwise showing everybody the entire thing was far from new to him.' (Authors' collection)

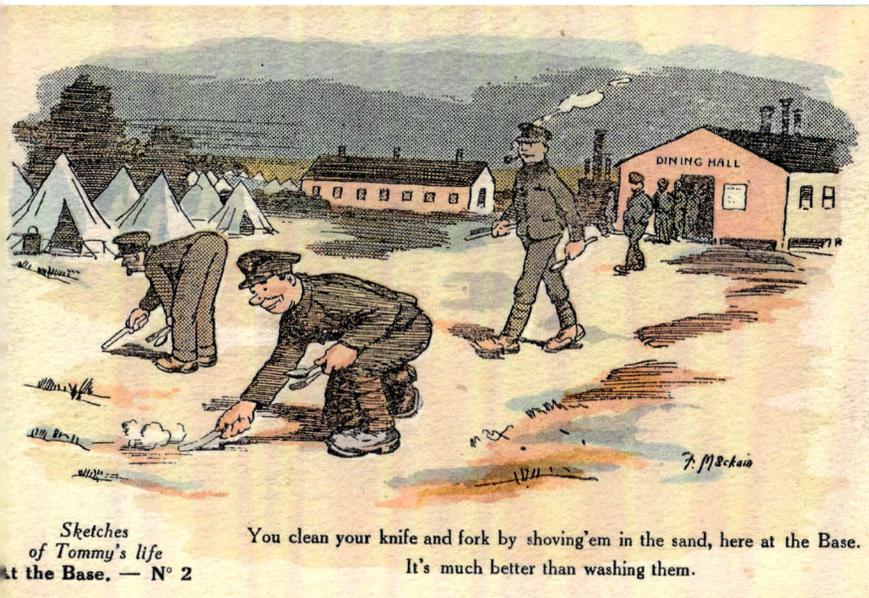

Sketches
of Tommy's life
At the Base. — N° 2

You clean your knife and fork by shoving'em in the sand, here at the Base.
It's much better than washing them.

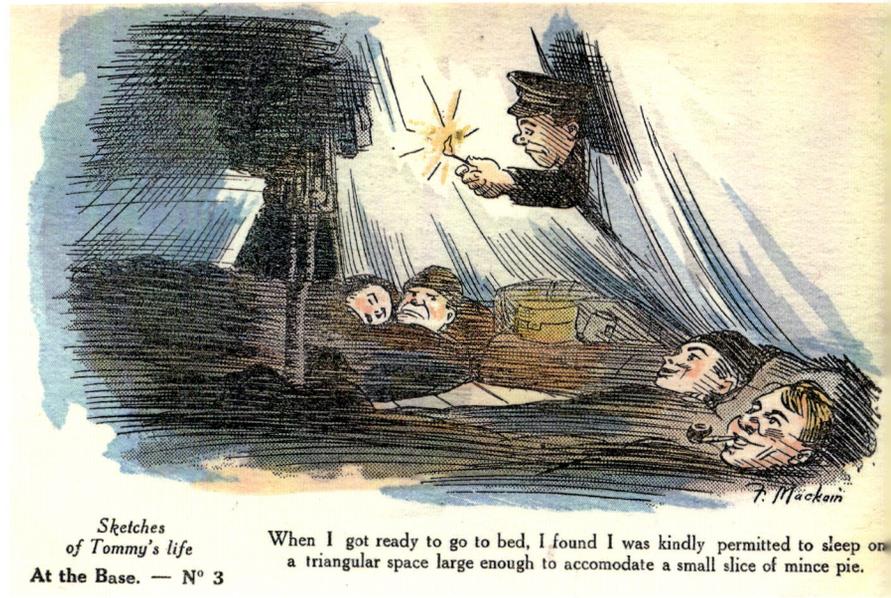

Sketches
of Tommy's life
At the Base. — N° 3

When I got ready to go to bed, I found I was kindly permitted to sleep on
a triangular space large enough to accomodate a small slice of mince pie.

Above left: 40. At the Base No. 2, 'You clean your knife and fork by shoving 'em in the sand, here at the Base. It's much better than cleaning them.' (Authors' collection)

Above right: 41. At the Base No. 3, 'When I got ready to go to bed, I found I was kindly permitted to sleep on a triangular space large enough to accommodate a small slice of mince pie.' (Authors' collection)

Overleaf, left: 42. At the Base No. 4, '"House" is the most popular game at the Base. Who hasn't heard those familiar lines: "Eyes down! Legs eleven! Kelly's Eye! Blind half hundred! And another lucky dip in the old bag!"'. (Authors' collection)

Overleaf, right: 43. An old Bingo card.

Drafts not destined to go straight to units – the majority of men arriving in France from mid-1916 – went instead to Étaples and its surroundings, the unwelcoming world of the base depots with the infamous 'bullrings'. The areas east of the River Canche were home to a variety of infantry base depots, hospitals and convalescent camps. The sandy area north of the depots had a long line of training compounds.

Bell tents were large, round, white fabric constructs that could house up to ten men, with low wooden beds arranged like the spokes of a wheel around the central tent pole. When it rained the floor of the tent would become very wet and muddy, and the soldiers would hang their boots from the ceiling to stop them filling with water.

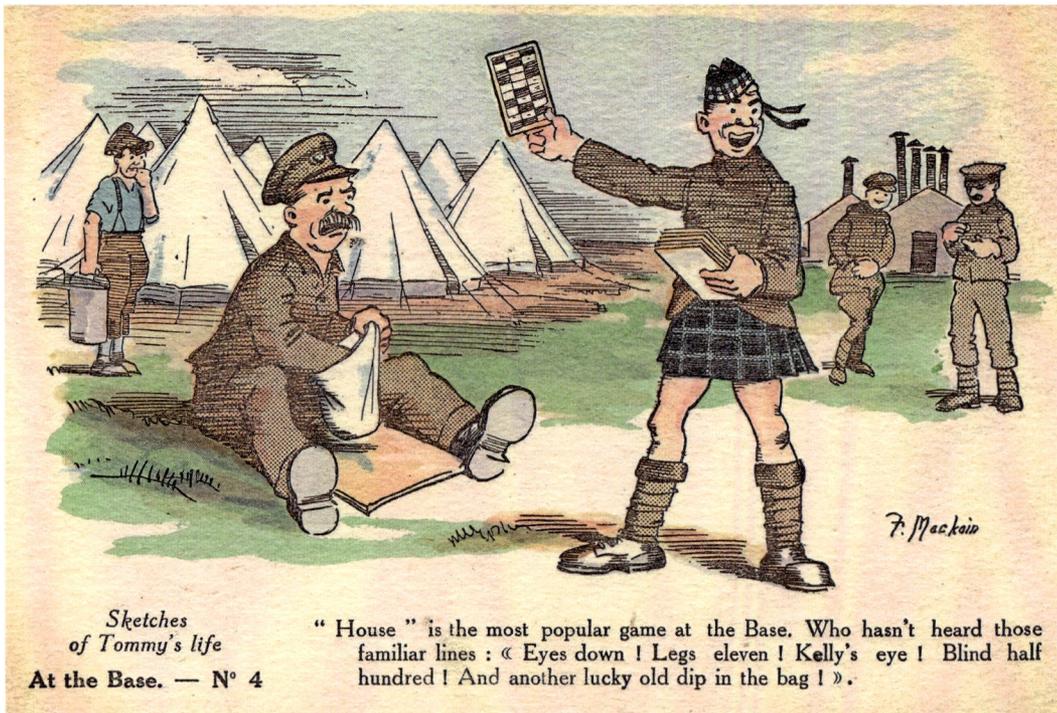

Sketches
of Tommy's life

At the Base. — Nº 4

" House " is the most popular game at the Base. Who hasn't heard those familiar lines : « Eyes down ! Legs eleven ! Kelly's eye ! Blind half hundred ! And another lucky old dip in the bag ! ».

Carolyn Downs writes in her book on the social history of bingo that 'despite the ambivalence of opinion about bingo in the First World War it appears to have been a popular game and one where potential prizes were large'. One veteran recollected a housey-housey game in 1915 at Catterick Camp, near Richmond, Yorkshire. These games were popular with the men, but the sergeant and the corporal evidently fixed the games: 'Well we used to go to the canteen at night and they'd run what's called bingo now. Well, we called it housey-housey, but the trouble was there was these old soldiers, and we youngsters,

and they'd get their own mates calling out "Bingo" and the cards was never checked, so you never knew.'

The game was also popular in the trenches, during lulls in the shelling: 'The most complex game tolerated by the authorities was house. Twenty-four cards were issued at two shillings and six pence a time. Each card had three lines with five numbers on. One man handled the cash and cards while the other called out the numbers.' The money from these games was a means of raising mess funds for servicemen.

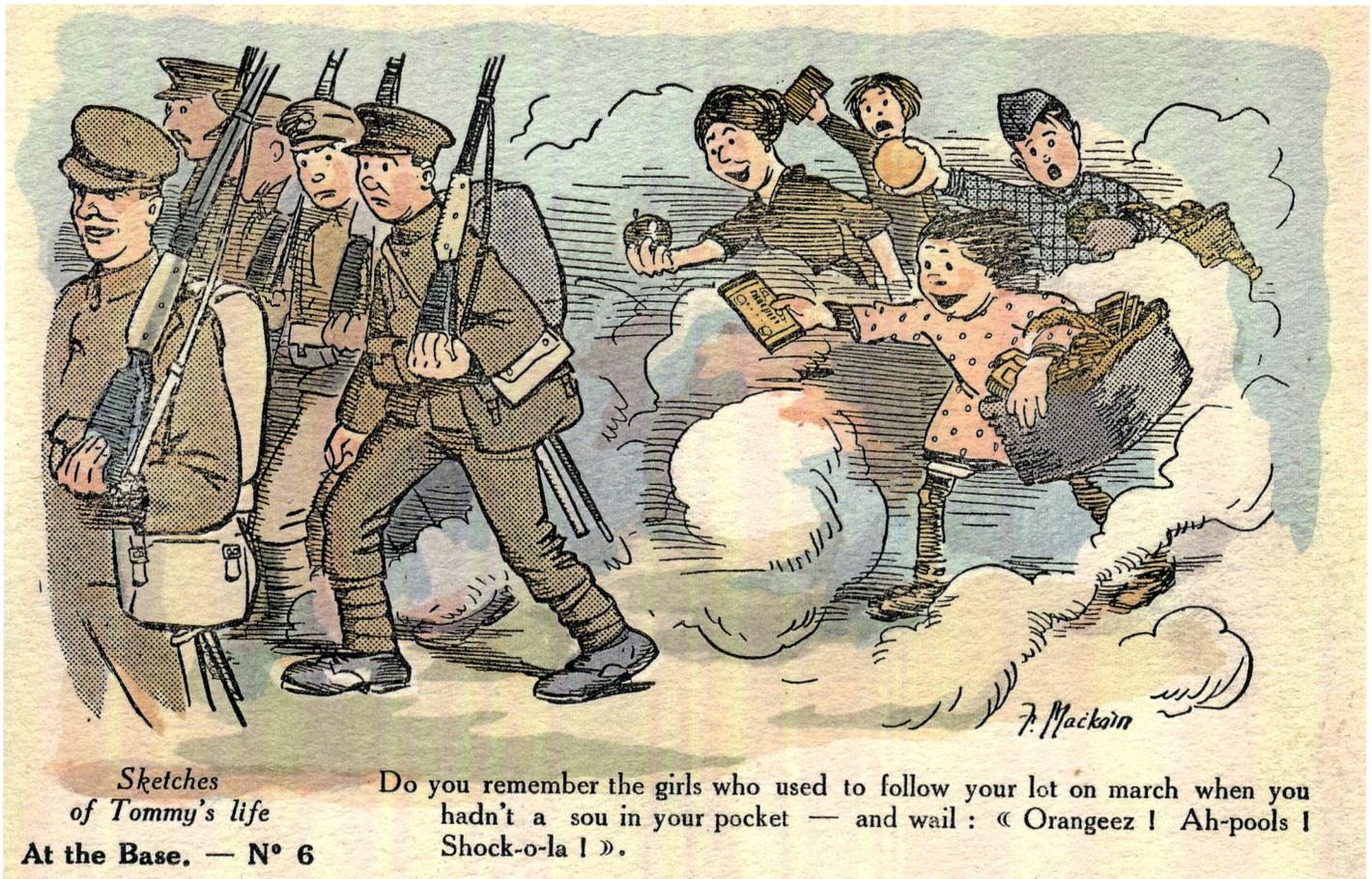

Sketches of Tommy's life

At the Base. — N° 6

Do you remember the girls who used to follow your lot on march when you hadn't a sou in your pocket — and wail : « Orangeez ! Ah-pools ! Shock-o-la ! ».

A new 'Franglais appeared', as the Tommies turned French words and places into recognisable English terms ('Ypres' becoming 'Wipers', for example), and the French natives attempted to cope with this influx of English soldiers and new words they needed to know. Hence 'Boo-lee-Bee-ee-f', 'Bis-kweet', 'Orangeez', 'Ah-pools' and 'Shock-o-la' became new terms to quickly learn.

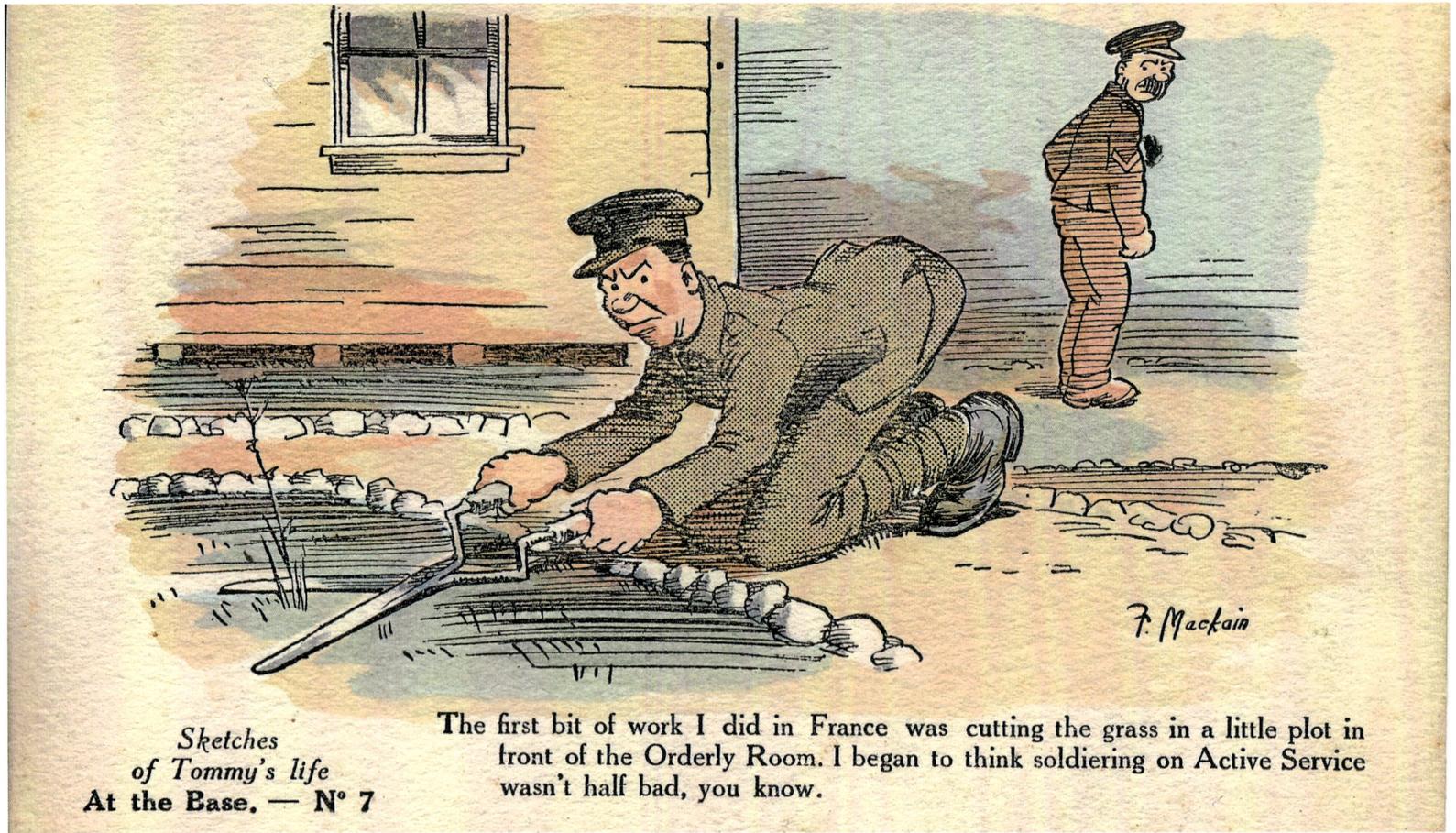

Sketches
of Tommy's life
At the Base. — Nº 7

The first bit of work I did in France was cutting the grass in a little plot in front of the Orderly Room. I began to think soldiering on Active Service wasn't half bad, you know.

F. Mackain

An ironic take on petty fatigues and overzealous NCOs. The orderly room in the barracks of a battalion or company was used for general administrative purposes. Efforts were made to beautify the camps, and in front of the officers' quarters little gardens had been planted with flowers and vegetables, and in some cases regimental crests had been worked with various pieces of coloured glass.

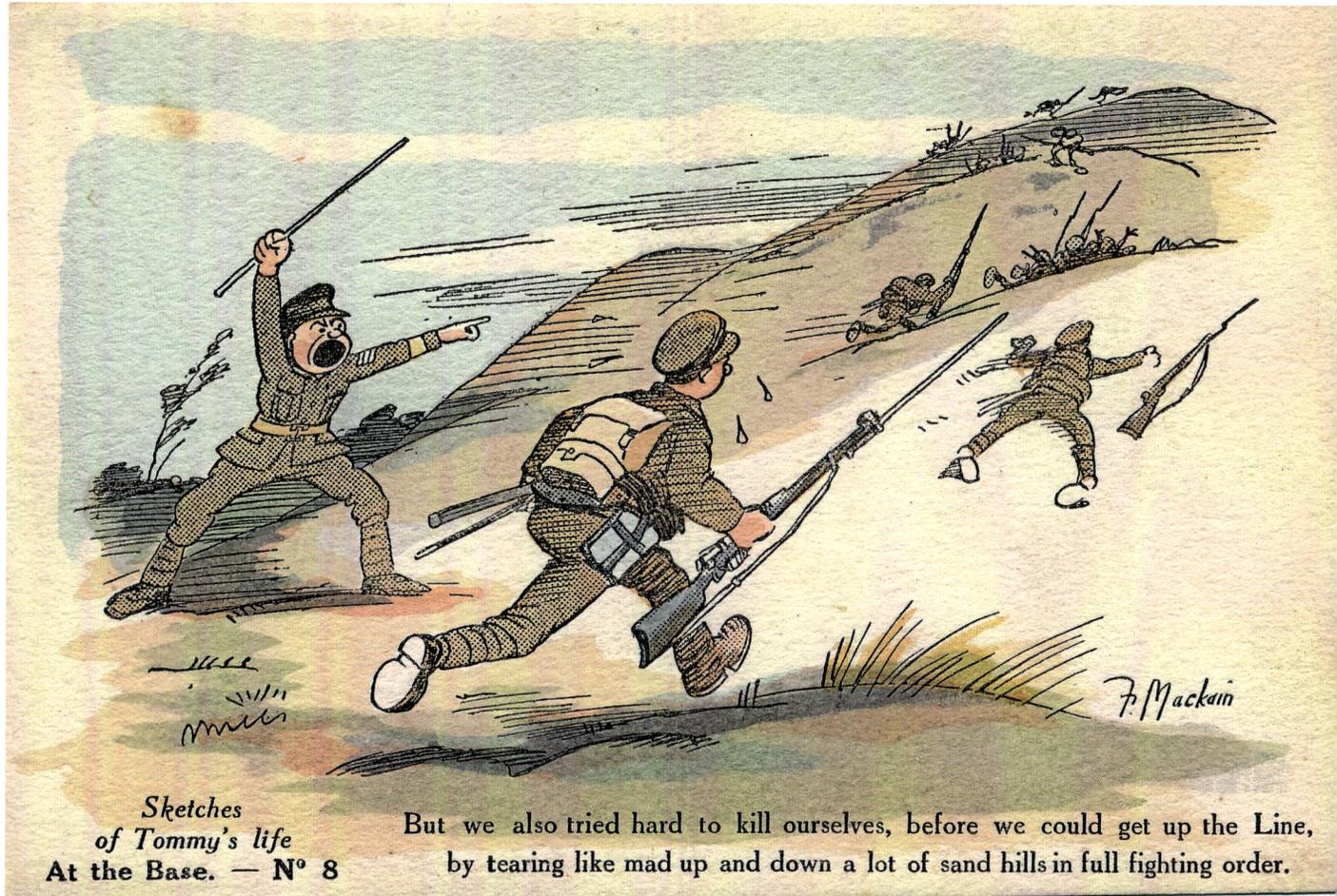

Sketches
of Tommy's life
At the Base. — Nº 8

But we also tried hard to kill ourselves, before we could get up the Line,
by tearing like mad up and down a lot of sand hills in full fighting order.

F. Mackain

Previous spread, right: 44. At the Base No. 6, 'Do you remember the girls who used to follow your lot on march when you hadn't a sou in your pocket? – and wail: "Orangeez! Ah-pools! Shock-o-la!"' (Authors' collection)

Opposite: 45. At the Base No. 7, 'The first bit of work I did in France was cutting the grass in a little plot in front of the Orderly Room. I began to think soldiering on Active Service wasn't half bad, you know.' (Authors' collection)

Right: 46. At the Base No. 8, 'But we also tried hard to kill ourselves, before we could get up the Line by tearing like mad up and down a lot of sand hills in full fighting order.' (Authors' collection)

The instructors at the infamous Étaples sand hills were known as Canaries because of their penetrating voices and their yellow-coloured 'brassards' or armbands.

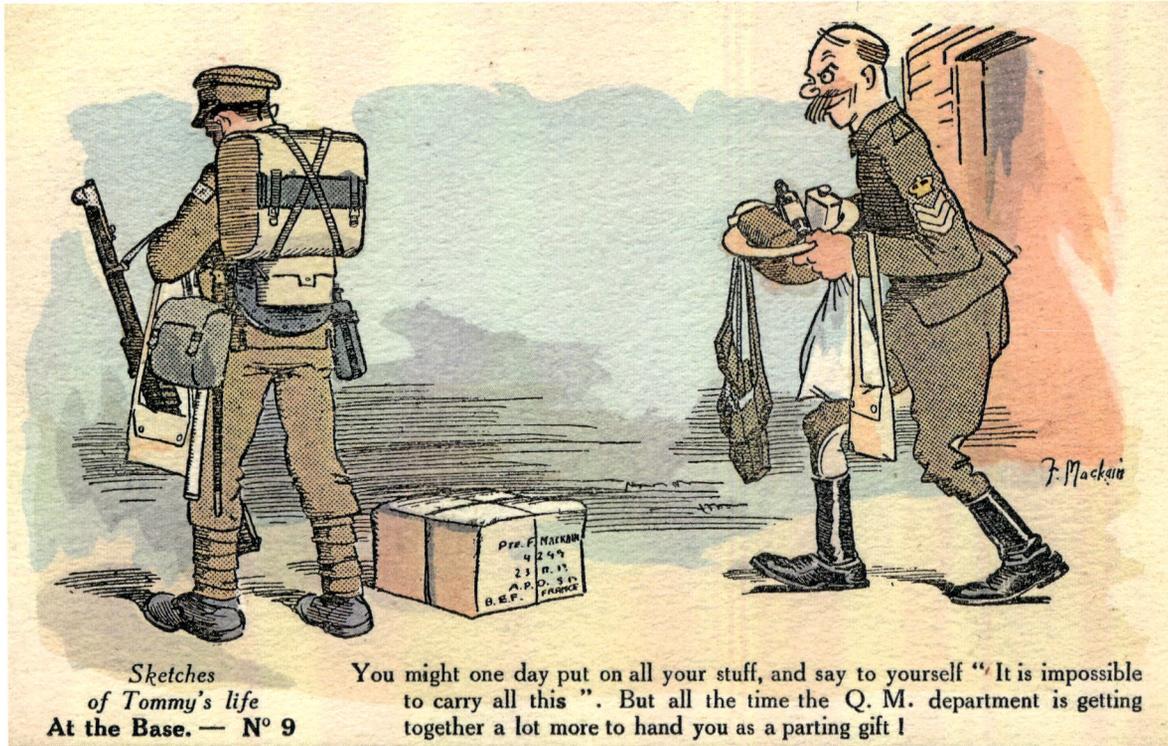

Sketches of Tommy's life **At the Base. — N⁰ 9**

You might one day put on all your stuff, and say to yourself "' It is impossible to carry all this ". But all the time the Q. M. department is getting together a lot more to hand you as a parting gift !

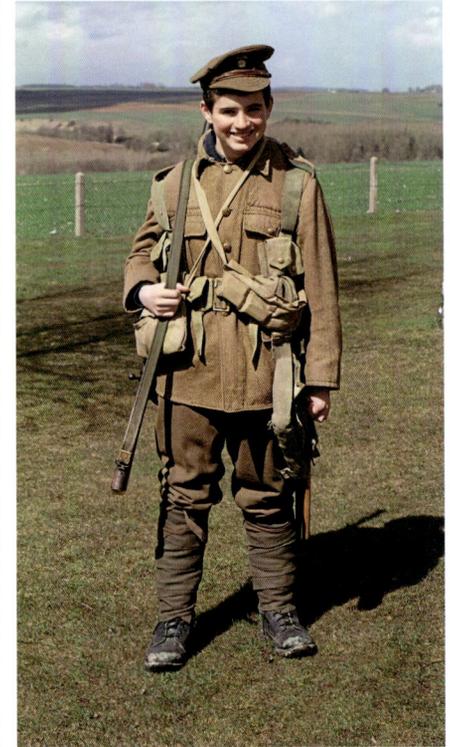

Soldiers had to have a large amount of kit! Andrew Robertshaw (*24 Hr Trench*) lists: standard clothing – long johns, shirt, braces, socks, etc., service dress trousers, Pattern belt, puttees, additional knitted clothing for warmth, leather jerkin, trench cap (after 1916 tin helmet), service dress tunic, webbing. Equipment – army pay book, 'First Field Dressing' kit for soldiers to give themselves first aid, haversack, mess tin, bayonet, 'pick mattock' (entrenching tool), ammunition (150 rounds), respirator and satchel (SBR 'Small Box Respirator from 1916), set of mess tins, ground sheet, rations, holdall with washing and shaving kit and eating utensils, jack knife, rifle (.303 standard Short-Magazine Lee-Enfield). Additionally, flares, rockets, tent props and personal items.

The narrow gauge railroads of France had boxcars that were used to transport the soldiers to and from the fighting fronts. Each boxcar carried forty men or eight horses. The cars were stubby, only 20½ feet long and 8½ feet wide.

This last card in the 'At the Base' series links up to the first card in the following series, 'Up the Line', detailing that part of the soldier's story where he leaves the base camp and sets off for the front line. Mackain elects not to show the soldiers thinking ahead to what they might be facing, but instead sanitises the experience by showing children and the excitement of the occasion.

Opposite, left: 47. At the Base No. 9, 'You might one day put on all your stuff, and say to yourself "It is impossible to carry all this." But all the time the Q.M. department is getting together a lot more to hand you as a parting gift!' (Authors' collection)

Opposite, right: 48. One of the author John Place's school pupils 'at the front' recreates the Tommy with all his equipment! Needless to say, he found it very tiring after the first excitement of wearing it … (Authors' collection)

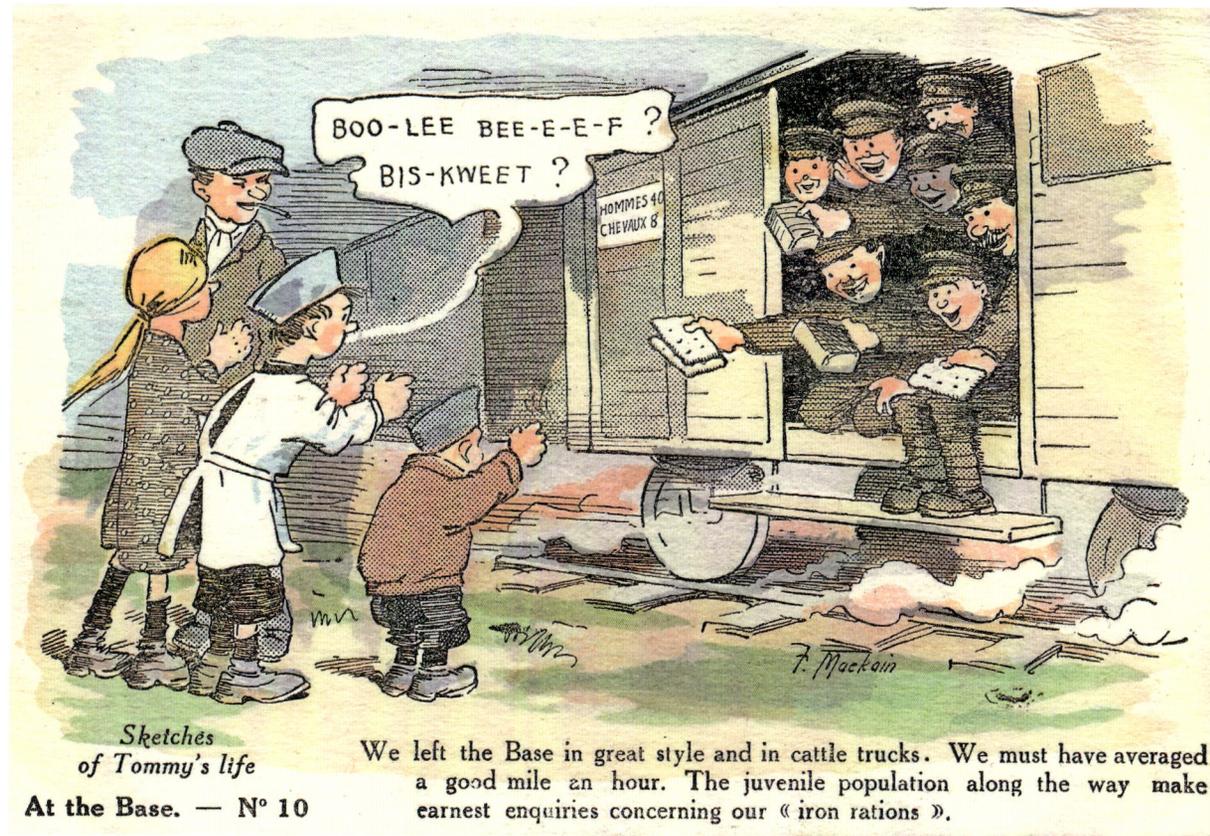

Above: 49. At the Base No. 10, 'We left the base in great style and in cattle trucks. We must have averaged a good mile an hour. The juvenile population along the way make earnest enquiries concerning our "iron rations".' (Authors' collection)

Up the Line (Set 3)

The third series, 'Up the Line', must have been a test of Mackain's comic sensibility. The experience of the front was one which no soldier could look back at with any pleasure whatsoever (except perhaps at the comradeship). Some of these cards, therefore, while in general keeping their positive approach, are darker in mood.

According to Fred Ward's book on the 23rd Royal Fusiliers, it was in Steenbecque that the sound of artillery in action was first heard by the Battalion.

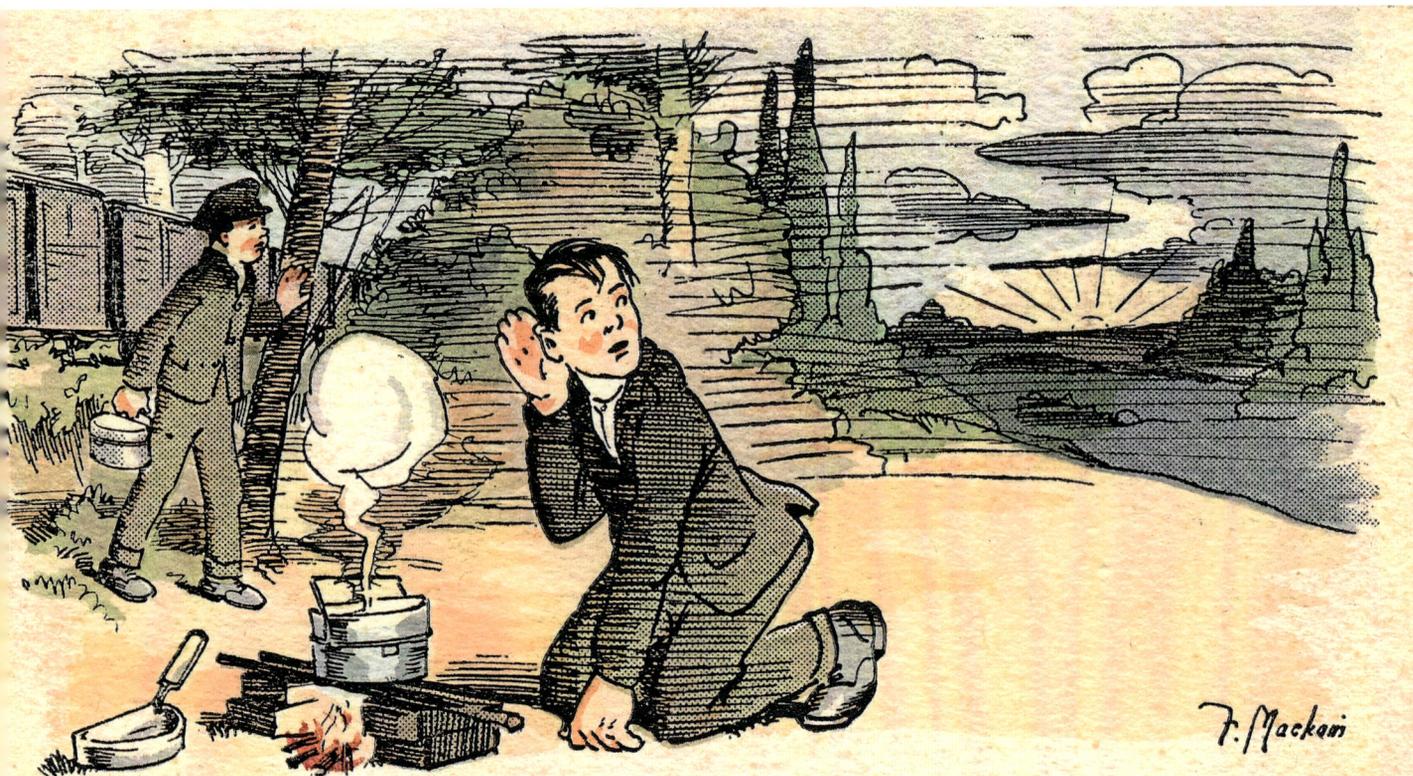

Left: 50. Up the Line No. 1, 'I got up early in the morning. Our train had gone as far as it was to go. As I was making tea in the dawn, I heard for the first time a sound like distant thunder ... but it wasn't thunder.' (Authors' collection)

Opposite: 51. Up the Line No. 2, 'The first trench I saw was an old communication trench, where we were taken one night on fatigue. So this was really my first sight of the trenches and my first sight of the star shells. We did more star gazing than trench repairing that night!' (Authors' collection)

Sketches of Tommy's life

Up the line. — N° 1

I got up early in the morning, Our train had gone as far as it was to go. As I was making tea in the dawn, I heard for the first time a sound like distant thunder... but it wasn't thunder.

Between the zigzags of the front-line trenches (so constructed to prevent enfilading fire whereby an enemy, having captured one part, could fire down the whole of the trench) were connecting communication trenches. These allowed the safer movement of troops and supplies. Star shells were used to illuminate the battlefield at night. A fuse burst at a pre-set height, igniting a magnesium flare which burned while the shell fell by parachute to ground. Different coloured flares might be used as signals.

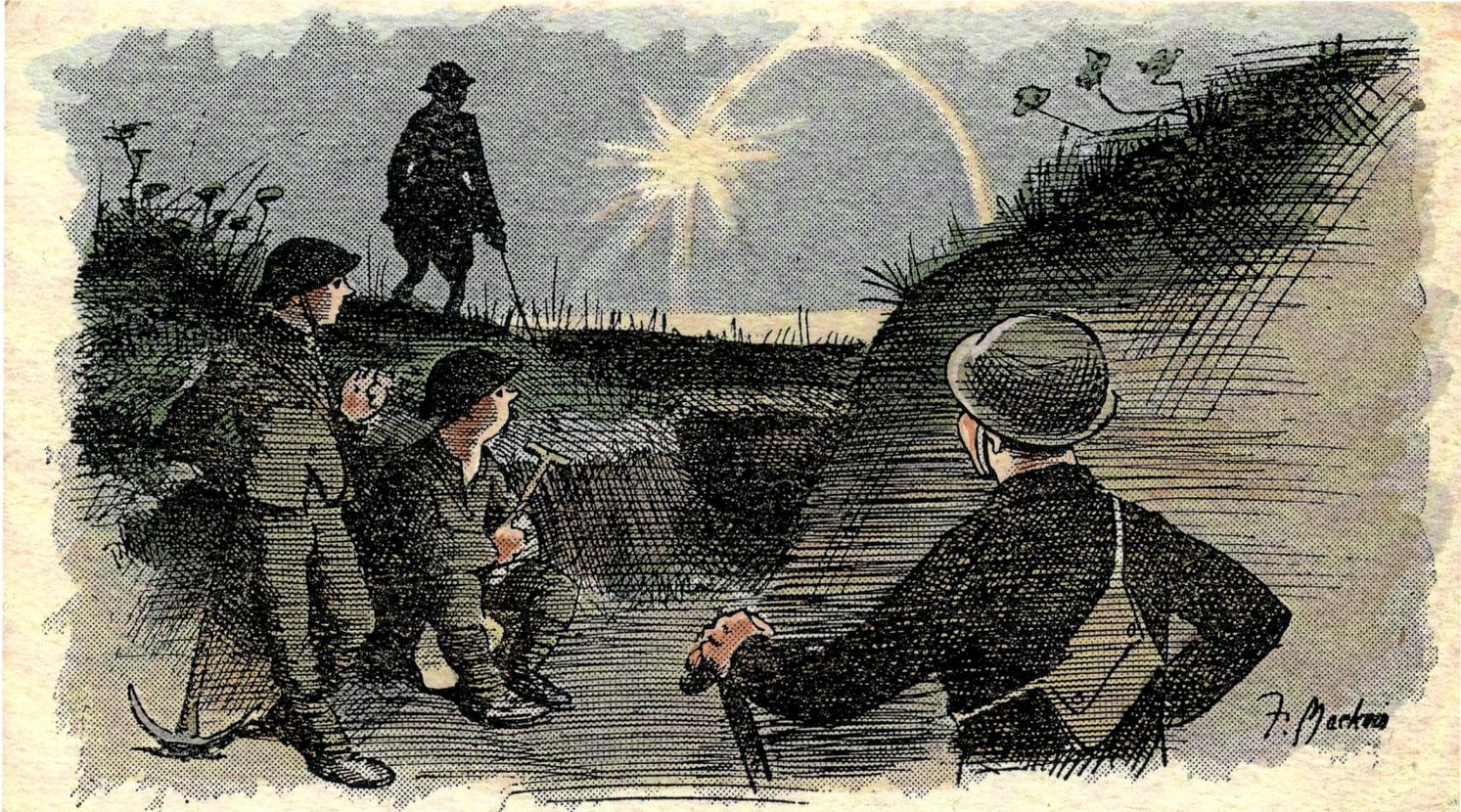

Sketches of Tommy's life
Up the line. — Nº 2

The first trench I ever saw was an old communication trench where we were taken one night on fatigue. So this was really my first sight of the trenches and my first sight of the star shells. We did more star gazing than trench repairing that night!

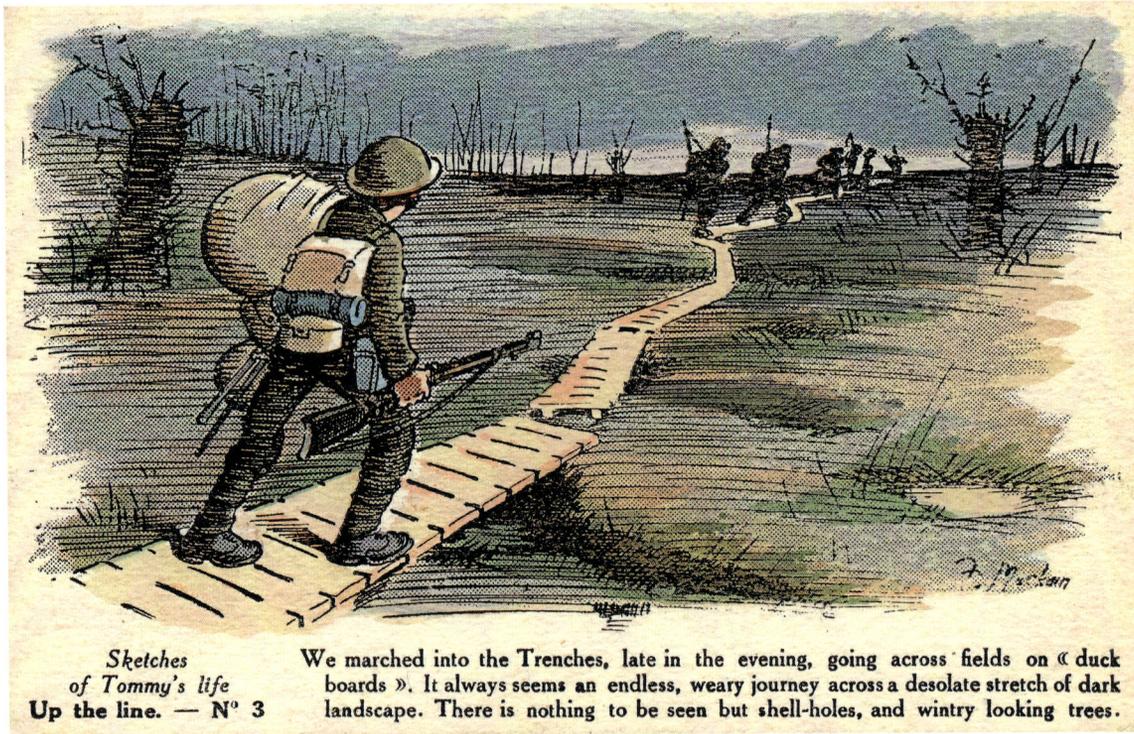

Sketches
of Tommy's life
Up the line. — Nº 3

We marched into the Trenches, late in the evening, going across fields on « duck boards ». It always seems an endless, weary journey across a desolate stretch of dark landscape. There is nothing to be seen but shell-holes, and wintry looking trees.

Left: 52. Up the Line No. 3, 'We marched into the Trenches, late in the evening, going across fields on "duck boards". It always seems an endless, weary journey across a desolate stretch of dark landscape. There is nothing to be seen but shell-holes, and wintry looking trees.' (Authors' collection)

Opposite: 53. A photograph from the First World War shows duckboards in position. (Jonathan Reeve JRb11pic9)

Duckboards were used to line the bottom of trenches on the Western Front, as these were regularly flooded. Mud and water would lie in the trenches for months on end. The boards helped to keep the soldiers' feet dry and prevent the development of trench foot caused by prolonged standing in waterlogged conditions. They also allowed for troops' easier movement through the trench systems. Falling or slipping off the duckboards could often be deadly, with unfortunate soldiers drowning in mud under the weight of their equipment.

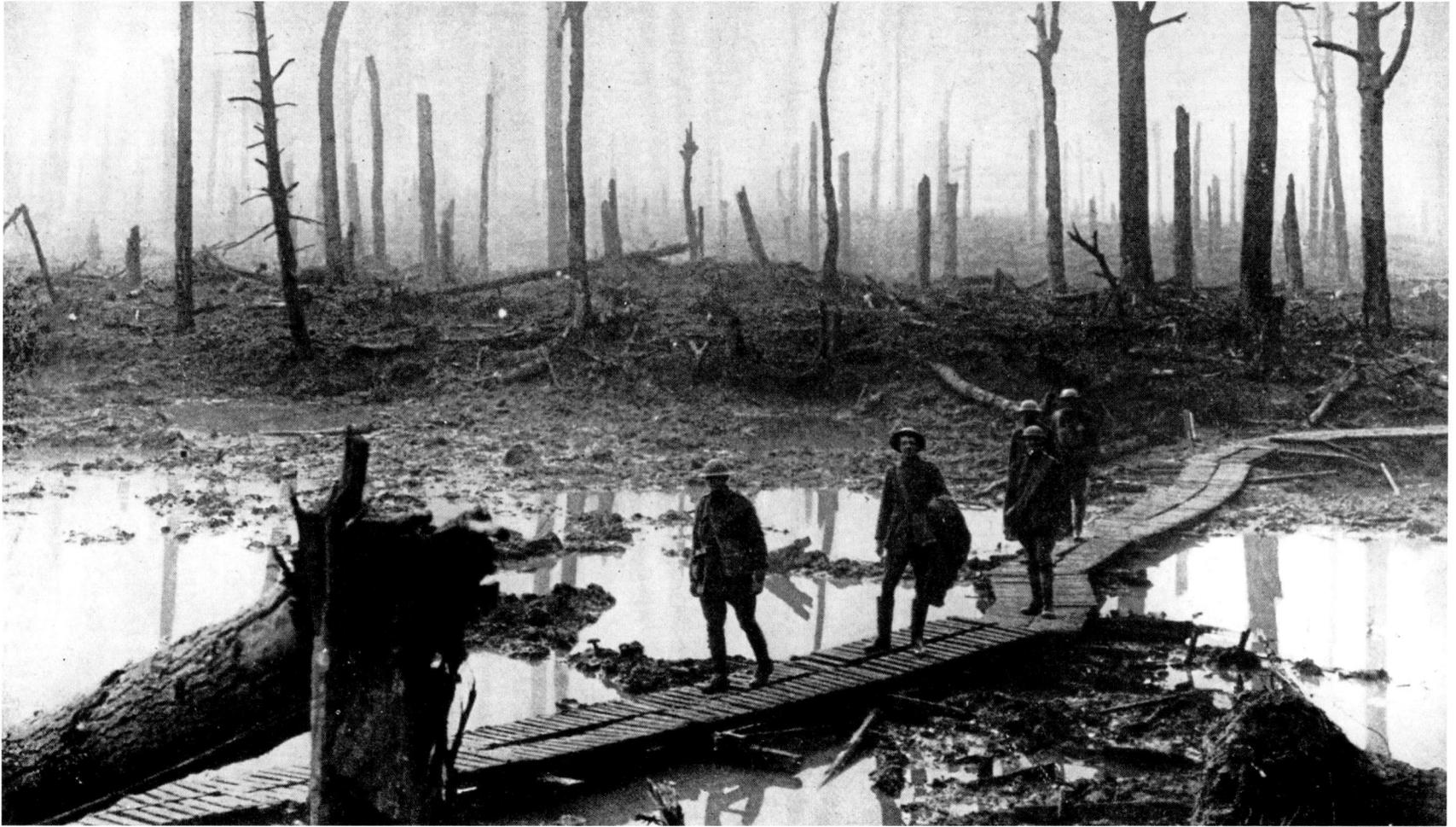

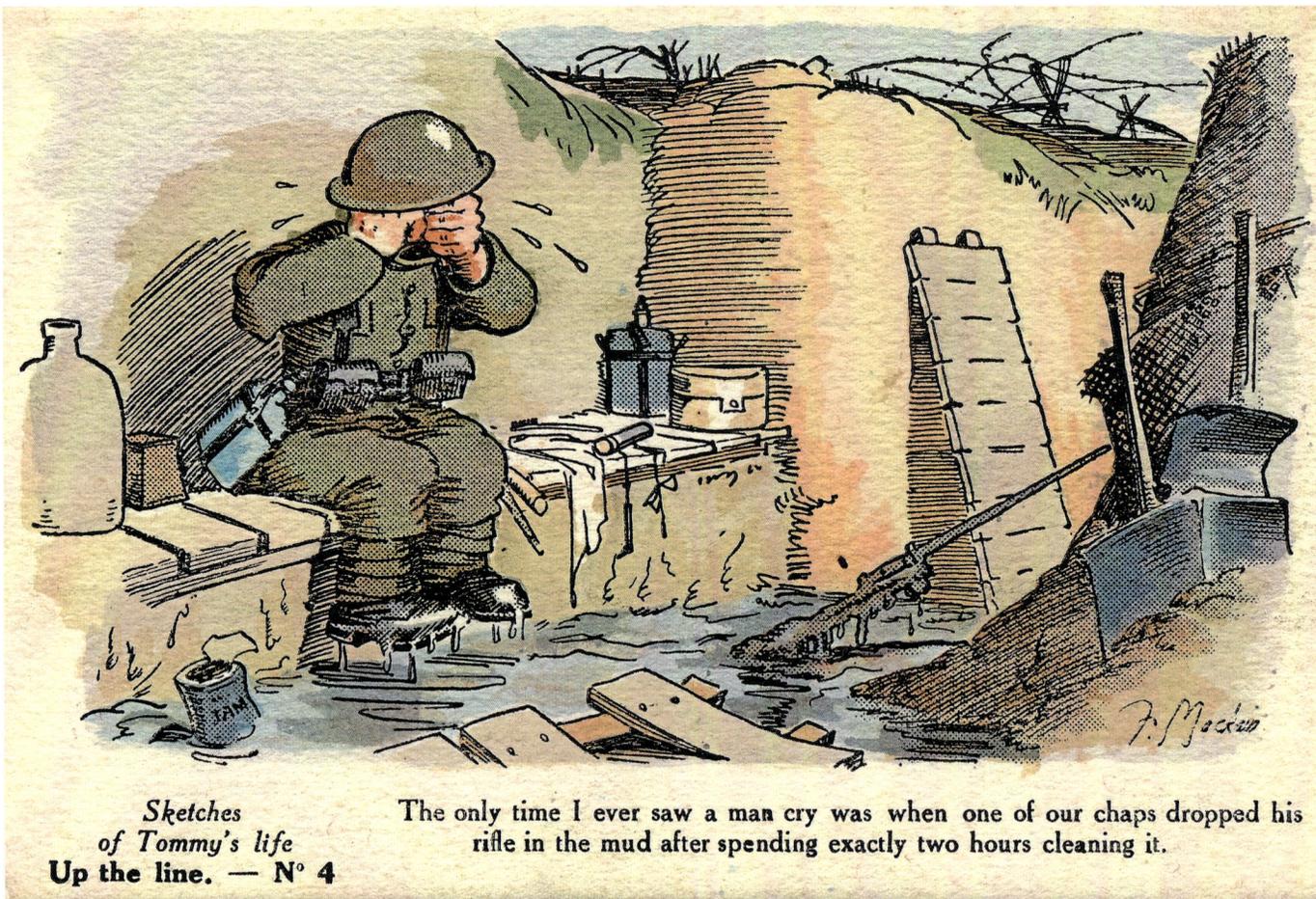

Sketches
of Tommy's life
Up the line. — Nº 4

The only time I ever saw a man cry was when one of our chaps dropped his rifle in the mud after spending exactly two hours cleaning it.

Notice the scattered equipment – rum jar, mess kit, trenching tools, duckboards … soldiers were still expected to keep their rifles clean, despite the mud and trench water.

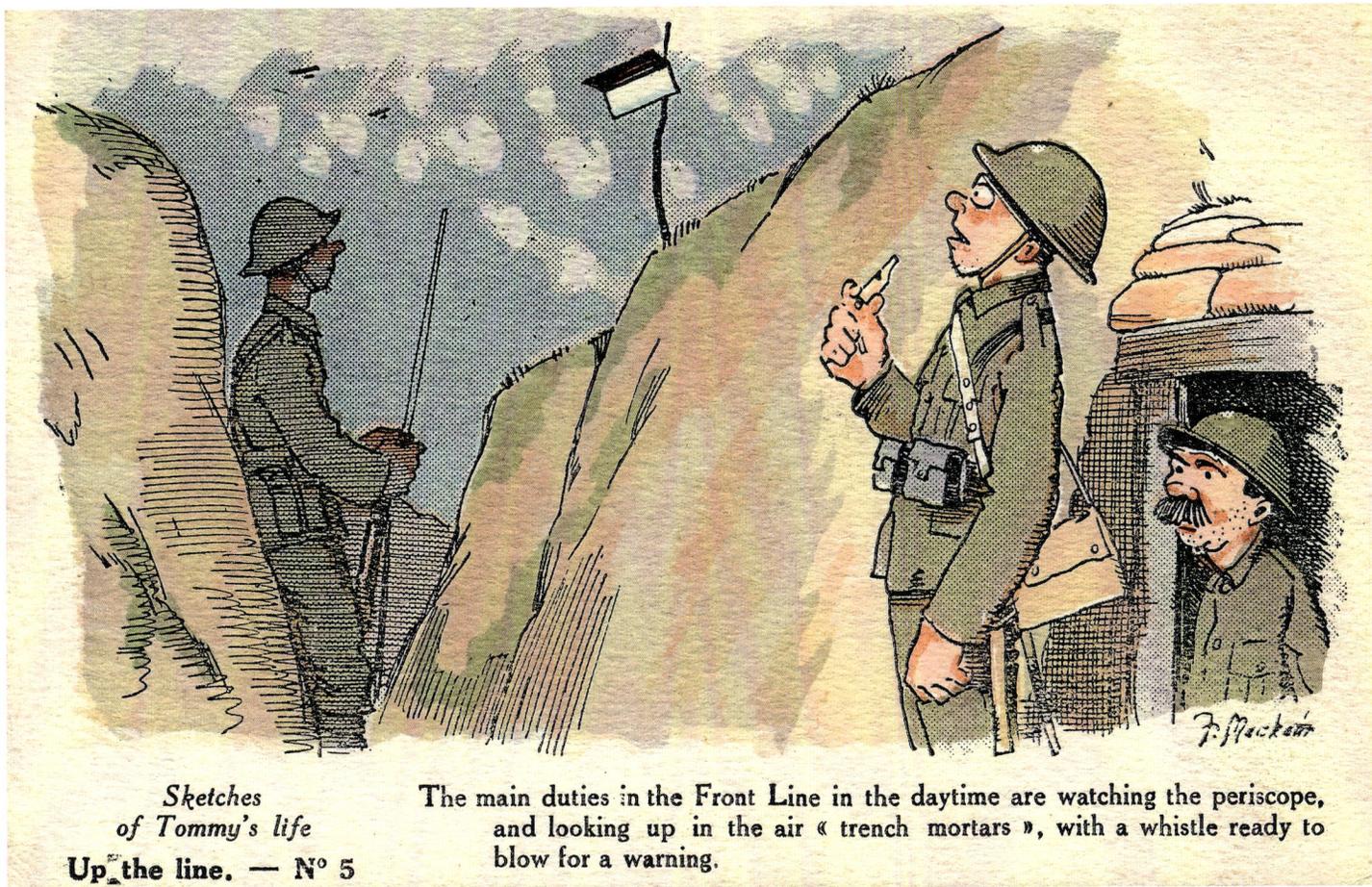

Sketches of Tommy's life

Up the line. — Nº 5

The main duties in the Front Line in the daytime are watching the periscope, and looking up in the air « trench mortars », with a whistle ready to blow for a warning.

The German trench mortar, or Minenwerfer, was nicknamed the 'flying pig' by British soldiers due to the shape of the charge being flung across no man's land. Note the appearance of airplanes in the skies above.

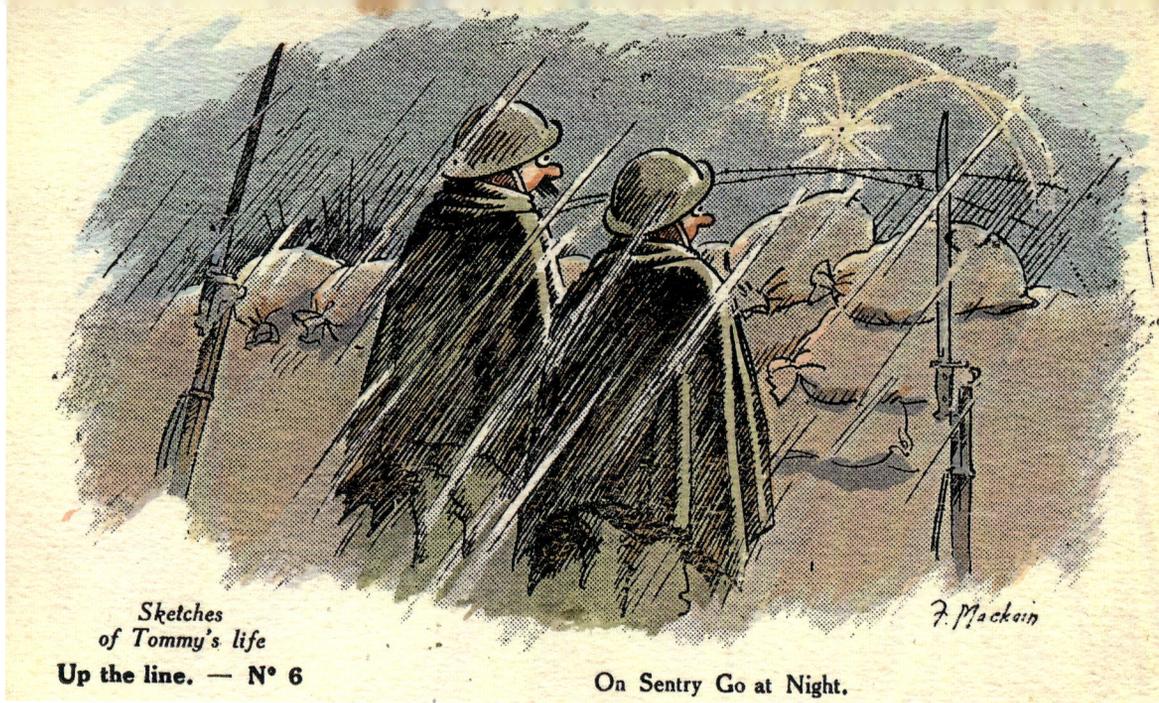

Sketches
of Tommy's life
Up the line. — N° 6

On Sentry Go at Night.

F. Mackain

Soldiers adhered to very firmly followed routines in the trenches. From before dawn, every man on the front line has been prepared for attack, bayonets fixed. Guard duty (one man in three) has been assiduous since the previous evening, soldiers standing in turn for one hour on the fire step for the best possible sight. Tasks occupy them between duties. As dawn approaches, the 'Stand to' order is given, and all the men crouch on the fire step below the level of the trench. When it is fully light and the risk of attack is judged over, one man in ten is left as look out or on the trench periscopes (see card 5) and the remainder 'stand down'. By 8.30 a.m. the men are ready for the rum ration (see card 7) and breakfast, followed by washing/shaving, all of these within the narrow confines of the trench. The hours until noon are then filled with repairing, trench maintenance and weapon cleaning. Sentry duties will follow, but from 11 a.m. some of the men will be able to take about two hours' rest, letter writing, a midday meal, latrine visits (in special areas off the communication trenches) and sleep (usually in the mid-afternoon, as it was the least likely time for an attack). By 4.30 p.m., half an hour before sunset, 'Stand to' is again called, this readiness for attack continuing until half an hour after darkness has fallen. Silence is kept. Supper follows at 6 p.m. after 'stand down'. Raiding parties might operate at night; sentry duties begin, soldiers alternating between working, resting and duty until daylight starts to approach again. It was exhausting.

The Army had a daily rum ration of half a gill, often issued after a night on the trench fire step, which must have been a welcome boost to morale. Some units issued the ration before a battle; others used it against the shock and strain after a battle.

Some believe that 'S.R.D.' might have stood for: Supply Reserve Depot; Service Ration Department; Standard Rum, Diluted; Service Rum Distribution; or Service Rum Department. Soldiers' slang for SRD included: 'Seldom or Rarely Delivered'; 'Soldiers Run Dry'; 'Soon Runs Dry'; and 'Seldom Reaches Destination'.

It seems very likely that another of the well-known officers of the 23rd Royal Fusiliers is caricatured in card 7. The cross officer may well be Lt Colonel H. A. Vernon DSO, who was Colonel in Command of the battalion from January 1916 until May 1917 (and therefore at the time when Mackain left the battalion to join the ASC). Transferring from the 1st King's Royal Rifle Regiment, Vernon had won the Croix de Chevalier in February 1916 and the DSO in October 1916.

Right: 58. SRD jar in the museum at Hill 62, near Ypres. (Authors' collection)

Right, middle: 59. Detail of an officer who is probably Vernon. (Authors' collection)

Far right: 60. Photo of Lt Colonel H. A. Vernon DSO. (Authors' collection)

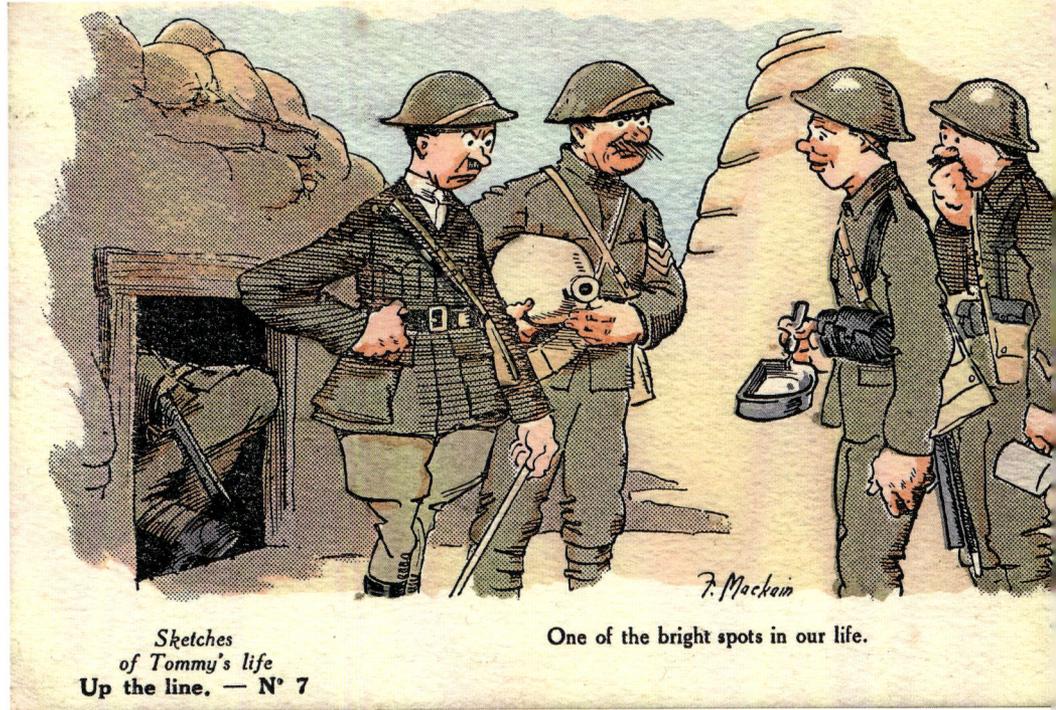

Sketches of Tommy's life Up the line. — N° 7

One of the bright spots in our life.

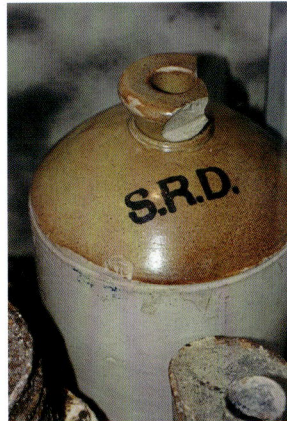

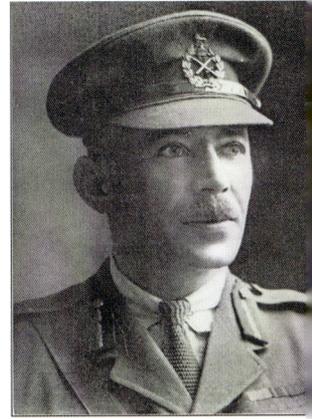

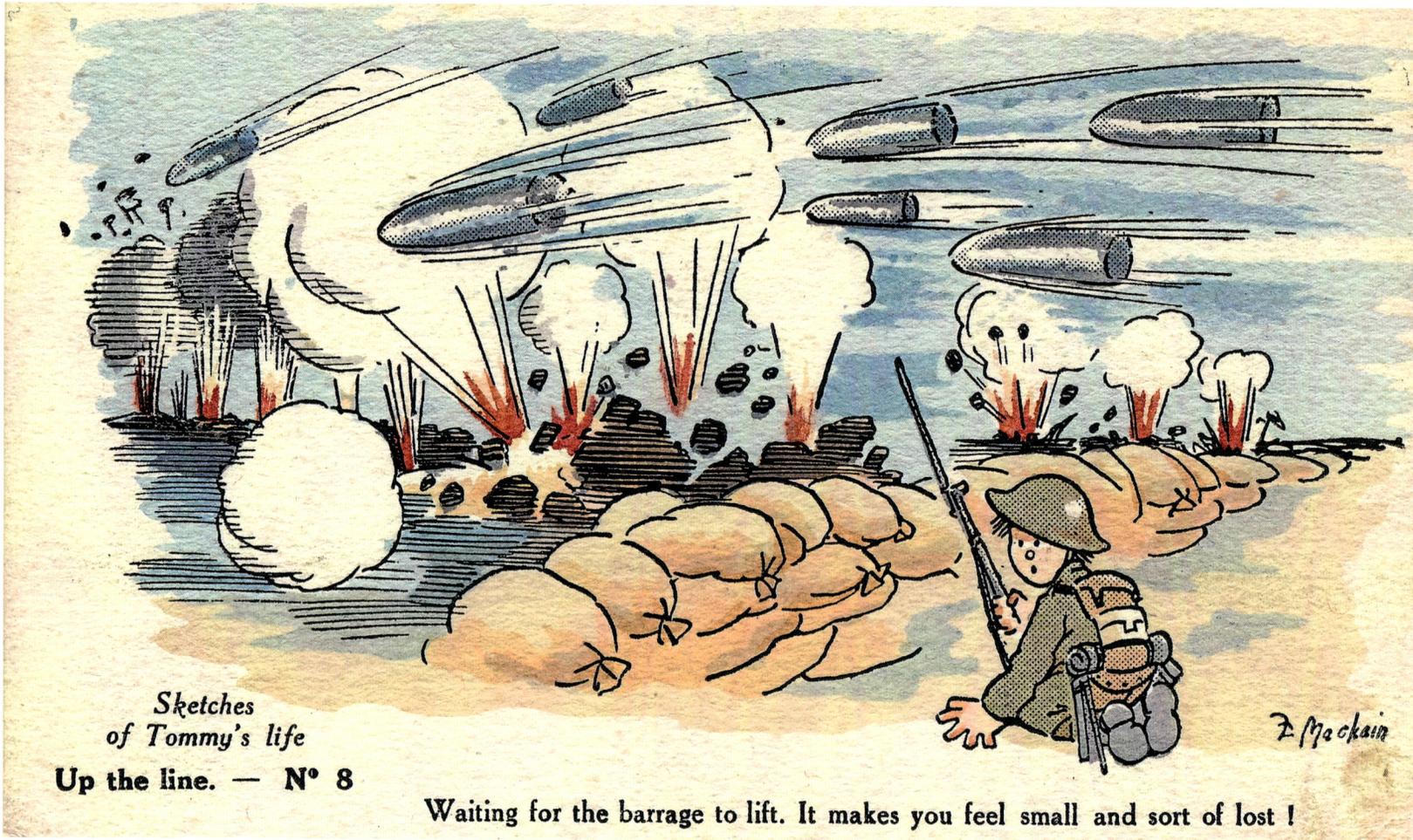

Sketches of Tommy's life

Up the line. — N° 8

Waiting for the barrage to lift. It makes you feel small and sort of lost !

A 'preliminary barrage' was a bombardment of enemy lines prior to an assault. Experienced soldiers could tell the direction of overhead shells (outbound or inbound) by the unique noise they made.

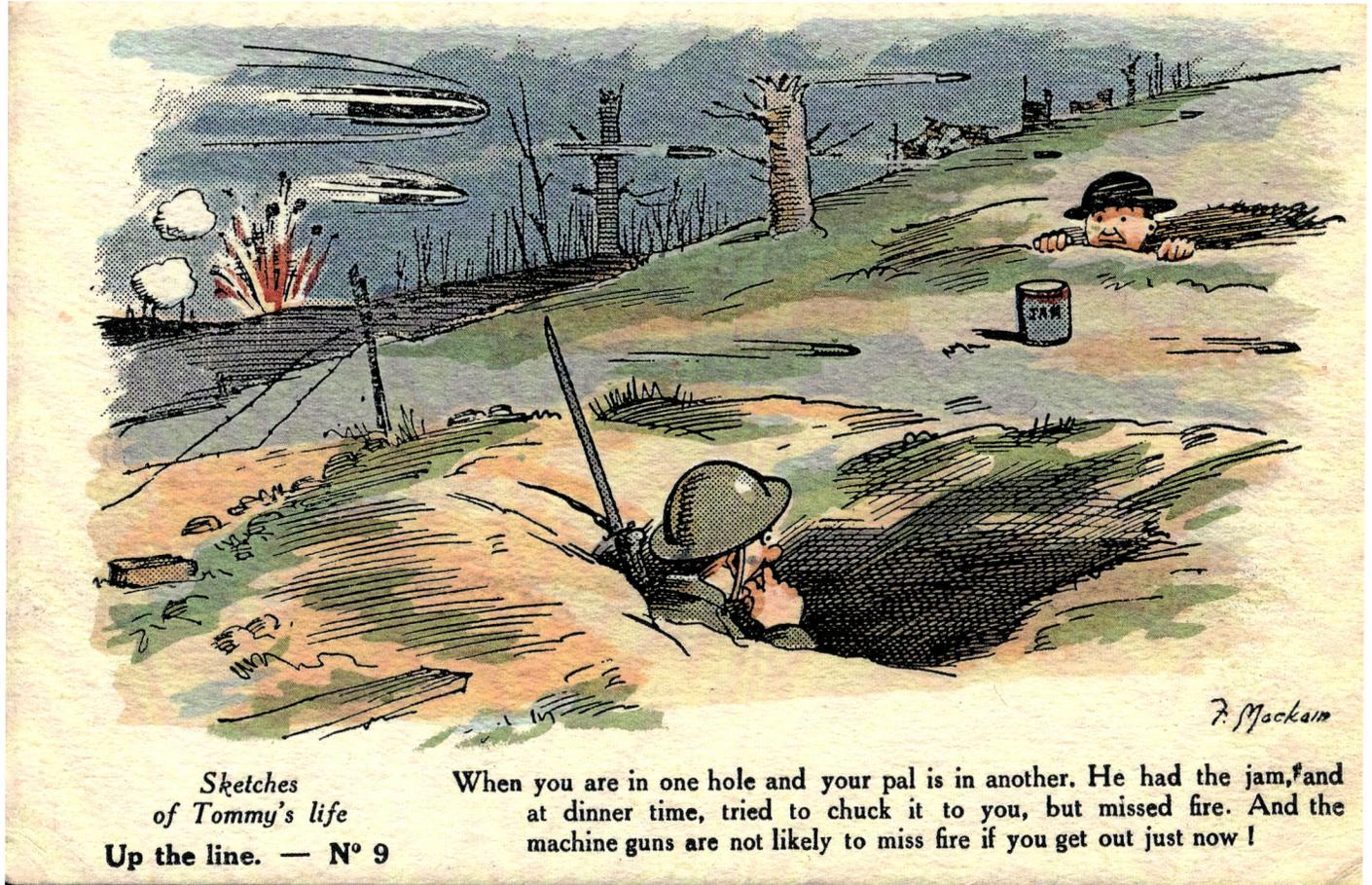

Sketches
of Tommy's life

Up the line. — Nº 9

When you are in one hole and your pal is in another. He had the jam, and at dinner time, tried to chuck it to you, but missed fire. And the machine guns are not likely to miss fire if you get out just now!

F. Mackain

Standing water in the trenches was a cause of trench foot. The condition could occur with as little as thirteen hours' exposure. Soldiers were paired off to supervise each other's precautions against this.

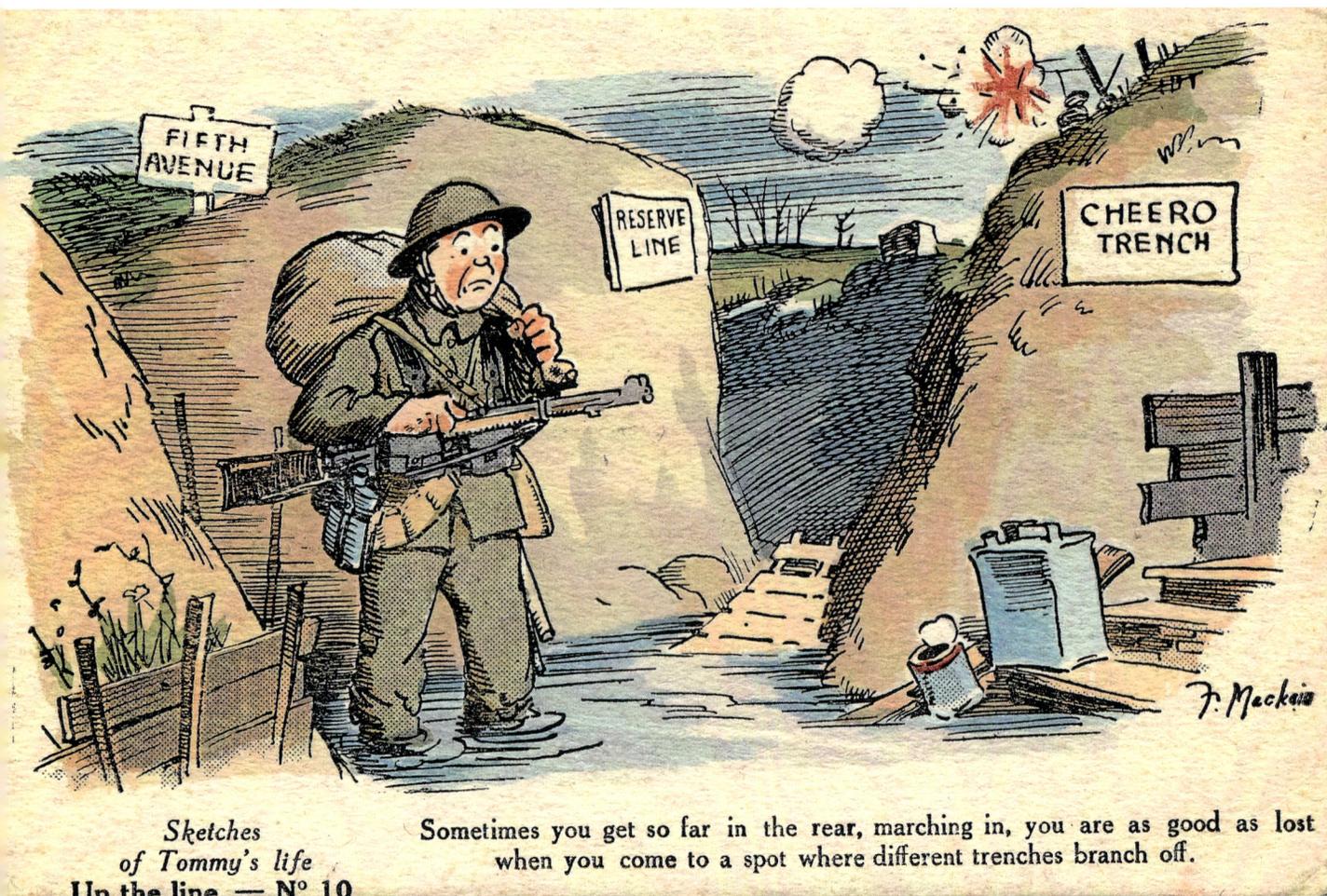

FIFTH AVENUE

RESERVE LINE

CHEERO TRENCH

F. Mackain

Sketches of Tommy's life Up the line. — Nᵒ 10

Sometimes you get so far in the rear, marching in, you are as good as lost when you come to a spot where different trenches branch off.

Opposite: 64. Out on Rest No. 1, 'A wash up in the rest trenches.' (Authors' collection)

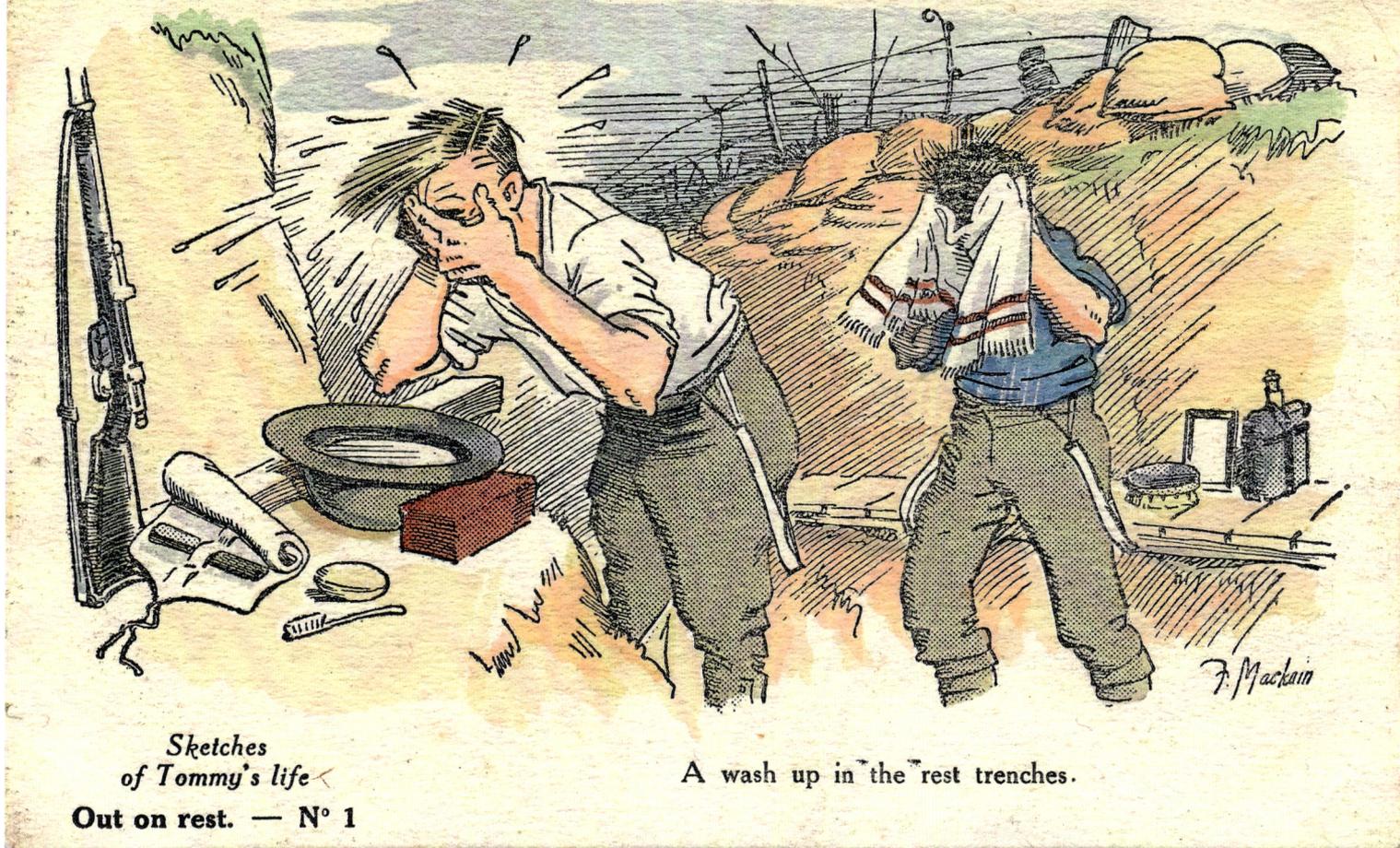

Sketches
of Tommy's life
Out on rest. — N° 1

A wash up in the rest trenches.

Out on Rest (Set 4)

Soldiers were rotated between the front line, the support line and the reserve line, then spending a short time 'at rest' before beginning the cycle again. Typically, a soldier had two months 'at rest' each year. This term was somewhat misleading, as it was a time when the men received further training and formed squads for fatigue parties supplying the front lines. Periods of rotation varied according to situation and circumstance, but were typically about three weeks.

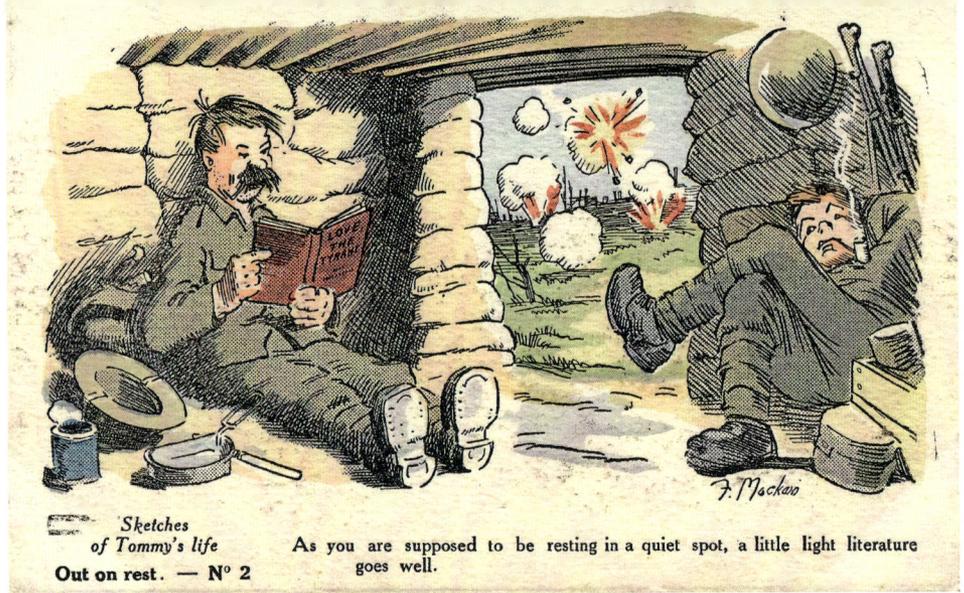

'Sketches of Tommy's life
Out on rest. — Nº 2

As you are supposed to be resting in a quiet spot, a little light literature goes well.

Soldiers were expected to be clean shaven, although moustaches were allowed. The toothbrush was universally regarded as the best instrument for cleaning rifles.

War thunders outside as the soldiers relax … *Love, The Tyrant* (or, *Where Her Heart Led*) was written by Charles Garvice, published 1900 in New York and 1905 in London. The choice of book is of course ironic here.

Charles Andrew Garvice (24 August 1850–1 March 1920) was a prolific and popular author of romance novels in Britain, the United States and translated around the world. By 1913 he was selling 1.75 million books annually, a pace which he maintained at least until his death.

Garvice published over 150 novels, selling over 7 million copies worldwide by 1914. He was 'the most successful novelist in England', according to Arnold Bennett in 1910. Despite his enormous success, he was poorly received by literary critics, and is almost forgotten today.

Above left: 65. The soldier here is enjoying what was commonly known as a 'Duck's Breakfast'. (Authors' collection)

Above: 66. Out on Rest No. 2, 'As you are supposed to be resting in a quiet spot, a little light literature goes well.' (Authors' collection)

Opposite: 67. Out on Rest No. 3, 'Sometimes when you are "out on rest", you think you'd almost rather stop in the trenches.' (Authors' collection)

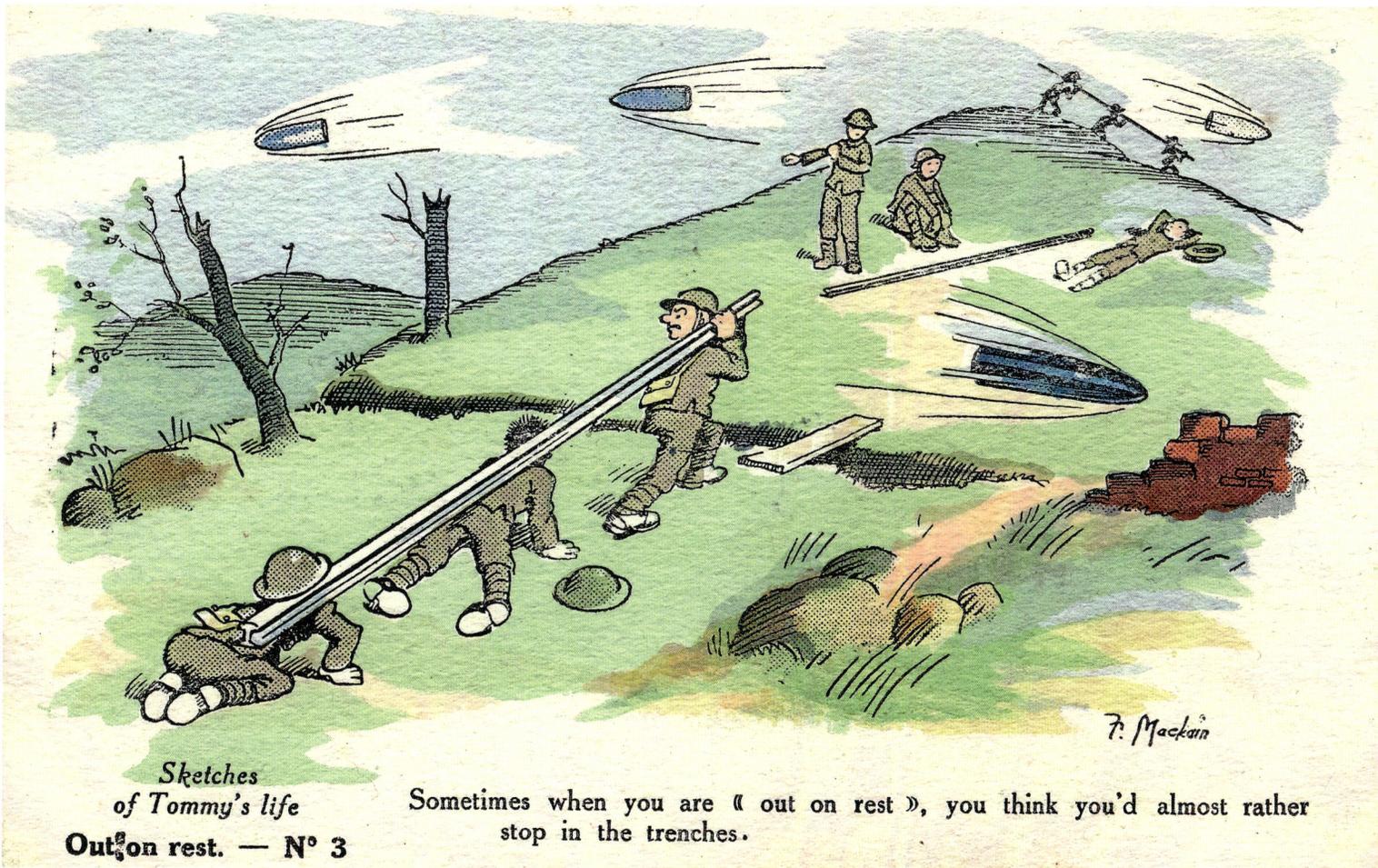

*Sketches
of Tommy's life*

Out on rest. — Nº 3

Sometimes when you are « out on rest », you think you'd almost rather
stop in the trenches.

Military railways were constructed hastily by the advancing
army. They were essential for transporting supplies and
provided much-needed lines of communication.

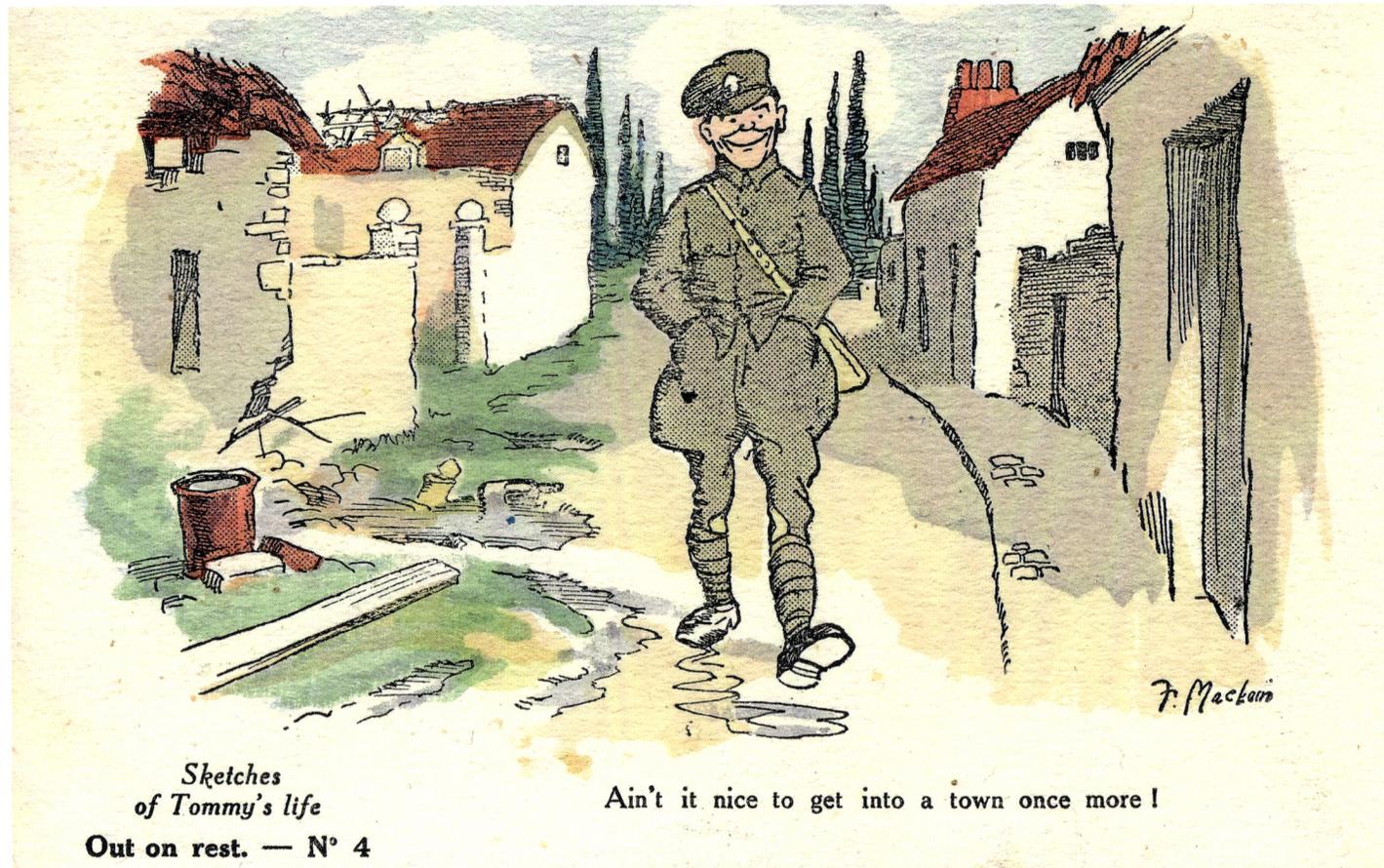

Sketches
of Tommy's life

Out on rest. — Nº 4

Ain't it nice to get into a town once more!

F. Mackain

Keeping going and keeping up morale were very much the order of the day. Even among the ruins there was at least a semblance of normal life.

Above: 68. Out on Rest No. 4, 'Ain't it nice to get into a town once more!' (Authors' collection)

Opposite: 69. Out on Rest No. 5, 'A regular carouse of coffee and fried eggs is one of the things we always have when we get to one of these villages.' (Authors' collection)

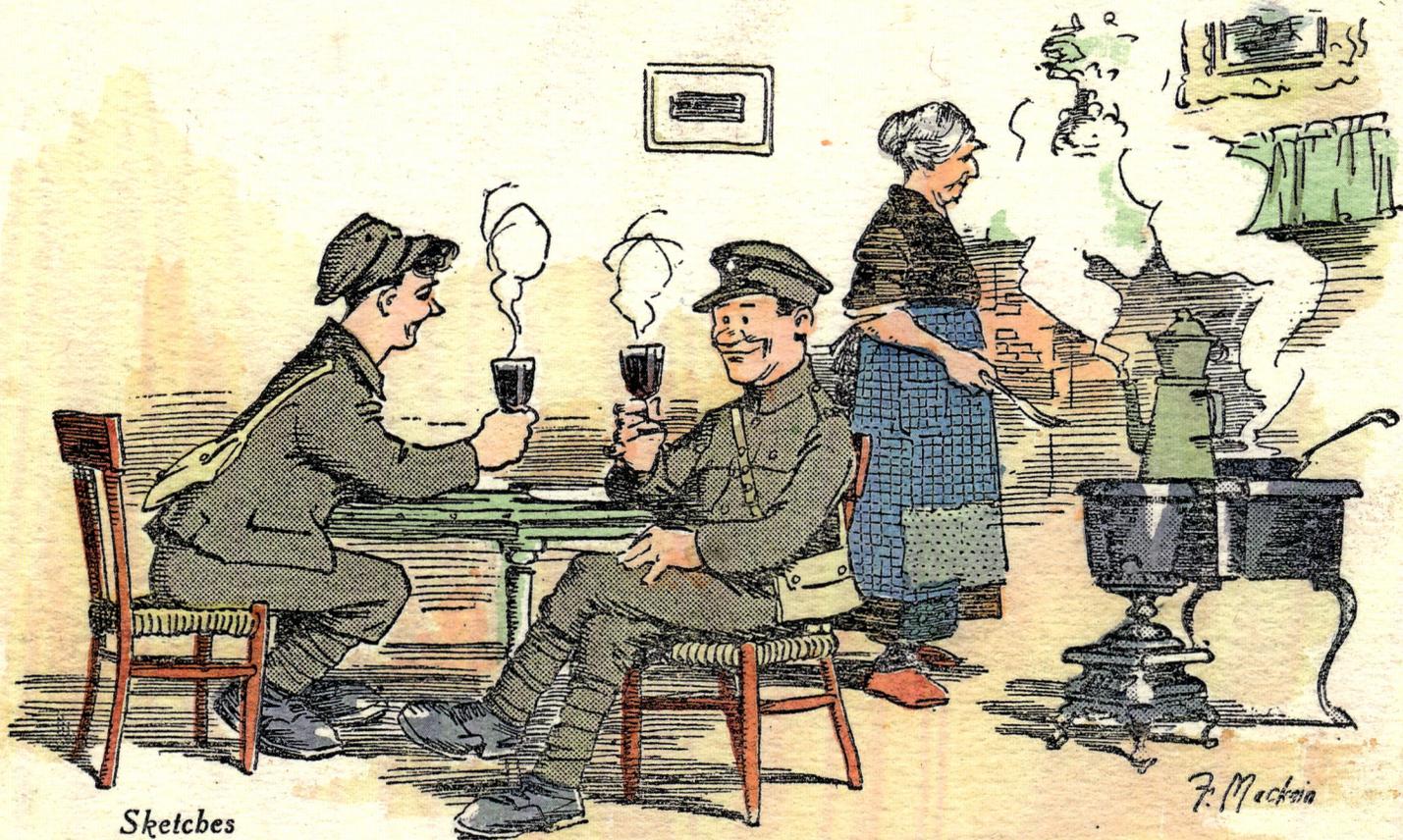

Sketches of Tommy's life

Out on rest. — Nº 5

A regular carouse of coffee and fried eggs is one of the things we always have when we get to one of these villages.

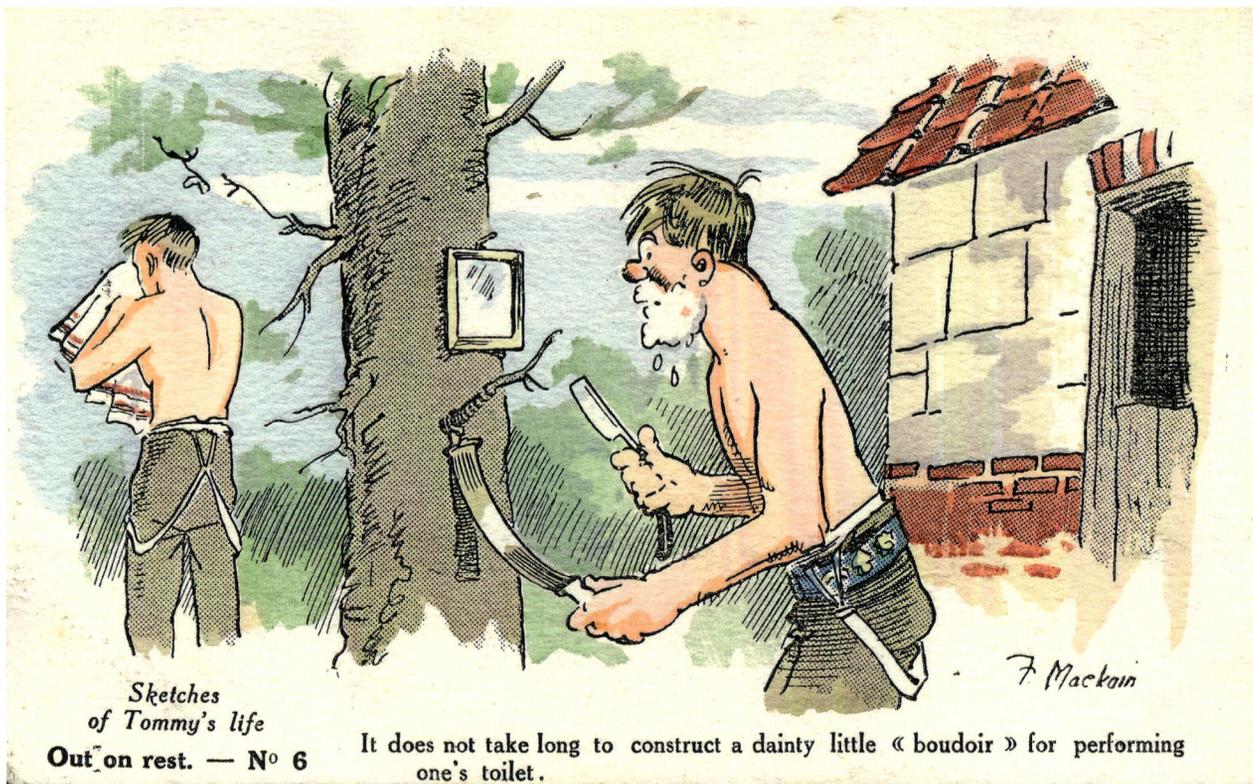

Sketches
of Tommy's life

Out on rest. — N⁰ 6

It does not take long to construct a dainty little « boudoir » for performing one's toilet.

F. Mackain

70. Out on Rest No. 6, 'It does not take long to construct a dainty little boudoir for performing one's toilet.' (Authors' collection)

Braces at this time were made of cotton with no 'give' and soldiers allowed them to flop down so that they could bend over easily. However, loose-fitting trousers tended to slip down and so at first soldiers cinched them in with leather belts. Later on, the regimental saddlers began to make belts from the same plain canvas strapping used for the horses and utilizing the same double leather strap-and-buckle arrangement. In the war it became common for soldiers to collect the badges and shoulder titles of various units and secure them to stable belts, thus commemorating all those units with which they had contact. The soldier here is 'stropping his razor' while shaving.

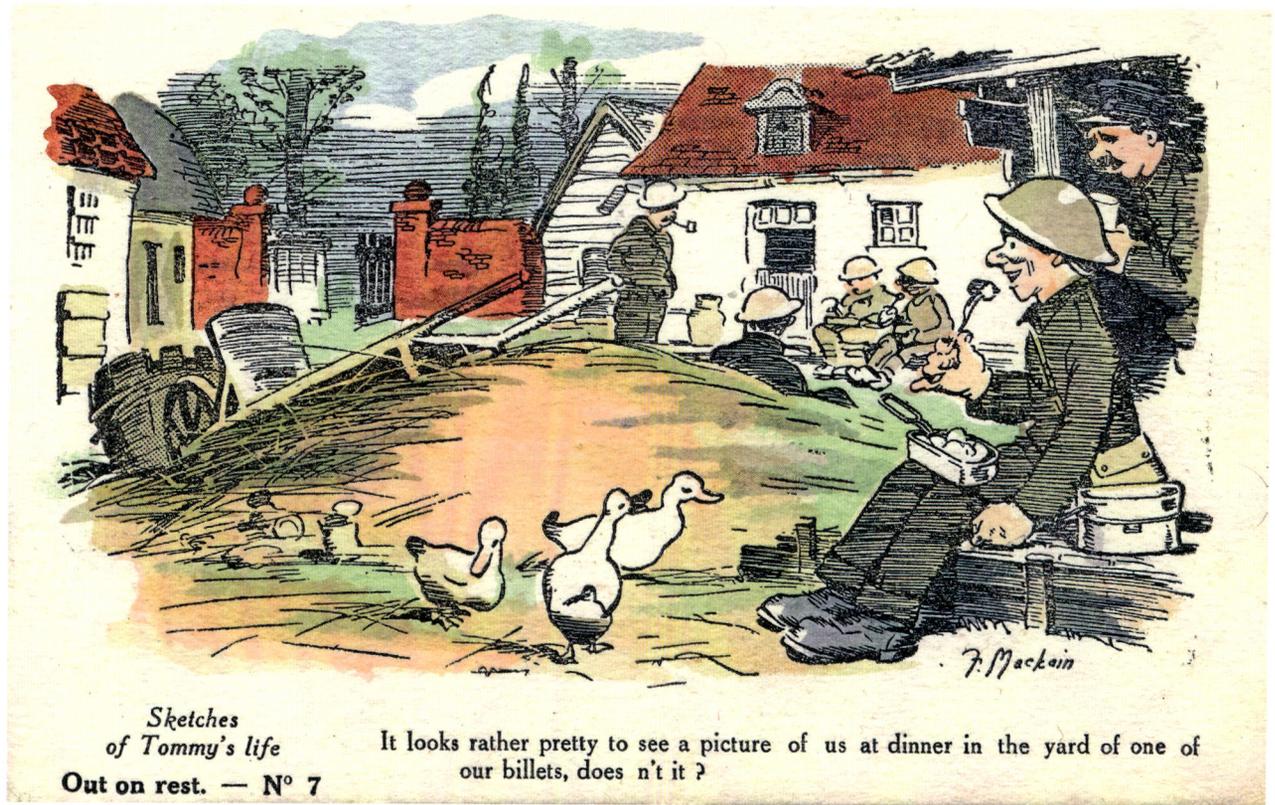

Sketches
of Tommy's life
Out on rest. — N° 7

It looks rather pretty to see a picture of us at dinner in the yard of one of our billets, does n't it ?

Right: 71. Out on Rest No. 7, 'It looks rather pretty to see a picture of us at dinner in the yard of one of our billets, doesn't it?' (Authors' collection)

Overleaf: 72. Out on Rest No. 8, 'In every section there is at least one musical genius to cheer you up when you feel down-hearted. Generally he plays a penny whistle!' (Authors' collection)

'Billet' is a term for living quarters to which a soldier is assigned to sleep. Historically, it referred to a private dwelling that was required to accept the soldier. Originally, a 'billet' (from the French) was a note, commonly used in the eighteenth and early nineteenth centuries as a 'billet of invitation'. A particular use of the word in this sense is to denote an order issued to a soldier entitling him to quarters with a certain person. From this meaning, the word billet came to be loosely used for the quarters thus obtained.

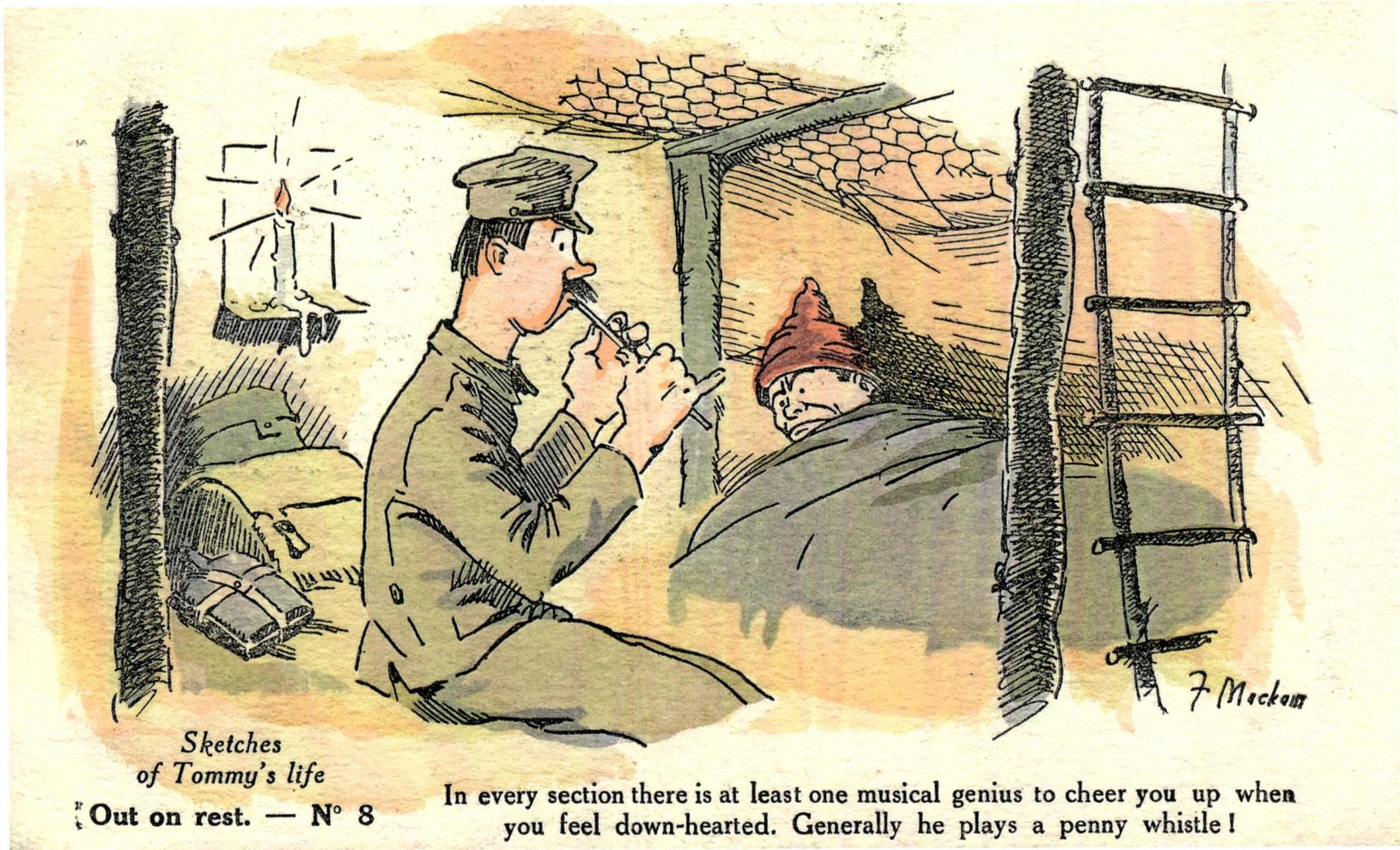

Sketches
of Tommy's life
Out on rest. — N° 8

In every section there is at least one musical genius to cheer you up when
you feel down-hearted. Generally he plays a penny whistle!

Note the use of chicken wire here to protect the walls and
ceiling of the dugout.

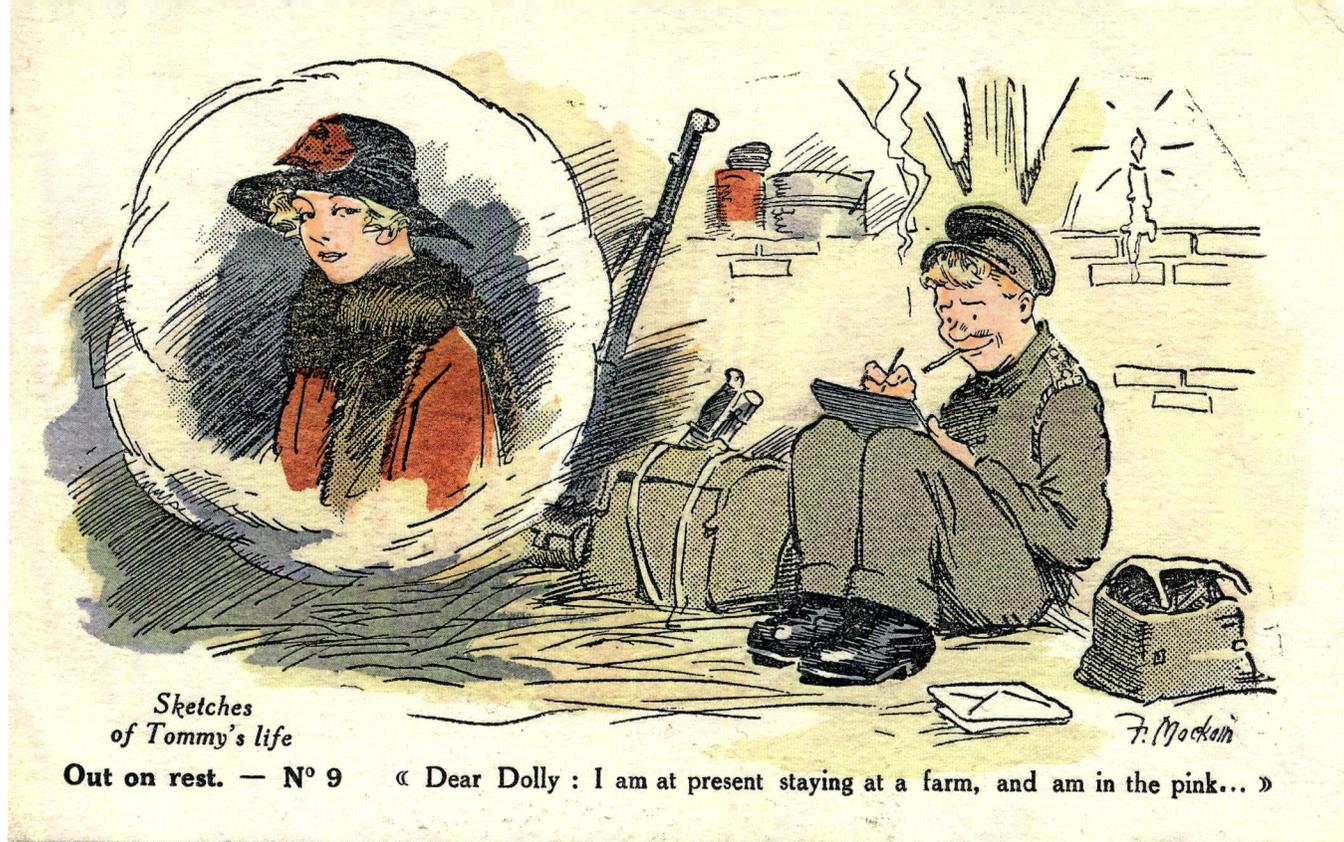

Sketches of Tommy's life

Out on rest. — N° 9 « Dear Dolly : I am at present staying at a farm, and am in the pink... »

F. Mackain

'In the pink' means in very good health, in very good condition physically and emotionally. Often used in a tongue-in-cheek fashion to indicate one's situation.

The Tommy is wearing the shoulder badge of the 23rd (First Sportsman's) Battalion, Royal Fusiliers. Badges such as this were either removed or darkened before going into the trenches, to reduce visibility to the enemy.

The opportunity to write a proper letter (or postcard!) was one to be seized upon: much more could be said than on the standard card from the Front.

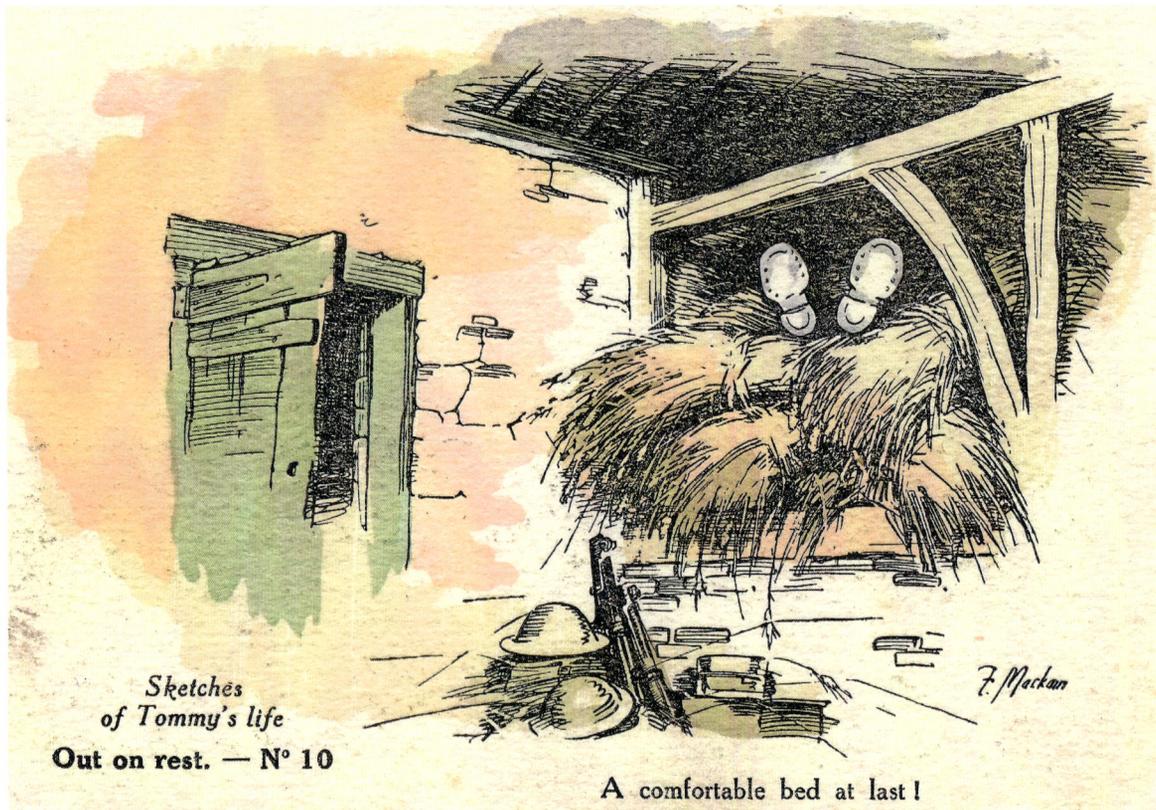

Sketches
of Tommy's life

Out on rest. — N° 10

F. Mackain

A comfortable bed at last !

After the rigours of the dugout and many nights of little continuous sleep, the chance to stretch out and have a full night's sleep must have seemed a luxury, and a hay loft was just the job!

Note the similarities with the image of a bed-bound Tommy in the Illustrated Letter (*Scribner's*, September 1917).

MESSAGES FROM THE FRONT

Of the many millions of postcards, it is perhaps the messages to be found on those sent from the front line that are the most tragic and moving. Many of the senders did not survive; their messages, sometimes sad, sometimes gaily frivolous as they try to hide the daily realities of their lives from their loved ones, are now whispers from a fading past. Many of Mackain's cards were sent home under wrapper and bear no message (so the recipient could immediately collect the whole set together). The following, though, are from various soldiers 'on active service', and show a cross-section of chat, concerns and allusions to what was happening.

Darling Lill, No.1 of a new set! Note the colouring and type. Distinctly a French creation! There is 10 of this set which you will receive in due course if Fritz does not dislocate things! Yours as forever, Jimmie.

From 'Jimmie' to Lillian
21 March 1918

Sketches of Tommy's life
Up the line. — Nº 1

I got up early in the morning, Our train had gone as far as it was to go. As I was making tea in the dawn, I heard for the first time a sound like distant thunder... but it wasn't thunder.

24 March 1918

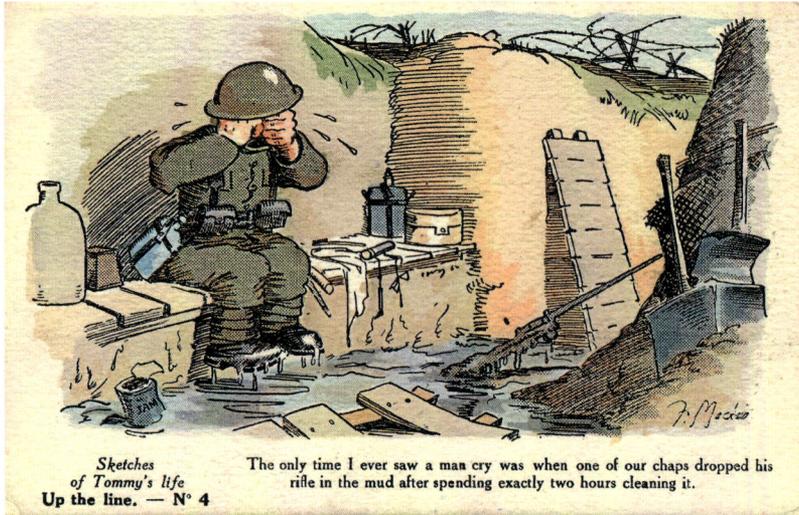

Sketches
of Tommy's life
Up the line. — N° 4

The only time I ever saw a man cry was when one of our chaps dropped his rifle in the mud after spending exactly two hours cleaning it.

Darling Lill, No.4 of this series! Your parcel has not arrived so I presume it must have got mixed up with the Channel affair! However it can't be helped. The weather is glorious and everything looks at its best out here. Bye Bye girlie yours as ever forever, Jimmie.

28 March 1918

Darling Girlie, No.7 of this series! Only three more to worry you with! I hope you like the expression on the Tommies' faces. They are not bad, and to a certain extent quite realistic! Bye Bye Kiddie, Yours as forever, Jimmie.

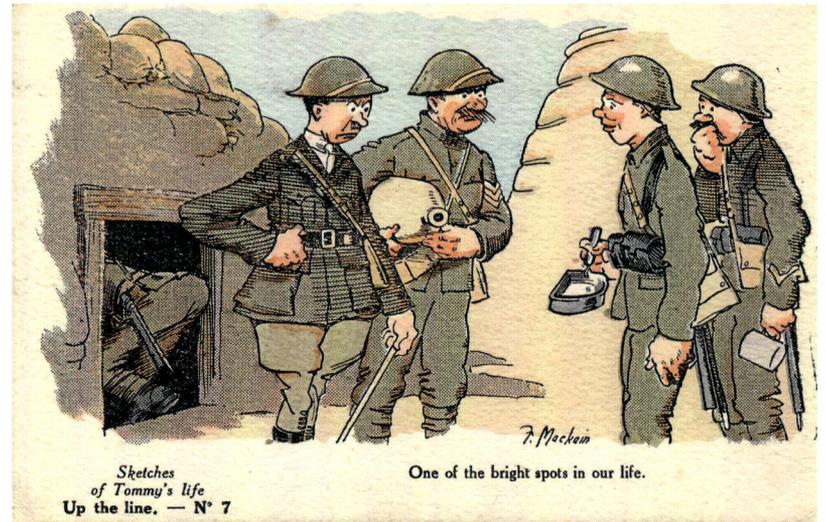

Sketches
of Tommy's life
Up the line. — N° 7

One of the bright spots in our life.

29 March 1918

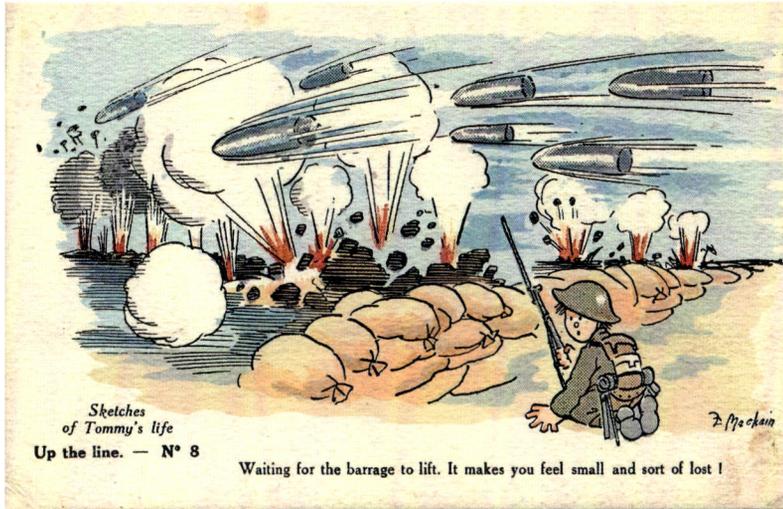

Sketches
of Tommy's life

Up the line. — N° 8

Waiting for the barrage to lift. It makes you feel small and sort of lost !

Darling o'mine, No.8 of this collection! Just two more! How is the "Undie" making going on? I am afraid your pal the chauffeur won't get much of a chance to dodge overseas service, now that the present crisis has arrived. It's about time he did something and thousands more like him! Bye bye Lillian, yours as forever, Jimmie.

31 March 1918

Darling Lill, The last but one of this little lot. I am enclosing a sprig of May blossom, which I plucked from a hedge near here. It would have been out earlier had the weather been more favourable of late. Bye bye, Kiddie mine. Yours as and forever, Jimmie.

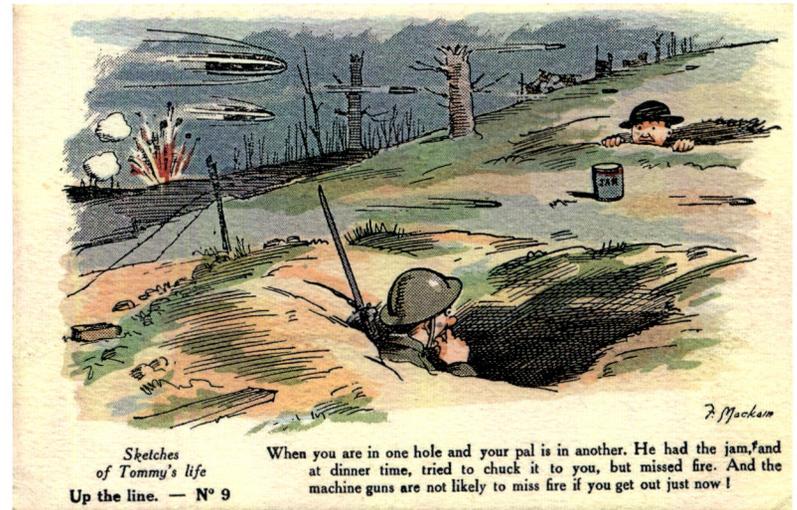

Sketches
of Tommy's life

Up the line. — N° 9

When you are in one hole and your pal is in another. He had the jam, and at dinner time, tried to chuck it to you, but missed fire. And the machine guns are not likely to miss fire if you get out just now !

1 April 1918

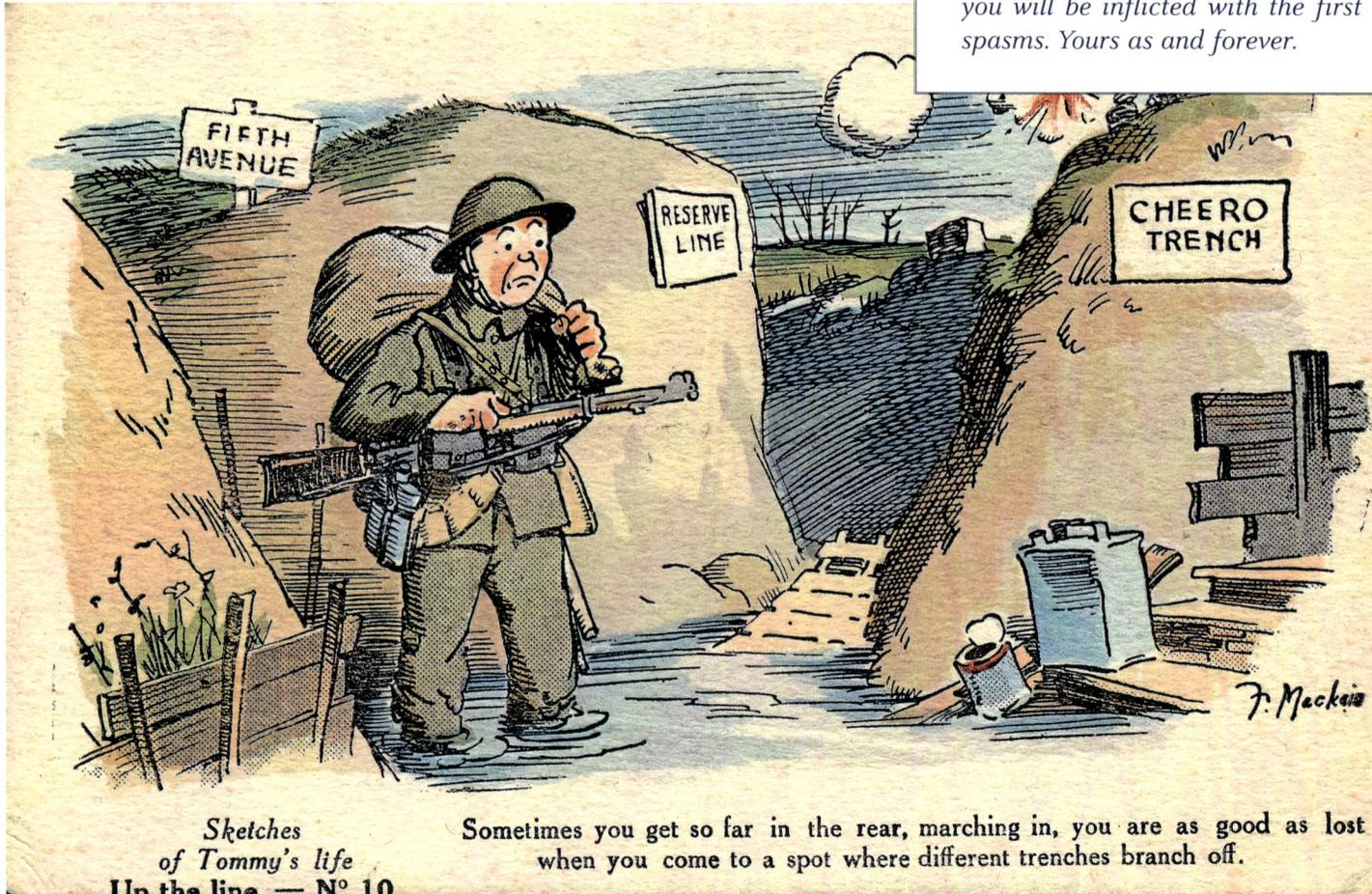

Sketches of Tommy's life Up the line. — N° 10

Sometimes you get so far in the rear, marching in, you are as good as lost when you come to a spot where different trenches branch off.

From 'Harold' to His Mother

12 August 1918

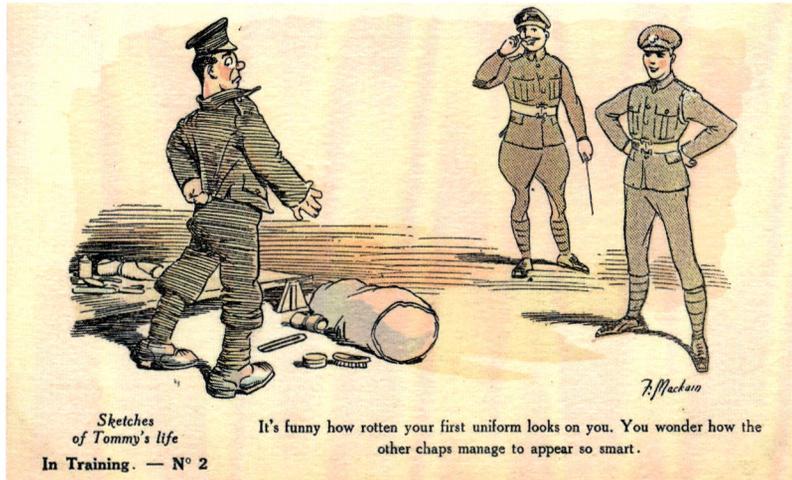

Sketches
of Tommy's life

In Training. — N° 2

It's funny how rotten your first uniform looks on you. You wonder how the other chaps manage to appear so smart.

> *Dear Mother, Just a line to let you know that I'm having a decent time and that we are getting very good weather. I was just thinking that in another few days I shall have four years in, long time isn't it. Shall be glad when we finish. Your loving son, Harold.*

28 August 1918

> *Dear Mother, Pleased to say I am feeling fine and having a glorious time chasing Jerry. Hope you are enjoying your holidays as you deserve to. Your loving son.*

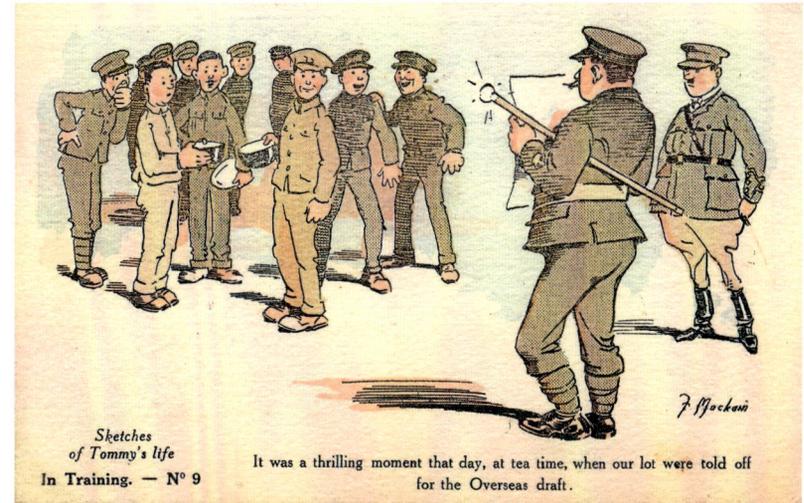

Sketches
of Tommy's life

In Training. — N° 9

It was a thrilling moment that day, at tea time, when our lot were told off for the Overseas draft.

From 'Bert' to Bertha
19 March 1918

Happy New Year

Visé Paris 713

« Merry Christmas ! here's looking at you !

Dear Bertha, Just a PC to let you know I am still allright and I hope you are and ask your Dad if this is anything like his cafes well Bertha cheer up Best of luck to Clara Aunt Lizzie Ivy Dad and yourself from Bert xx

The message on this card turns Mackain's postcard into a metaphor for life – a dark and unforgiving one.

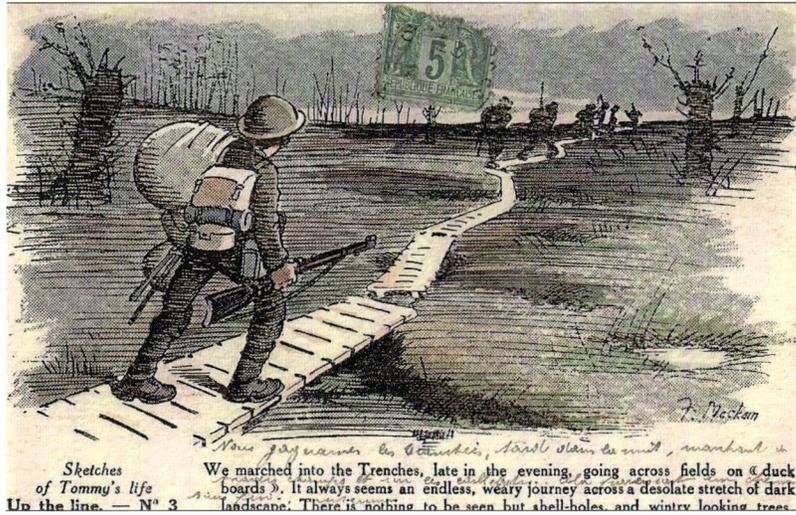

Sketches of Tommy's life
Up the line. — Nº 3

We marched into the Trenches, late in the evening, going across fields on «duck boards». It always seems an endless, weary journey across a desolate stretch of dark landscape: There is nothing to be seen but shell-holes, and wintry looking trees.

My dear Jacques, read this letter well. After having marched for a very long time over small duckboards (these are wooden walkways) in the night, and having seen on the way only desolation and ruin, the soldier arrives at the trench to fight there. Life for you, my children, will be just the same. Until now, you have been pampered and spoilt, and soon you will be old enough to work seriously. For a good many years, it will be necessary for you to learn to make your way like the soldier who, for a long time, marches through the night thinking always that the roads will never end. And, when you arrive at the end of your studies, you will have to fight even more strongly for your life. Think carefully on this, and you will understand.

88. Field Post Office and Censor marks
– be careful what you write! (Authors'
collection)

Christmas, New Year, and Greetings Cards

The Christmas and New Year 'Greetings Cards' seem to be all of the same date as the first issue of the main series and carry postmarks from December 1917 onwards. An advertisement for this set can be found on the thin tissue wrapper below:

89. Advert for Tommy's Christmas cards. (Authors' collection)

The cards remained on sale for many years after the war (one surfacing as late as 1940, sent from France on active service!), proving their popularity. All were published by the Paris firm of Savigny. Although, as indicated above, they were designed in sets of ten, it may well be that paper shortage curtailed this later to sets of eight: at least one message informs the recipient that 'this is one of a set of eight cards'. Already mentioned earlier is how Savigny were forced to shorten their sets of the 'Tommy's Life' cards for this reason.

The cards are recognisable by the red Christmas greeting printed on the front of the card. These vary from card to card, some cards having four or five different versions (see 'Fergus Mackain's Wartime Sketches' at fmsketches.blogspot.com for a full list). Different stencil fonts exist of particular greetings, too. Suitably, the artwork conveys the Christmas spirit of snow, holly, snowmen, Father Christmas, puddings, stockings, gifts and greetings, all rendered with Mackain's usual gentle humour.

Father Christmas makes his appearance in another card in this set, the snowy setting and laden bag on his shoulder creating the festive atmosphere for this Tommy. (The typesetters clearly struggled with 'whiskers'!)

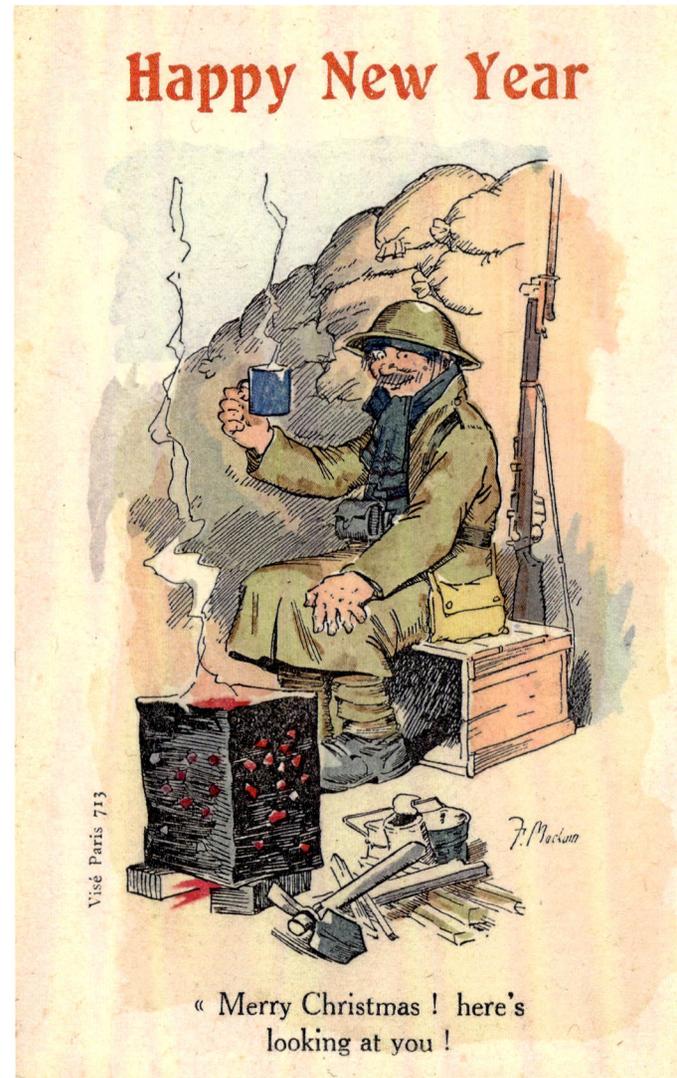

90. Here's looking at you! (Authors' collection)

Below: 91. Detail of stove from previous card. (Authors' collection)

Right: 92. A real stove in use in the trenches. (Jonathan Reeve JRb601p232)

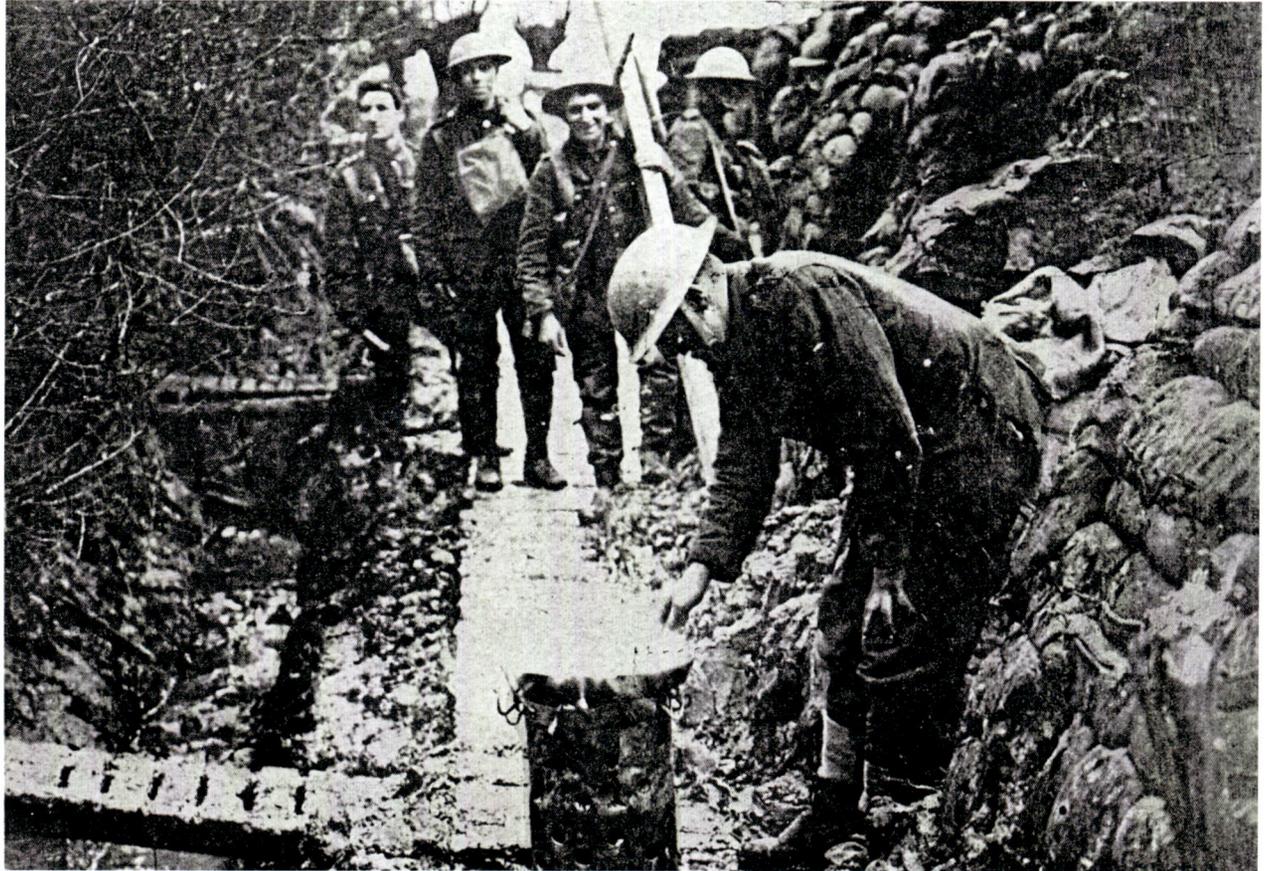

Soldiers often cooked their meals in a small mess tin on top of a brazier made of a square tin with holes in it. The brazier was frequently set up on a couple of empty food cans.

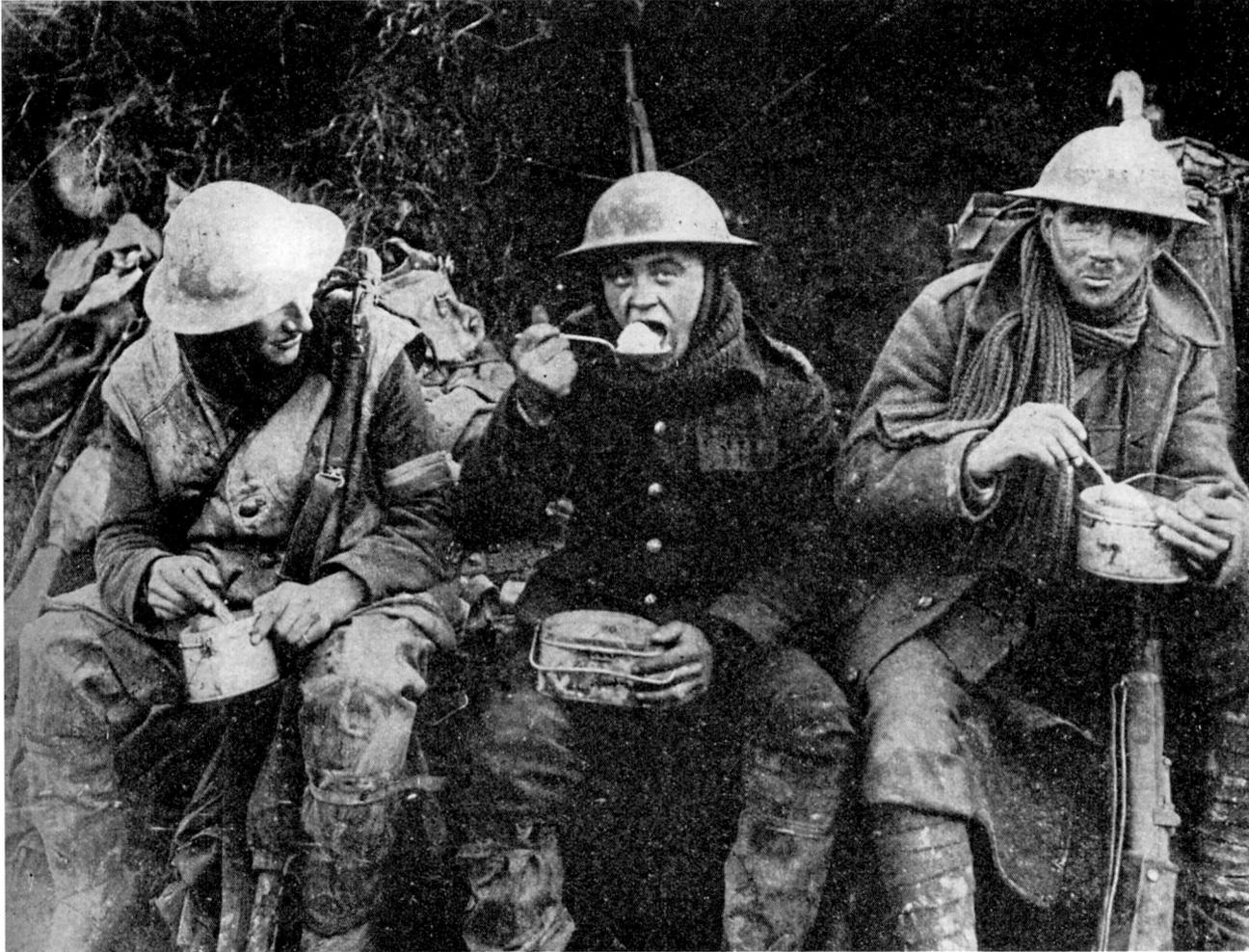

For ease of identification, many trenches were named after local landmarks or familiar streets in towns and cities at home by the units that occupied them. The names were painted on wooden boards and placed like street signs throughout the maze of trenches. Other signs indicated the whereabouts of unit headquarters, medical aid posts and supply dumps, or warned soldiers of danger spots.

Left: 93. Cheery soldiers eating food. (Jonathan Reeve JRb600p1125)

Opposite: 94. 'Good morning! Everything's as right as rain!' (Authors' collection)

Compliments from France

"Good morning! Everything's as right as rain!"

GREETINGS
From "somewhere" in France

Visé Paris 713

« Remember the day, Bill : Let's make these look a bit cheerful ! »

The two soldiers are painting a two-inch medium trench mortar (phonetically, 'Toc Emma'), also known as the two-inch Howitzer, and nicknamed the 'Toffee Apple' or 'Plum Pudding' mortar, a British SBML (Smooth Bore Muzzle Loading) medium trench mortar in use from mid-1915 to mid-1917. Its primary use was in cutting barbed wire defences and attacking enemy front-line trenches, such as in the July 1916 attack on the Somme.

Tommy and his colleague appear to be launched into the air as a result of an underground mine dug by German sappers.

Sandbags were used for building up the front of the trenches, for extra defence around machine-gun posts, for the front of dugouts and for protection of communication lines above the ground.

Opposite: 95. 'Remember the day, Bill: Let's make these look a bit cheerful!' (Authors' collection)

Right: 96. 'Don't worry! We're winning' (Authors' collection)

GREETINGS

Don't worry ¡ We're winning

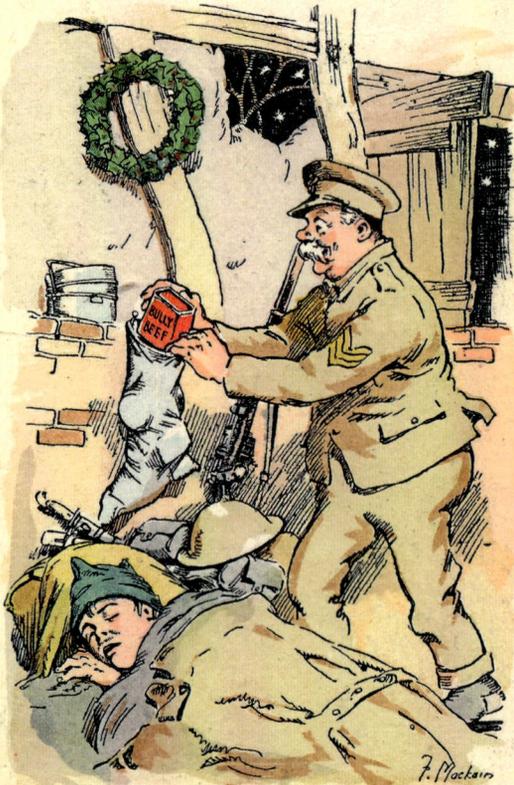

Greetings

Our Sergeant plays Father Xmas
for Bill the Ration Scoffer

Visé Paris 713

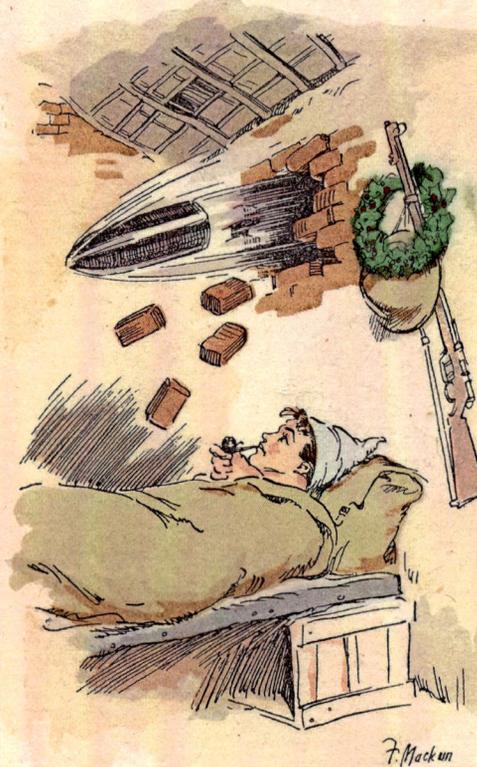

SWEET REMEMBRANCE
from France

« The same to you,
and many of them !

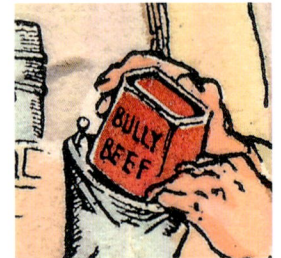

Far left: 97. 'Our Sergeant plays Father Xmas for Bill the Ration Scoffer.' (Authors' collection)

Left: 98. 'The same to you, and many of them!' (Authors' collection)

Opposite: 99. "I don't want it myself: and besides, it makes a fine Xmas gift for my country!" (Authors' collection)

Sweet Remembrance from France

« I don't want it myself : and besides, it makes a fine gift for my country ! »

German POWs were asked their names and rank, in accordance with the 1907 Hague Convention, Article 9, which states, 'Every prisoner of war is bound to give, if he is questioned on the subject, his true name and rank.' The first attempt to make rules for the treatment of prisoners of war was formulated in the Hague Peace Conference of 1899, this further refined by the Hague Convention of 1907. Unfortunately, these humanitarian ideals were not always put into practice during the First World War, possibly partly due to the huge numbers of men involved.

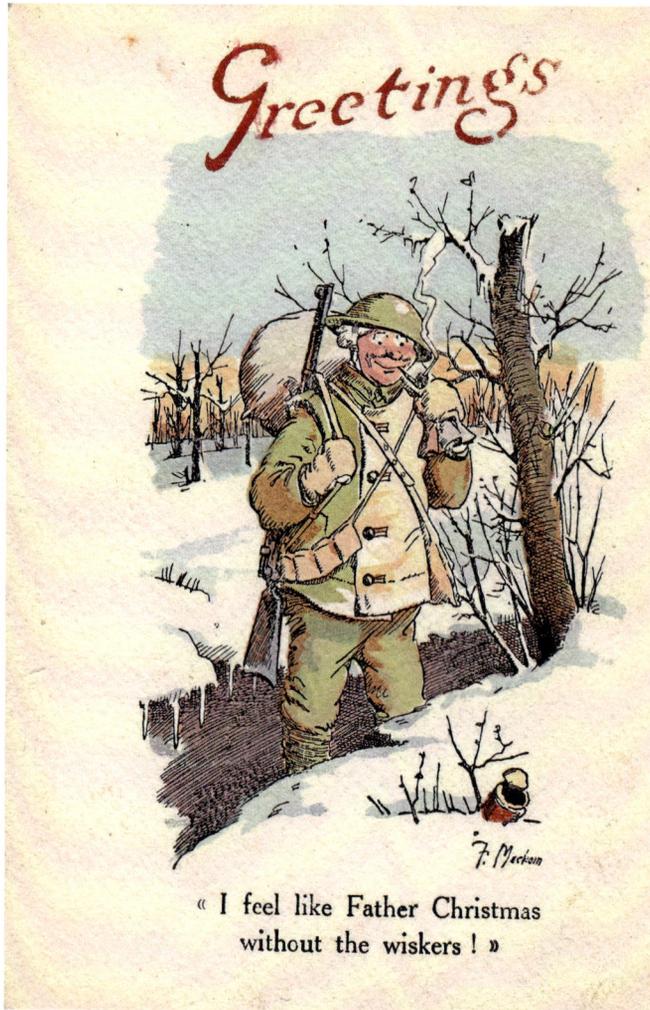

Left: 100. 'I feel like Father Christmas without the wiskers!' (Authors' collection)

Below: 101. 'Good morning! The compliments of the season!' (Authors' collection)

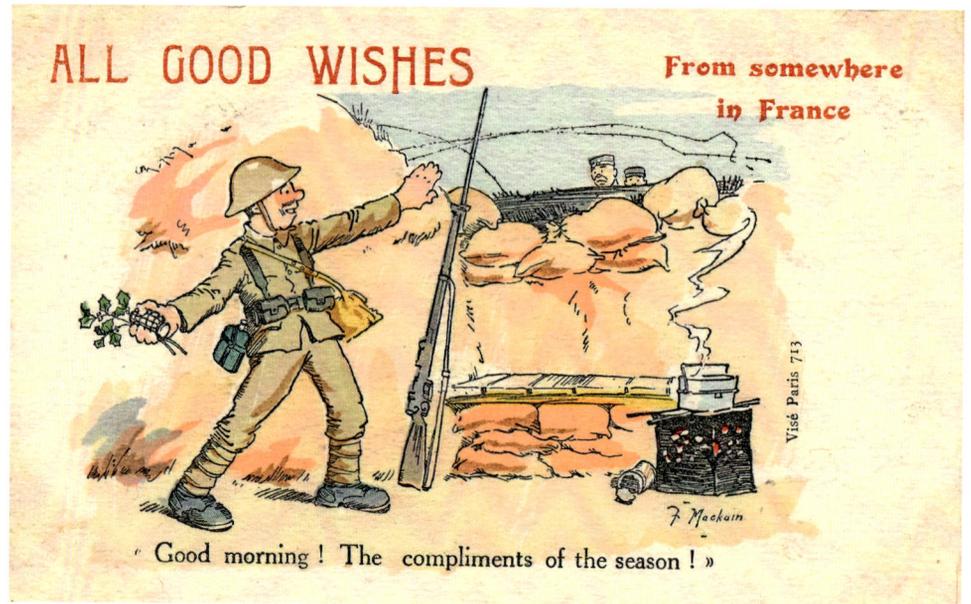

Right: 102a. A Mills No. 36 bomb, dating from the First World War. This model was used into the 1960s. (Courtesy of Jean-Louis Dubois under Creative Commons 2.0)

Far right: 102b. 'I feel that I am a nice present to get soon!' (Authors' collection)

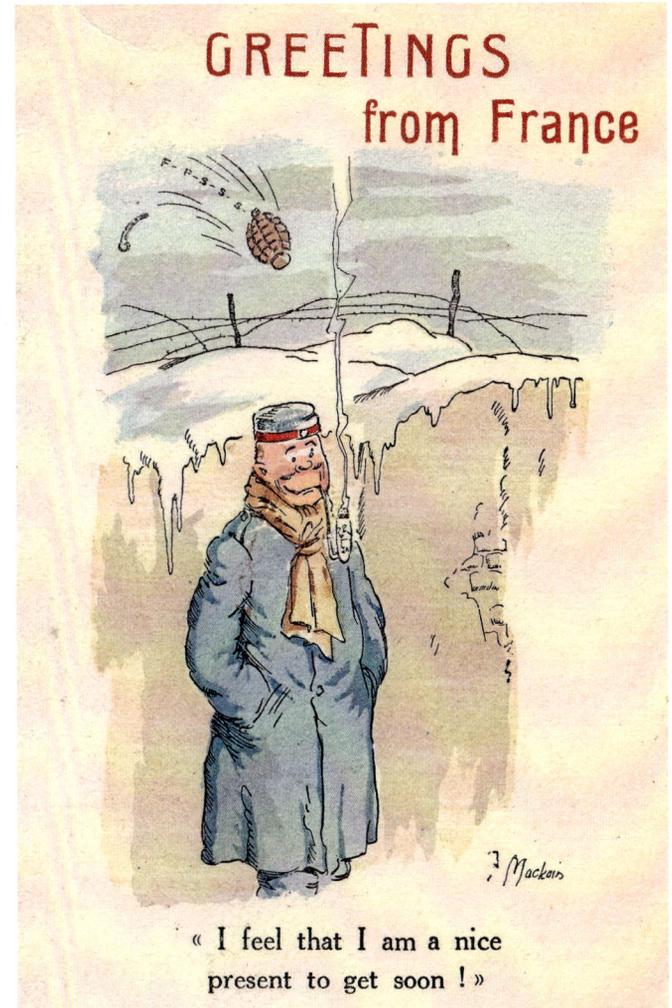

GREETINGS from France

« I feel that I am a nice present to get soon ! »

William Mills, a hand grenade designer from Sunderland, patented, developed and manufactured the 'Mills bomb' at the Mills Munition Factory in Birmingham, England in 1915.

In 1915, the Mills bomb was adopted by the British Army as its standard hand grenade, and designated as the No. 5. 'Mills bomb' was first coined early in the war, as grenadiers were referred to as 'bombers'. During the war Britain was producing an average of 250,000 hand grenades each week. Over 75 million Mills bombs were manufactured between April 1915 and late 1918.

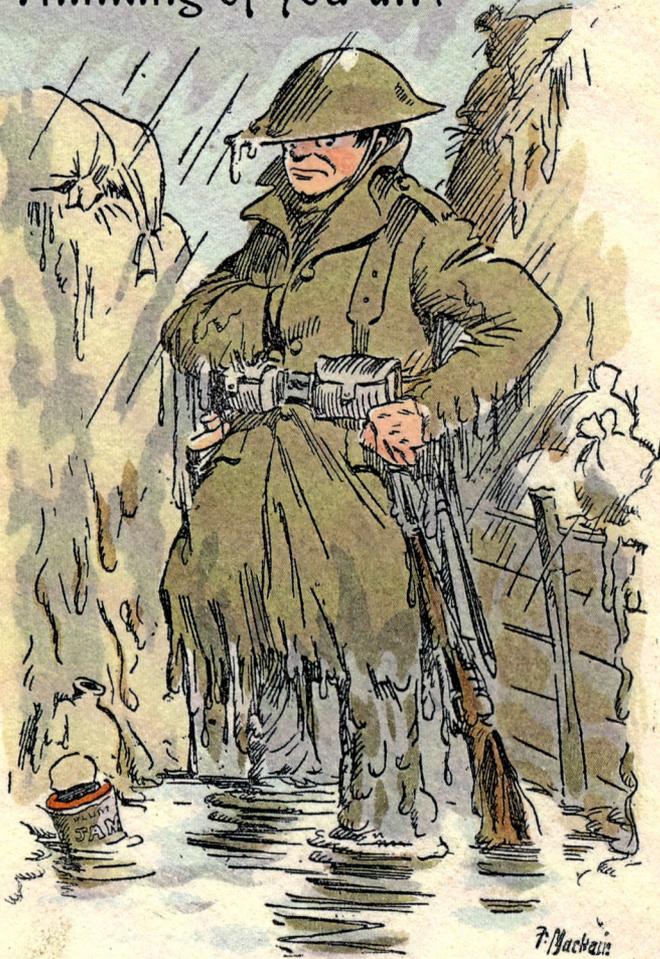

Thinking of you all!

Napoleon said : " I am France ".
I feel the same way, with all this French mud on me.

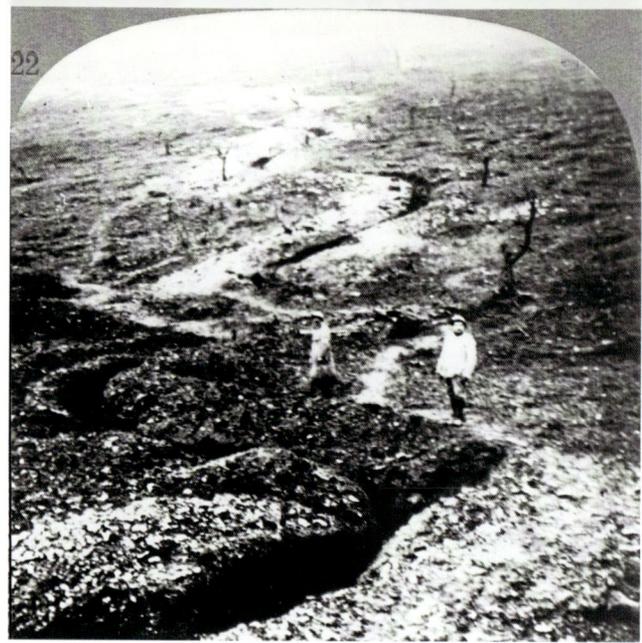

'The Cheerful Tommy'

These cards were produced by Gaultier and were all printed on 18 January 1918. There are six cards in this set: one of these seems to be an 'extra' card, therefore.

The Allied trenches were generally lower and wetter than the German trenches. The constant water was not only uncomfortable for the men, but also caused the trench sides to subside.

The full quote that Napoleon made to his Foreign Minister, Talleyrand, was: 'Today, I am France, and France is me. How can there be any dissent?'

Left: 103. 'Napoleon said: "I am France". I feel the same way, with all this French mud on me.' (Authors' collection)

Above: 103b. A trench wends its way from Chateau Thierry to Soissons, still visible in 1924. (Courtesy of the Library of Congress)

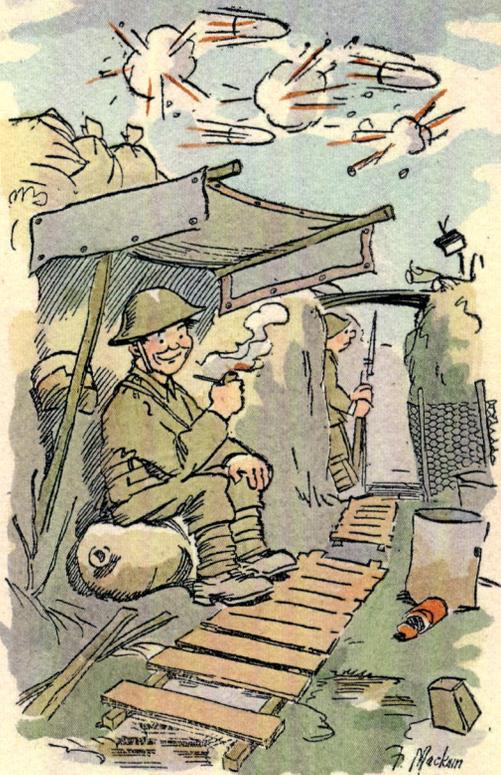

From somewhere in France

It gives you a confortable feeling to be under shelter !

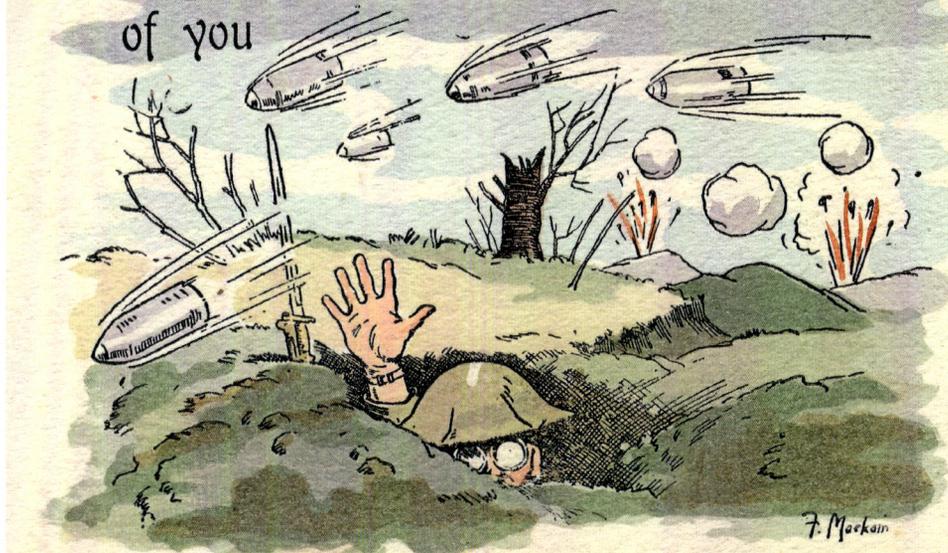

I am thinking of you

Here I am ! still well and enjoying life.

Left: 104. 'It gives you a confortable feeling to be under shelter!' Note the French spelling of the word 'comfortable'. (Authors' collection)

Above: 105. 'Here I am! Still well and enjoying life.' (Authors' collection)

Tommy is wearing a large box respirator, the first serviceable gas mask, invented by Edward Frank Harrison. Harrison enlisted in the 23rd Royal Fusiliers, the same battalion that Fergus Mackain joined.

Sorry ! but I must not let you know whereabouts I am in France !

Tommy is wearing a bandolier, jodhpurs, and spurs over his boots, which indicates that he is part of a mounted unit, possibly a sapper, signaller, or somebody in the Army Service Corps.

Plum & Apple jam was the most common flavour found in the trenches. Initially, when demand for grenades was at its greatest, engineers were encouraged to improvise their own grenades from the tins containing the soldier's ration of jam, hence the name 'jam tin grenades'. The tin was packed with shredded gun wadding and nails, a detonator added and the tin sealed with clay and Bickfords' No. 8 fuse added. The would-be bomber normally kept a pipe or cigarette lit in order to light the fuse.

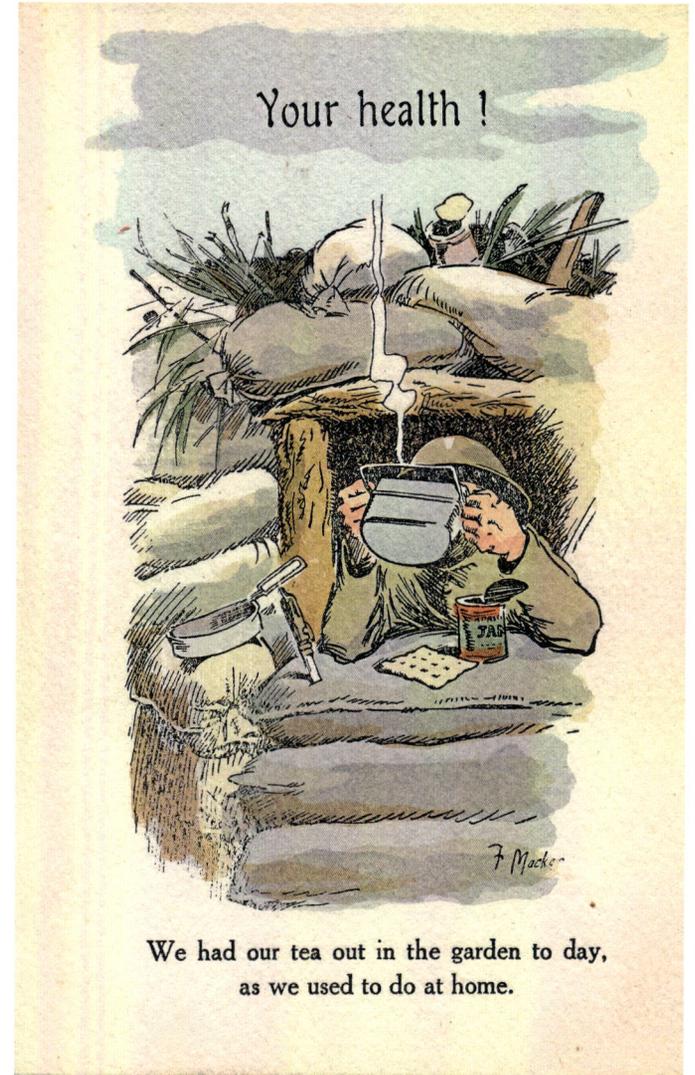

Your health !

F. Macker

We had our tea out in the garden to day,
as we used to do at home.

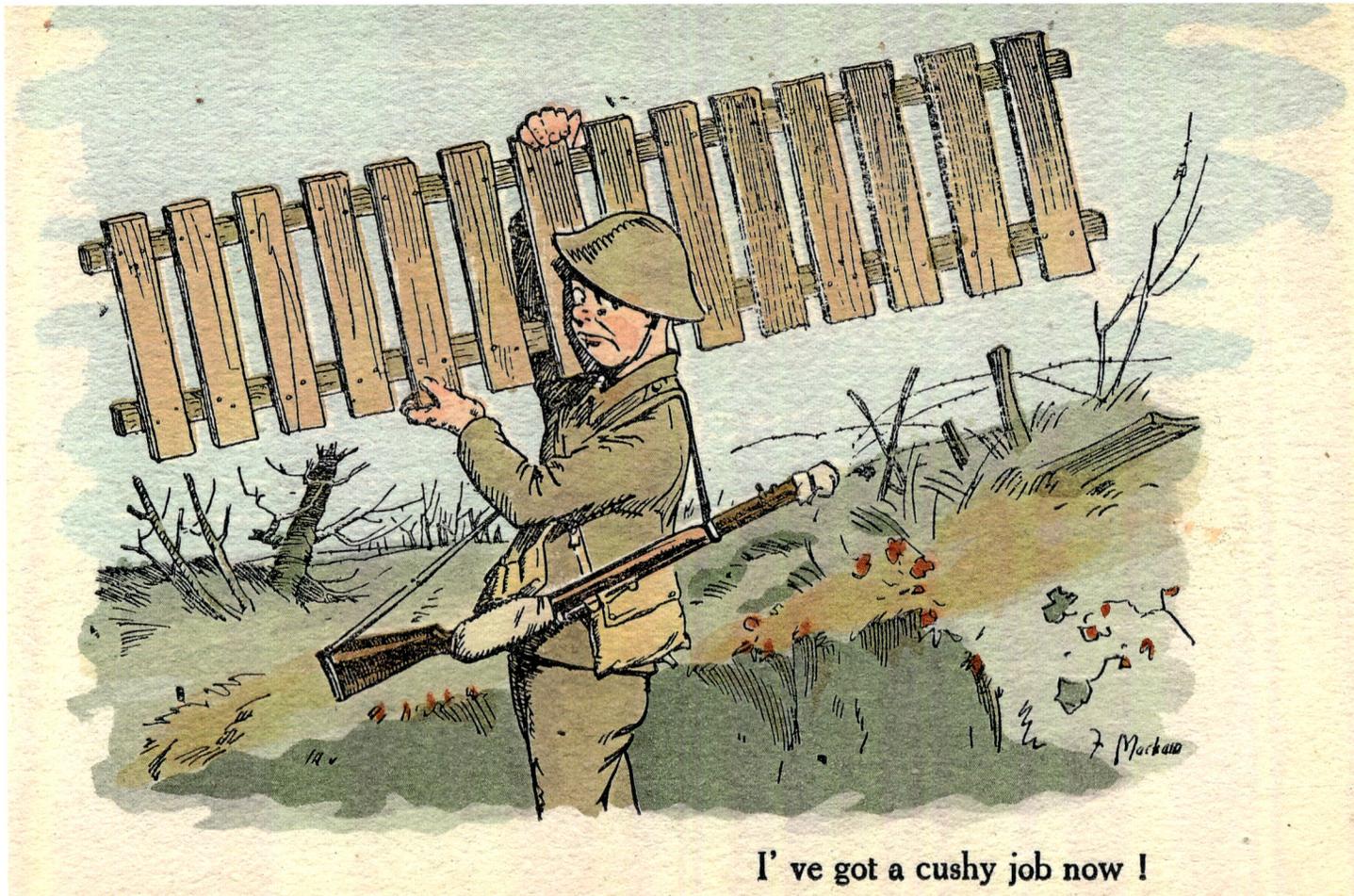

I've got a cushy job now !

Left: 109. 'I've
got a cushy
job now!'
(Authors'
collection)

Opposite: 110.
'There's so
much running
around to do,
it is rather
difficult
to write.'
(Authors'
collection)

'Cushy' is derived from the word *kushi* ('pleasant') in Hindi, a
remnant of slang used by old BEF hands who had served in India.
In this instance, the use is ironic, based on Tommy's expression.

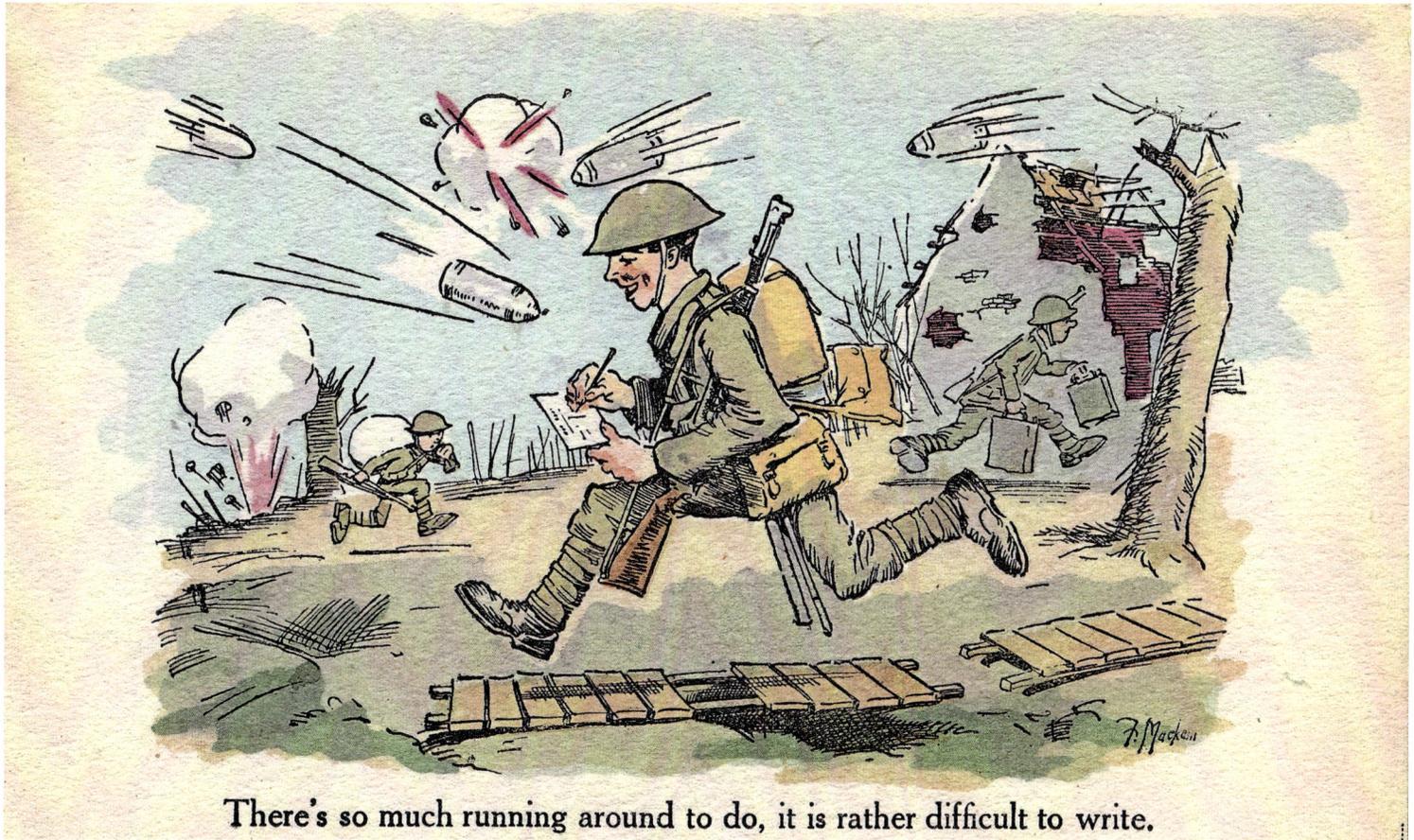

There's so much running around to do, it is rather difficult to write.

Water supplies were a constant problem throughout the war and the frequent lack of clean water often led to severe and debilitating gastric illnesses. The Germans frequently poisoned water supplies when they retreated from an area.

This card is very similar in style to the 'Cheerful Tommy' series, and was published on the same date.

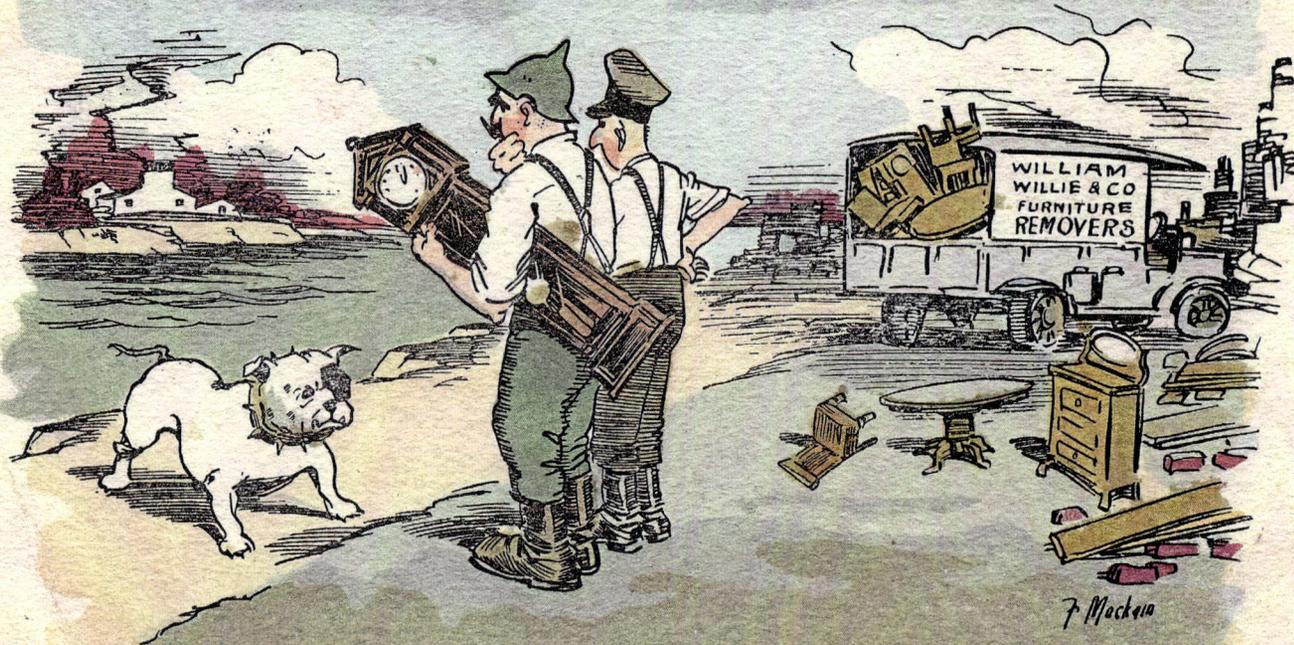

"Were it not for that brute, we could do some business over there!"

"Sans cet affreux boule-dogue, nous pourrions continuer par là-bas!"

The 'Kaiser' Set

A very different early series of cards is shown here, issued with English and French texts. The cards were published on 20 November 1917 by Gaultier; only three cards (out of a probable set of six) have so far been discovered.

French: '*Sans cet affreux boule-dogue, nous pourrions continuer là-bas*!' Literally: 'Without that awful bulldog, we could continue over there!'

This satirical card refers to the Kaiser's reportedly odd habit of 'stealing' furniture from his relatives, as a metaphor for empire-building. In this instance perhaps he is looking across the Channel at his kin in England and the only thing stopping him is the 'British Bulldog'.

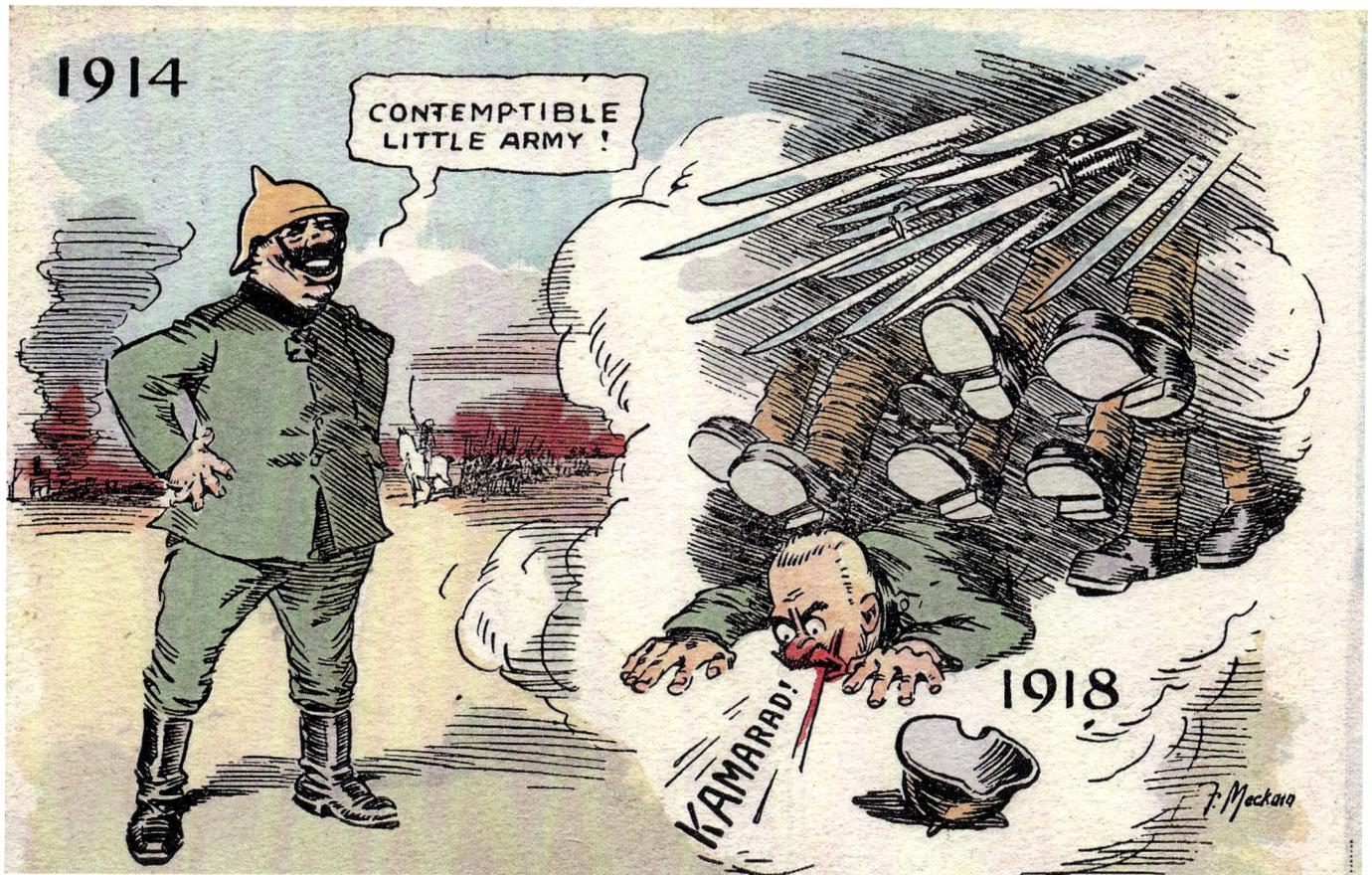

112. "Contemptible Little Army!" (Authors' collection)

Mackain seems to foresee the end of the war coming in 1918 with a very accurate prescience. The American spelling of 'kamarad' (friend) is used here; English usually prefers the form 'kamerad'. I like the almost surreal image of the large military boots of the Tommy and the forest of bayonets (an idea rather like those used by George E. Studdy, the cartoonist and postcard artist) and how the Kaiser's words come back to haunt him. This card and number 3 below follow the pattern of many such satirical cards of the period.

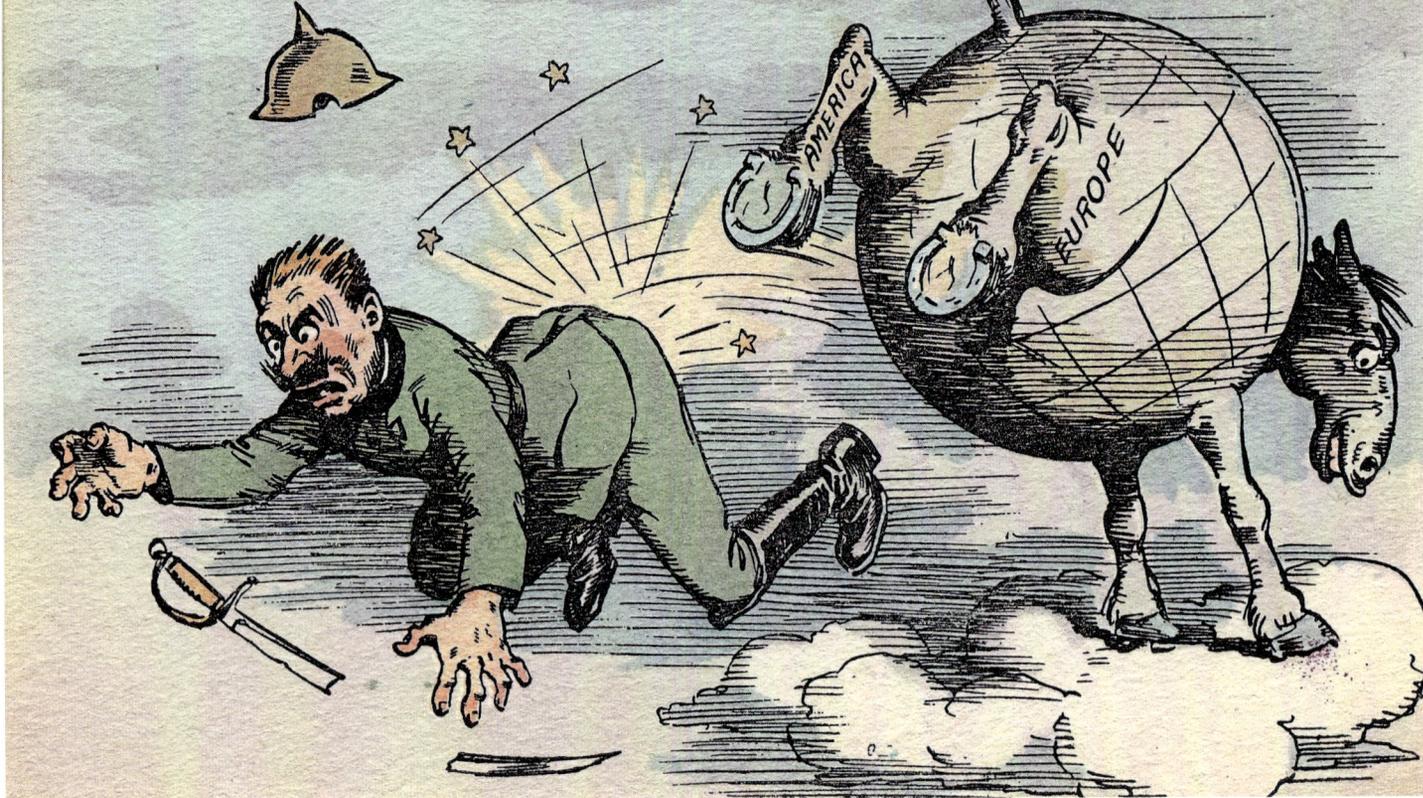

Peace will come when this happens
Quand vous verrez ceci, la paix sera proche

A literal translation of the French is 'When you see this, peace will be close'. The horse's legs have the words 'AMERICA' and 'EUROPE' on them, and its body is in the shape of the world.

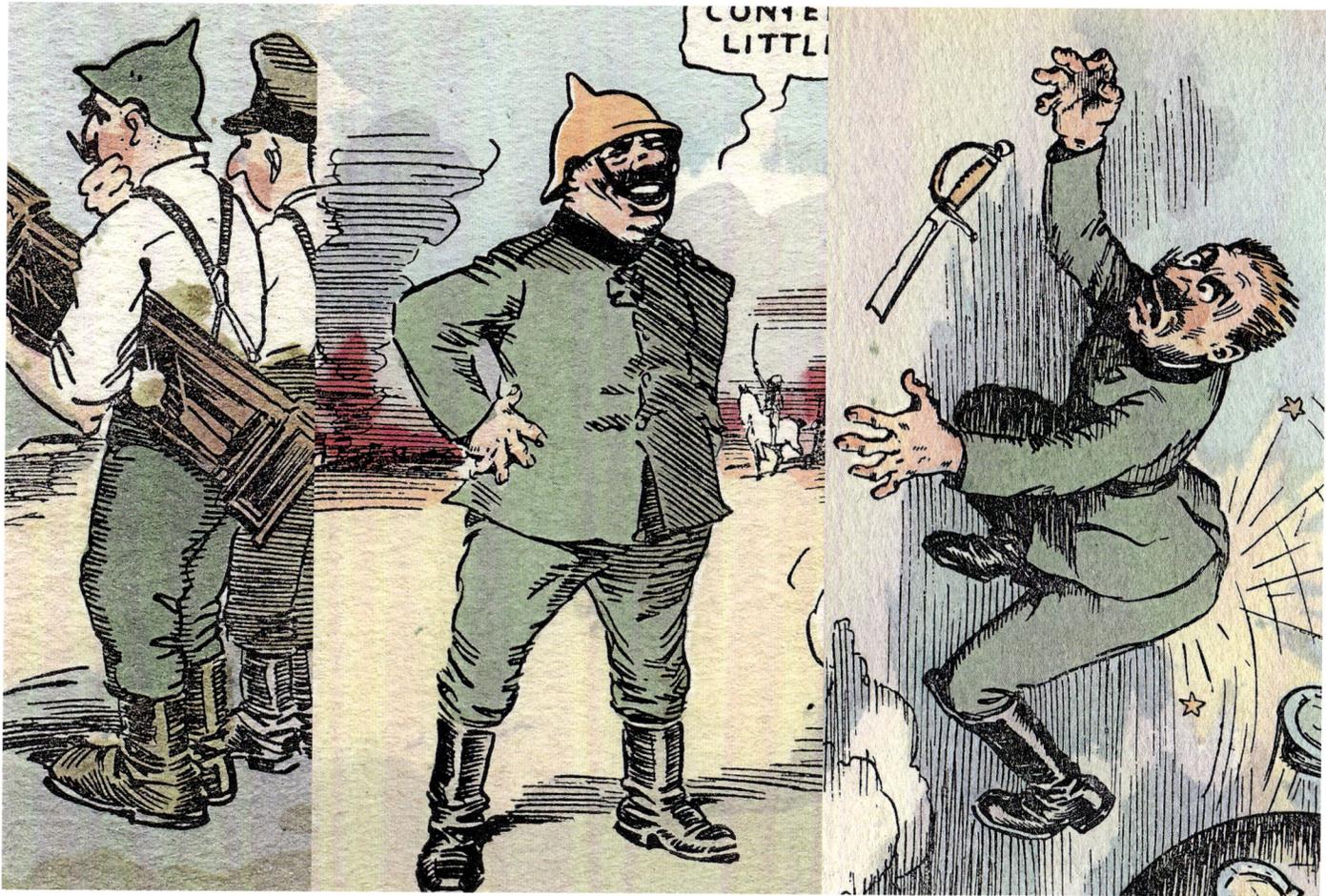

Opposite: 113. 'Peace will come when this happens ' (Authors' collection)

Above: 114. Details from the three 'Kaiser' cards discovered so far. (Authors' collection)

Sammy in France

On 6 April 1917, at almost the same time that Mackain was wounded and hospitalised, the Americans entered the war. Known as 'Sammies' (by the Allies) or 'Doughboys', their arrival marked a turning point in the war.

The Americans in France

With the Americans now in France, Mackain seems to have decided that cards should begin to appeal to this different market. John Laffin (*World War I in Postcards*) writes, 'Interestingly, American postcards did not cover the humorous aspect of the war, as did the Allies. Americans – publishers, artists, soldiers and public – took the war seriously. The British might laugh at some facet of training and even find humour on the battlefield … but the Americans perhaps either did not think of this side to the conflict or recoiled from it.' Mackain was to become, therefore, one of the few postcard artists who varied from this trend.

His first cards with an American theme were published by Paul Gaultier on 18 January 1918. They do not quite follow his usual style, losing the humorous focus of his earlier cards and reflecting various different sentiments and emotions. Some are contemplative, some cheerful and some almost romantic in appeal.

A standard 'Thinking of You', with additional 'hand-written' text (based on a line from the Scottish poet Thomas Campbell):

> Lochiel! Lochiel! Beware of the day!
> For, dark and despairing, my sight I may seal,
> But man cannot cover what God would reveal.
> 'Tis the sunset of life gives me mystical lore,
> And coming events cast their shadows before.

Coincidentally, Campbell died in Boulogne (1844).

Above left: 115. Detail from one of Mackain's sketches. (Authors' collection)

Opposite left: 116. 'Thinking of you all.' (Authors' collection)

Opposite middle: 117. 'Here I am, safe and well.' The silhouette design may have been based on the Savigny cards of French artist V. Galand, which were also advertised on some Mackain wrappers. (Authors' collection)

Opposite right: 118. 'The shadow of a coming event.' (Authors' collection)

Thinking of you all ____

Sammy in France
Les Américains en France

Here I am
safe and well

Sammy in France
Les Américains en France

Thinking of you !

The Shadow of a
Coming Event.

Sammy in France
Les Américains en France

Snow here, just like at home.

Sammy ih France
Les Américains en France

Mackain again focuses on the idea of the soldier's memories of home and how (for the recipient) there is really very little different over here.

Various First World War poets might have begged to differ, particularly Edgell Rickword (Artists Rifles) in his poem 'Winter Warfare'.

Colonel Cold strode up the line
(tabs of rime and spurs of ice);
stiffened all that met his glare:
fingers, men and lice.

119. 'Snow here, just like at home.' (Authors' collection)

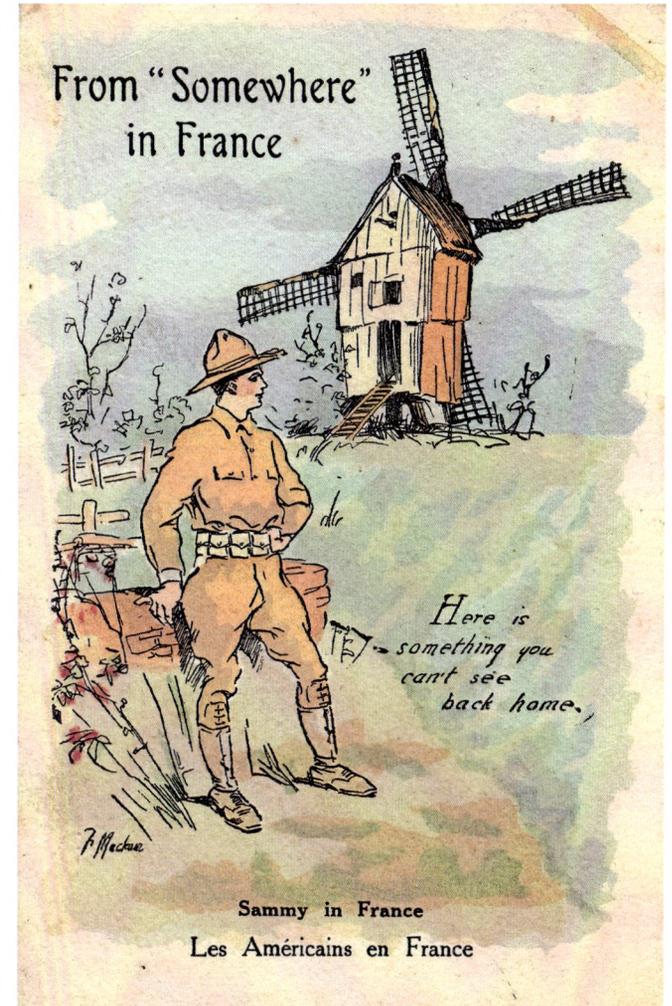

Above: 120. 'In a village "Somewhere in France".' (Authors' collection)

Right: 121. 'Here is something you can't see back home.' (Authors' collection)

Sketches of Sammy's Life in France

It was later decided (by Mackain or Gaultier or others) that a similar series to the 'Tommy's Life' cards could be produced, but directed at the American soldiers, and so, on 17 September 1918, the first card in a new series was issued.

Notice the American hats in the artwork of these cards, and the change of phrasing from the equivalent cards in 'Tommy's Life' ('the eats' replacing 'tea' in the first card in the series, for example; 'cigarette butts' replacing the jam from the 'Up the Line' series). The posture of the soldiers is more relaxed, and the dress more casual.

The war was to finish within months, and it is very likely that few of these cards were produced. They are certainly the hardest of Mackain's cards to find: collectors fight keenly to buy them on the internet (the author was lucky enough to find the first of the series at a dealer's stall – at a time when their existence was unknown – and the others through diligent searching of internet auctions). It was some battle to win them!

Other cards in this series not known.

Left: 122. Sammy's Life card on the left, Tommy's Life card on the right. (Authors' collection)

Opposite: 123. 'When we climbed out of our Pullman one morning for the eats, we heard a sound like distant thunder ... but it wasn't thunder ...' (Authors' collection)

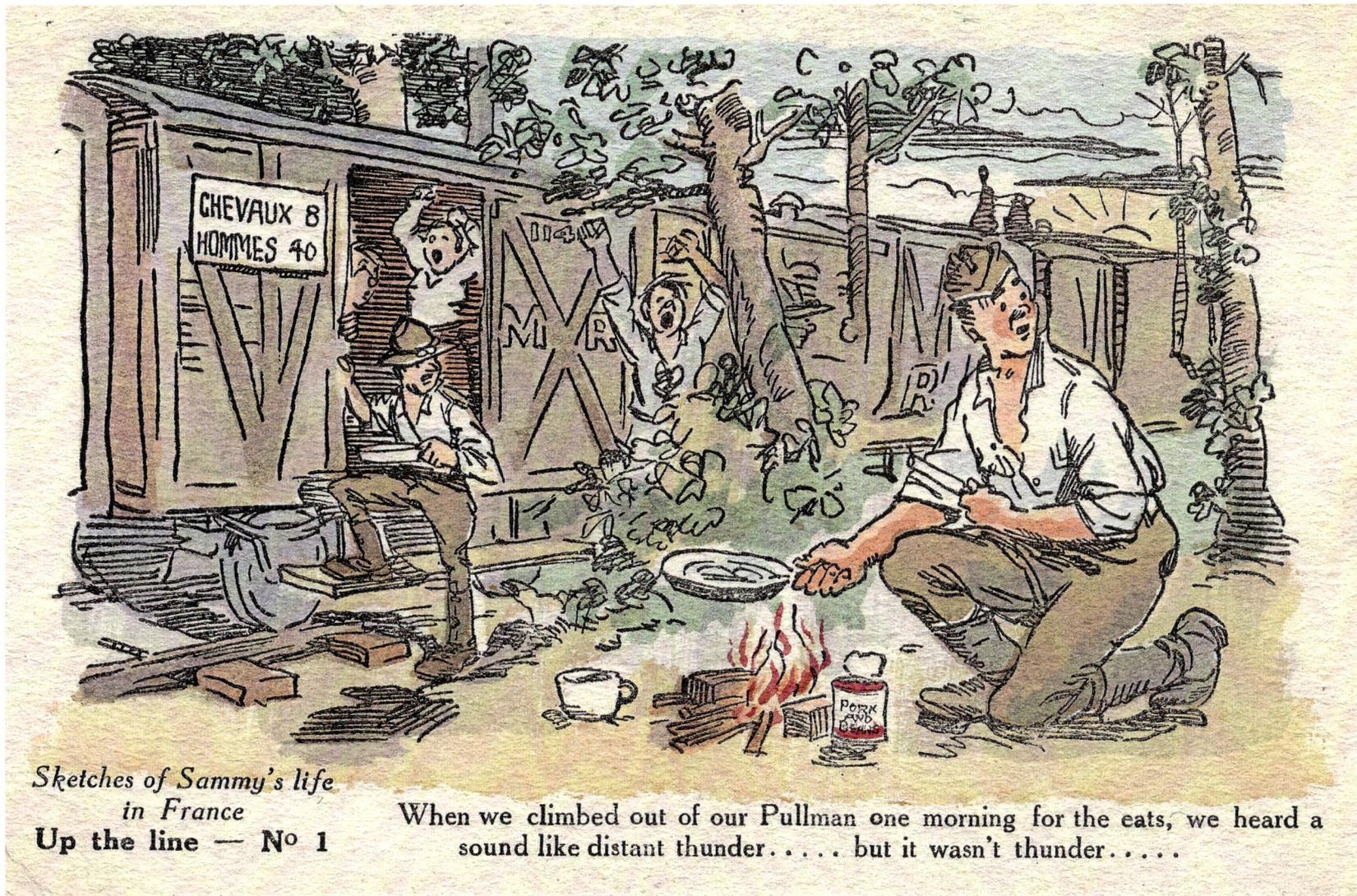

CHEVAUX 8
HOMMES 40

*Sketches of Sammy's life
in France*
Up the line — Nº 1

When we climbed out of our Pullman one morning for the eats, we heard a
sound like distant thunder but it wasn't thunder

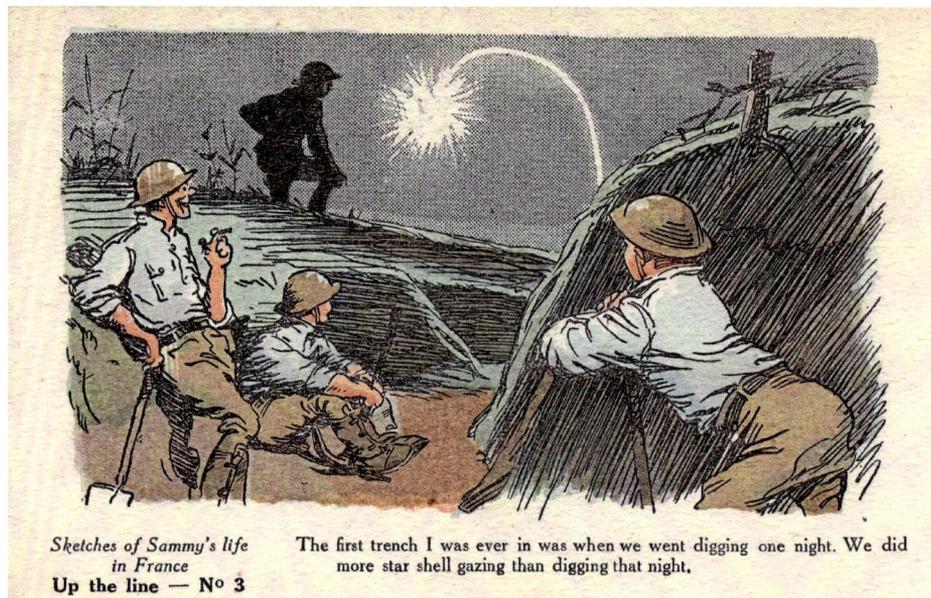

Sketches of Sammy's life in France
Up the line — Nº 3

The first trench I was ever in was when we went digging one night. We did more star shell gazing than digging that night.

Right: 124. 'The first trench I was ever in was when we went digging one night. We did more star shell gazing than digging that night.' (Authors' collection)

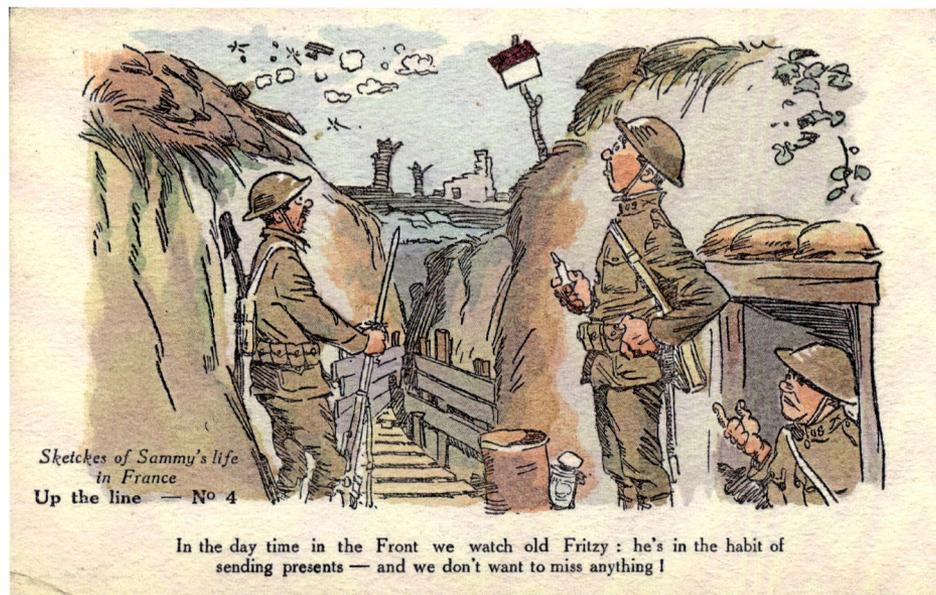

Sketches of Sammy's life in France
Up the line — Nº 4

In the day time in the Front we watch old Fritzy : he's in the habit of sending presents — and we don't want to miss anything !

Left: 125. 'In the day time in the Front we watch old Fritzy: he's in the habit of sending presents – and we don't want to miss anything!' (Authors' collection)

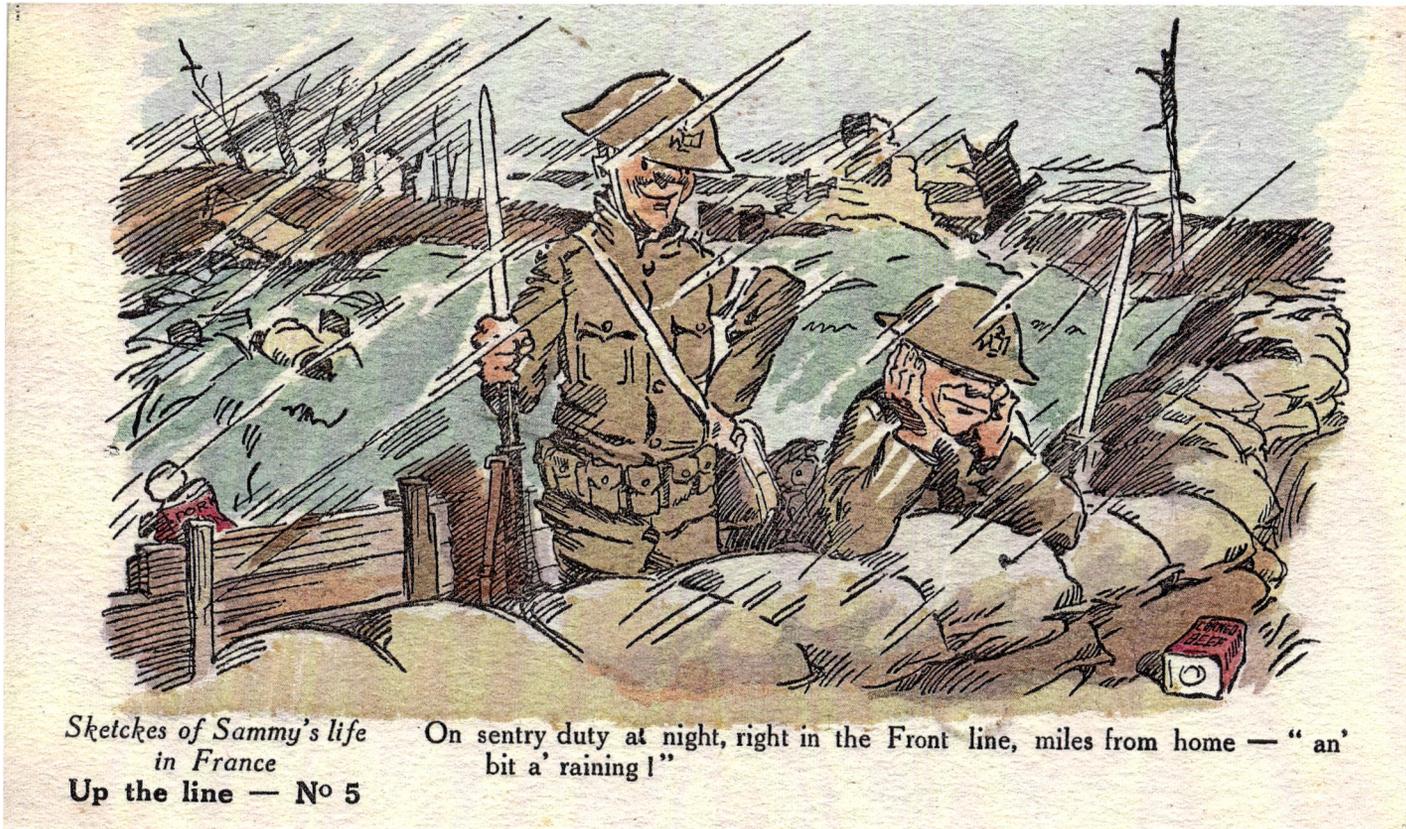

Sketckes of Sammy's life in France
Up the line — Nº 5

On sentry duty at night, right in the Front line, miles from home — " an' bit a' raining !"

Above: 126. 'On sentry duty at night, right in the Front line, miles from home – "an' bit a' raining!"' (Authors' collection)

Overleaf, left: 127. 'Waiting for the barrage to lift: it makes you feel sort of small and no account!' (Authors' collection)

Overleaf, right: 128. 'It's pretty tough when you're in one shell-hole, and your pal tries to chuck a box of butts from another, and misses fire – and if you get out to get them the machine gun won't miss fire, that's a cinch!' (Authors' collection)

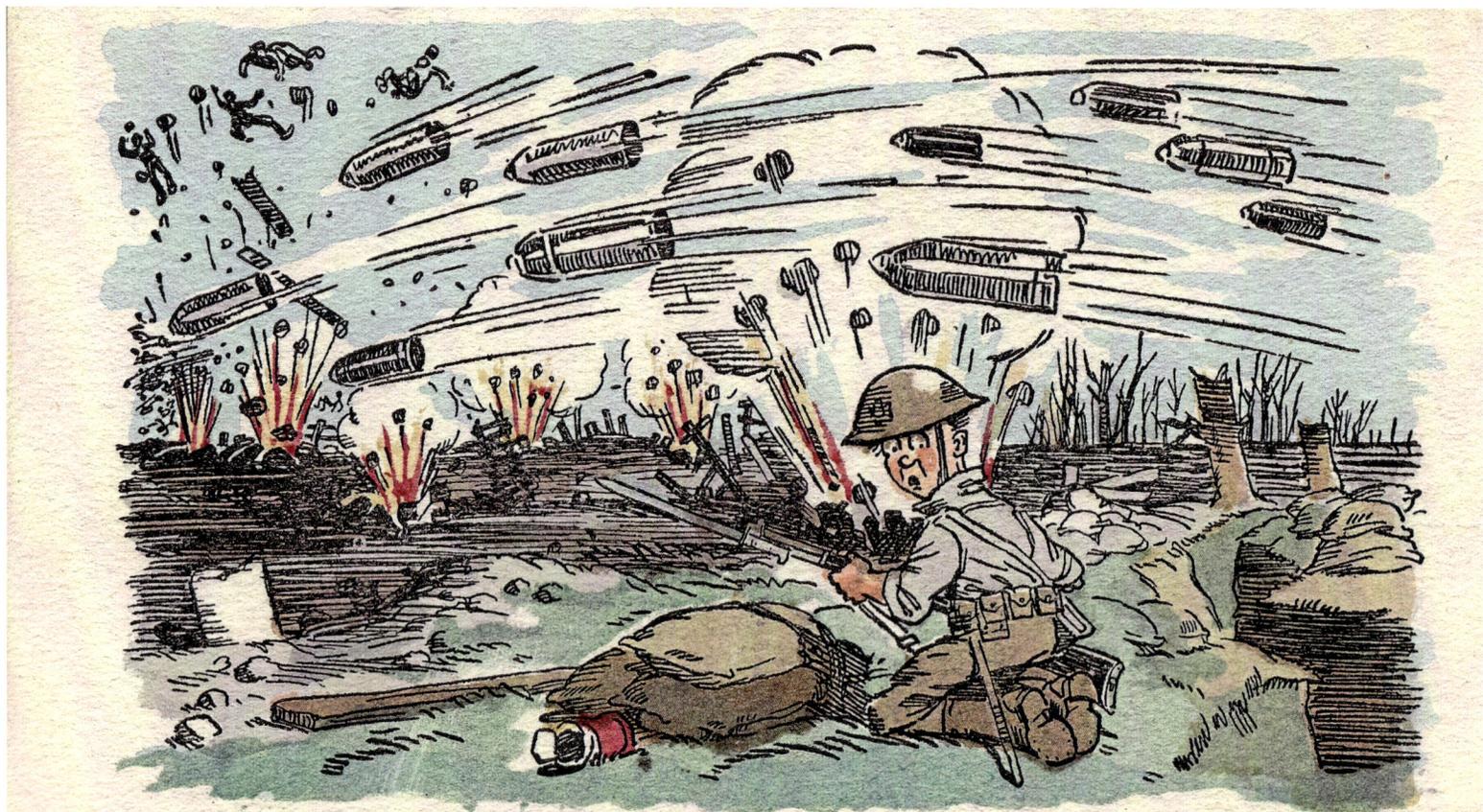

Sketches of Sammy's life in France
Up the line — Nº 6

Waiting for the barrage to lift : it makes you feel sort of small and no account !

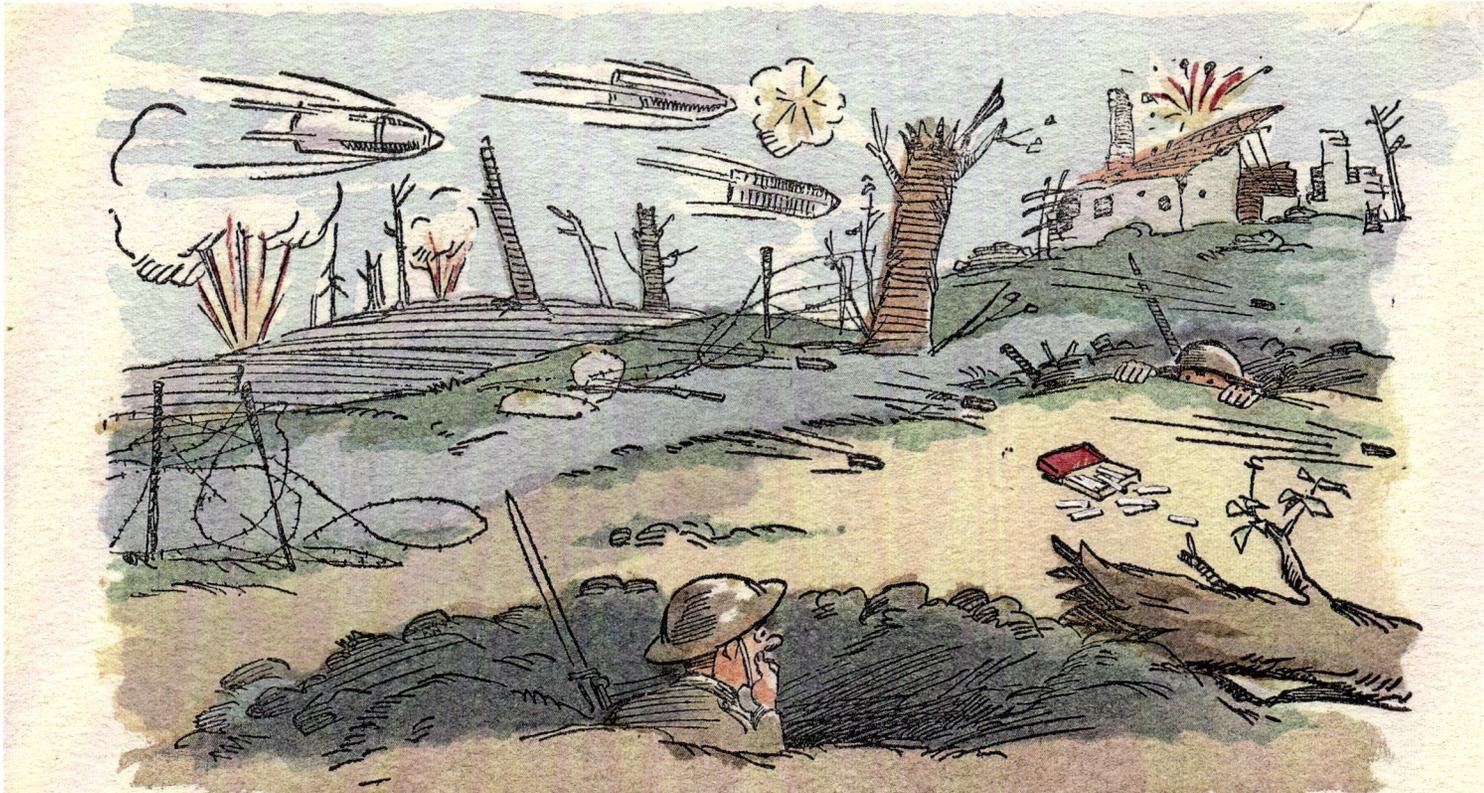

Sketches of Sammy's life in France
Up the line — Nº 7

It's pretty tough when you're in one shell-hole, and your pal tries to chuck a box of butts from another, and misses fire — and if you get out to get them the machine gun won't miss fire, that's a cinch !

ILLUSTRATING A FAMILIAR FRENCH PHRASE BOOK

Mackain illustrated an undated but likely 1917–18 French phrasebook for soldiers. These illustrations were black-and-white line drawings which accompanied the conversational texts in the book. The style of the artwork is the same as his postcards, but the drawings are unsigned. An advertisement at the back of this booklet, published by Martel-Loutil of Boulogne-sur-Mer, promotes Mackain's postcard sets and 'his well-known humorous style'. A similar booklet was published in Calais by Abbot Henri Delepine; this probably printed a little later and aimed at the American soldiers (Calais was a main disembarkation port for the US troops) as the cost had risen to 5d and currency conversions of 50 centimes and 10 cents are also given. Delepine had earlier in 1914 produced a booklet entitled *What a British Soldier Wants to Say in French and How to Say It: An English-French Booklet for the Use of the Expeditionary Forces*. This was priced at 3d. Interestingly, the 5d Delepine booklet also advertises Mackain's postcards, listing four sets but as follows: 1st set, At the Base; 2nd set, Up the Line; 3rd set, ditto; 4th set, Out on Rest.

Opposite: 129 & 130. The cover and an advert for the *Familiar French Phrase Book*. (Authors' collection)

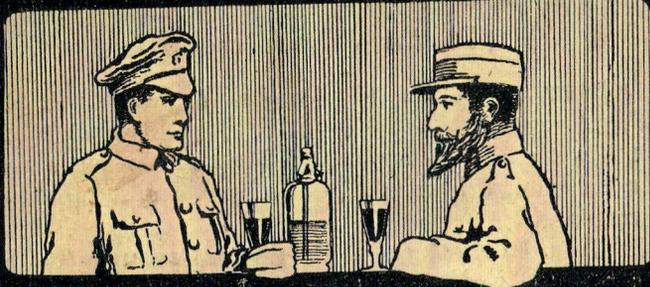

II. — ABOUT CHARACTER, PERSONAL ATTRIBUTS, etc...

A. — COLLOQUIAL EXPRESSIONS

English Equivalent or meaning.	French expression.	Phonetic pronunciation.
A clever man.	Un homme calé.	Eun(g) omm kahlay.
A good-hearted man.	Un bon cœur.	Eun(g) bon(g) kurr.
An outspoken man.	Un homme qui a le cœur sur la main.	Eun(g) omm kee ah ler kurr sür lah man(g).
As full of tricks as as monkey.	Malin comme un singe.	Mahlan(g) komm eun(g) sanje.
He is crackbrained.	C'est une tête fêlée.	Set ünn tett fehlay.
He has bats in his belfrey.	Il a une araignée au plafond.	Ill ah ünn ahray-neeay oh plahfon(g).
He is hot-headed.	C'est une tête chaude.	Seh t'ünn tett shod.
A busybody.	Un mêle-tout.	Eun(g) mell-too.
A coward.	Un poltron.	Eun(g) pohltron(g).
He speaks stuff and nonsense.	Il dit des bêtises.	Ill dee deh behteez.
He is in a brown study.	Il est de mauvaise humeur.	Ill ay der mohvayz ümurr.

◀ 6 ▶

ABOUT CHARACTER, PERSONAL ATTRIBUTS, etc. (Continued)

B. — FRENCH FAMILIAR EXPRESSIONS AND SLANG

English Equivalent or meaning.	French Expression.	Phonetic Pronunciation.
He is a clever chap.	C'est un type à hauteur.	Seh t'eun(g) teep ch ohturr.
A real sport.	Un chic type.	Eun(g) sheek teep.
A lucky man.	Un veinard.	Eun(g) vehnahr.
He has good luck.	Il a de la veine.	Ill ah der lah venn.
He is dotty.	Il est maboule.	Ill ay mahbool.
He is a softy.	C'est une poire.	Seh t'ünn pwarr.
He is windy.	C'est un froussard.	Seh t'eun(g) froossahrr.
He has the wind-up.	Il a la frousse.	Ill ah lah frooss.
He has cold feet.	d°	d°
He does not feel up to work.	Il a la flemme.	Ill ah lah flehmm.
He has the gift of the gab.	Il a de la blague.	Ill ah der lah blahg ;.

◀ 7 ▶

131 & 132. Two instructive pages from the *Familiar French Phrase Book*. (Authors' collection)

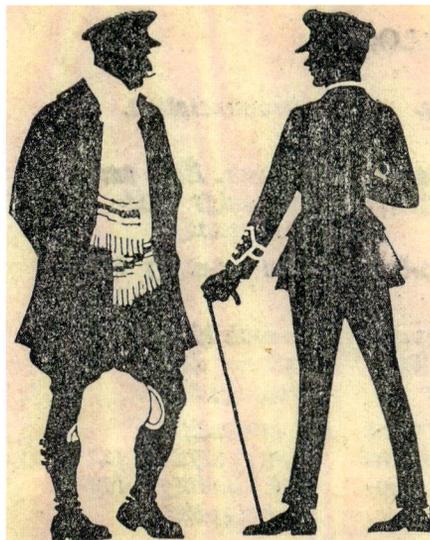

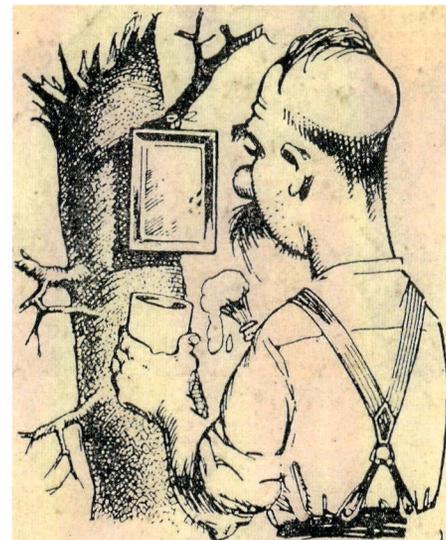

133–138. A selection of Mackain's sketches in the *Familiar French Phrase Book.* (Authors' collection)

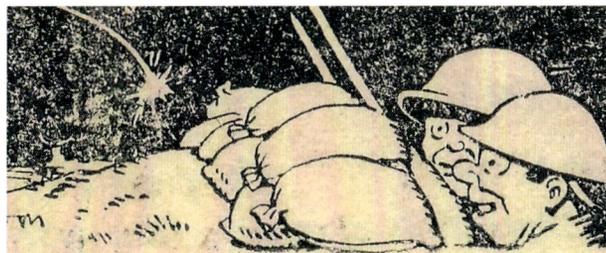

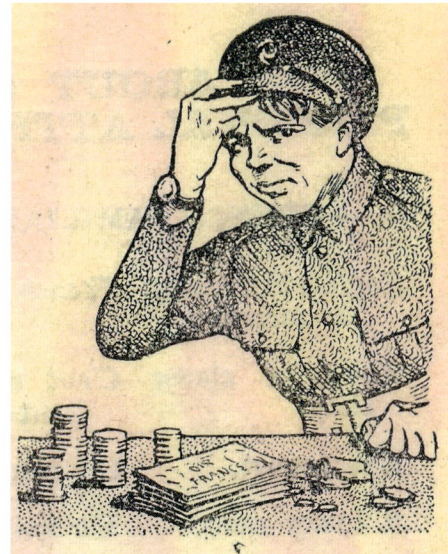

ESTAMINET

ENGLISH BEER

POST WAR, 1919-1924

A Summary of Mackain's Life Until His Death

30 December 1918 – Discharged, cause of discharge: sickness KR (King's Regulations) 392 XVI. Aged thirty-two years and one month; papers signed completed at Woolwich Dockyard.

Upon his demobilisation and return to England, Fergus Mackain stays with relatives in Earsham, Norfolk. This was the Seaton family. (George Flint Seaton had married Alice Reynaud Mackain, his aunt.)

1919–1920 – *Buzzy: The Story of a Little Friend of Mine*, written and illustrated by Mackain, is published in England (published by Jarrolds of Norwich in 1919) and New York (George W. Jacobs of Philadelphia in 1920) during this period of convalescence and recuperation. Mackain may also have designed greetings cards published by the London firm Delgado.

1 December 1919 – Mackain submits a cartoon for the magazine *Winter's Pie*.

May 1920 – Living near Russell Square in London.

139. The Rectory, Earsham, Norfolk. (Author's collection)

1920 – Stays immediately before his departure with his uncle the Revd William James Mackain at Oberon Lodge, 7 Mostyn Road, Merton Park, London.

9 September 1920 – Mackain arrives in New York, sailing on the *Kaiserin Auguste Victoria* from Liverpool. His passage is paid by the British Government. He intends rejoining his wife Louise and family at their rented home at 110 Lexington Avenue, NY and returning permanently to the United States. The passenger manifest describes him as 6 foot 3 three (a tall man!) of 'fresh complexion' and blue eyes. His 'condition of health' is described as 'good'. His age is given as thirty-two in the US 1920 census (he was probably thirty-four). 110 Lexington Avenue (comprising four or five relatively new apartments, built in 1910) seems to have been a focus for a coterie of several artists, Ruth Mary Hallock (well-known illustrator of children's books, particularly those by Robert Louis Stevenson) and sisters Susanna and Dora Donaldson (fashion magazine illustrators), each being resident there.

1920 – At some point Mackain is divorced from his wife, Louise. He moves from 110 Lexington Avenue in Manhattan, now living on his own, and seems to be living with relative C. Mackain (perhaps sisters Catherine or Claire or brother Clarence); address given as 2 Rector Street (the United States Express building, a Financial District skyscraper), so possibly a poste-restante address. The census shows Mackain's two sons Fergus (eight) and Linsley (seven) as boarders with the family

of John and Alice Stettinius in Starkey, NY. This may well have been with friends of Louise MacKain's mother: she had been widowed in 1906 and was resident in Starkey too. Mackain's mother Georgie ('Annie') dies at some point between 1920 and 1925.

1921 – Louise Mackain remarries. Her second husband is John H. Poppe (mistakenly written as John Poffe in some census transcripts). He is a New York automobile executive; they live in White Plains, NY. Fergus and Linsley accompany their mother.

17 February 1922 – Mackain marries again: his new wife is a Viola Robertson (probably one listed as thirty-nine, widowed, in the 1930 census, living in Manhattan). He states on his civil wedding certificate that it is his 'first marriage' and that he was 'single'. She was a well-known mezzo-soprano.

3 December 1922 – Works as an illustrator in New York: pictures by him in the *New York Tribune* accompany an article entitled 'Friendly Tips to the Tripper in England'.

9 November 1923 – Mackain, very ill with far advanced pulmonary tuberculosis caused by gas attack or the general conditions during the war, moves to the United States veterans home in Oteen, Asheville, North Carolina.

3 July 1924 – Mackain dies, aged thirty-seven years and three months. He is buried at Asheville Riverside Cemetery. Very plain gravestone with no memorial.

A First Children's Story – Buzzy: The Story of a Little Friend of Mine

The only example of Mackain's authorial career after the war is his work as both author and illustrator of a children's book entitled: *Buzzy: The Story of a Little Friend of Mine*. It was first published in 1919 by Empire Press in Norwich, part of Jarrold's. This would have been a convenient publishing house for Mackain as 'Buzzy' was written while Mackain was convalescent in Norfolk after his return from France. Jarrold's were no strangers to children's literature: Beatrix Potter's *The Story of Mrs Tiggy-Winkle* was also published by them in 1919.

The story itself follows the adventures of a teddy bear called Buzzy, and is a sort of fantasy precursor to *Winnie the Pooh* (1926). It is accompanied throughout the text by Mackain's illustrations. The style of some of the artwork is similar to Mackain's postcard artwork, but also reflects his wider range of ability as an artist.

Although the war seems far away from this story, there are several reflections of the experiences that Mackain went through during those years. As will be seen, the illustration of the scarecrow is horribly reminiscent of the emaciated remains of dead soldiers; the rabbit's burrow recalls the dugouts, often very complex with many rooms connected by tunnels; 'Emberland' recalls no man's land; the adventures in the woods recall Delville Wood and the theme of the defeat of the 'ogre' the defeat of the German army (often depicted in propaganda as a wild animal or fearsome creature. The design on the ogre's clothing is curiously similar to the German eagle insignia.). We leave the readers to form their own opinion on these!

Having returned from France in early 1919, Mackain went to stay in Earsham, Norfolk, with his cousin Alice Reynaud Mackain, who was married to George Flint Seaton. The Seatons had three children

(Winnifred, Margaret and George) and a maid called Edie. Mackain's dedication 'This little story is dedicated to those other friends of mine with whom my friend Buzzy lives' is to Margaret ('Peggy' in the story), George ('Bob') and the maid Edie (who carries her own name in the story) and Winnifred. The family regarded their maid as 'more family than any of us'. Buzzy itself was based on an Austrian teddy bear that George Flint Seaton, then working as a chaplain in Austria, had brought back at Christmas and had given to his two daughters Winnifred and Peggy (George was some six years younger than the two girls). The bear became part of family life, and instructions to the children would be given as though from the bear: 'Buzzy doesn't want you to …' Winnifred was to leave instructions that the bear be buried with her in St Mary's Church, Stoke-by-Nayland in Suffolk. The family was inventive and inspiring, and it is a measure of the gratitude that Mackain felt to them during this difficult period of readjustment in his life that he dedicated the book to them.

141–145. Colour plates from *Buzzy* by Fergus Mackain. Note the 'Bungay' sticker (above middle), where Mackain was staying. Above left shows 'The Defeated Ogre'. Above middle shows 'Thrown into Prison'. Above right is 'Buzzy in Mr Rabbit's House', and right is 'Peggy Preparing for the Trip'. The far-right picture is the most dramatic example of one of the many colour plates in *Buzzy*. The scarecrow, with its authentic skeletal legs, looks rather realistically like the emaciated body of a First World War soldier. (Authors' collection)

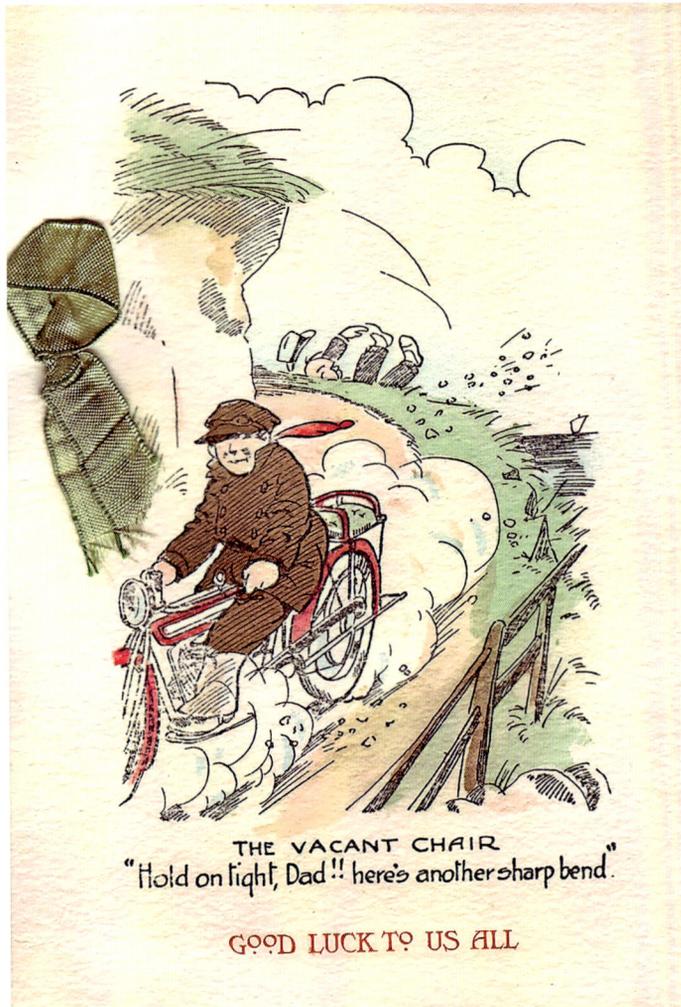

THE VACANT CHAIR
"Hold on tight, Dad!! here's another sharp bend".

GOOD LUCK TO US ALL

Commercial Work, 1919–22

A greetings card posted in late 1919 and strongly believed to be the design of Mackain. It was sent from a Norfolk address by a Norah Brunning. Marika Pirie describes how 'the obvious use of cross-hatching and the minimal strokes render a landscape – (grass, clouds), and there is a similarity in convention in terms of conveying the impact of an explosion. Look at how the soldier's hat in "Don't Worry We are Winning" (Mackain Greeting card), and the hat in the Vacant card appear to pop off. Also, the way the single strands of hair on the head of the men in both images stand up.' The card was published by Delgado's of London.

146. 'Good luck to us all.' (Authors' collection)

Mackain artwork for an article in the *New York Tribune*, Sunday 3 December 1922. The title of this artwork was 'Friendly Tips to the Tripper in England', the article written by 'A Britisher' with illustrations by F. E. Mackain. It is not impossible that Mackain also wrote the article himself. The picture to the right is believed to illustrate the entrance to Charing Cross station on the Strand, where Mackain possibly first arrived in London and met recruiters of the Royal Fusiliers.

How is it possible for a Londoner to describe London to a stranger? What is there in particular about the much loved streets which will strike the visitor as queer? The hansom cabs? The four-wheelers, with their purple-nosed drivers? The omnibuses which whirl through the thoroughfares at a pace that makes Fifth Avenue buses look like swaying snails? The mokes and barrows, making their way through the network of traffic? The smiling bobbies who pilot cripples and the blind across the streets? The great pyramids of colour heaped beside the cockney flower women? The good manners of every one in the streets when they happen to brush against you? The Britisher himself notices this only after having visited New York or perhaps Boston.

Right: 147. Mackain's work in the *New York Tribune*. (Authors' collection)

Overleaf, left: 148. Cartoon illustration from *Winter's Pie* magazine, 1919. (Authors' collection)

Overleaf, right: 149. Detail of two nurses from the *Familiar French Phrase Book*. The Maid: 'Little Willie Jones is here, and wants you to come out and play.' The Little Girl: 'Oh, bother the man! Tell him I've got a headache, and I'm lying down.' (Authors' collection)

How is it possible for a Londoner to describe London to a stranger?

The entrance of the bathtub in the morning, borne by your cheerful but stolid landlady or her assistant, will cause you to smile

THE MAID: "Little Willie Jones is here, and wants you to come out and play."
THE LITTLE GIRL: ' Oh, bother the man! Tell him I've got a headache, and I'm lying down."

The Last Chapter: Oteen United States Veterans Hospital No. 60

Fergus Mackain's pulmonary tuberculosis became so advanced that in November 1923 he entered the special USV hospital set up for soldiers who had been inflicted with the 'White Plague', as it was commonly known. Mackain's condition may have been the result of gassing during the First World War, or through the

weather conditions, living in close proximity with others with this condition and other war factors that might have an impact on the soldiers' immune systems. Rachel Hollis describes how 'cramped quarters, immense physical exertion and abnormal sleep cycles can all have a negative effect on the immune system and therefore if one person were to catch the disease, others were very likely to as well'.

Opened in 1918 for soldiers, this hospital instituted a different treatment for the soldiers who went there. Rather than injections, vaccines and various medicines, there was a recuperation programme that was concentrated on fresh air, rest and mental stimulation. The hospital, near Asheville (close to where Mackain grew up), is situated in the beautiful valley of the Swannanoa River in the midst of some of the most inspiring scenery of western North Carolina, and over a period of several years saw continuous work to improve its buildings and landscaping. The clean mountain air can only have helped the patients' lungs.

Mackain was in the hospital until his death on 23 July 1924, spending the last seven months of his life there. 'Military Service' is unsurprisingly given as the source of his disease; he had had no operations and there was no autopsy.

Below: 150. Convalescents at Oteen Hospital. (Mrs Walter L. Massie collection of Jesse Morris photographs of Oteen Hospital, D. H. Ramsey Library, special collections, University of Carolina at Asheville 28804)

Right: 151. A detail from the illustrated letters. (Authors' collection)

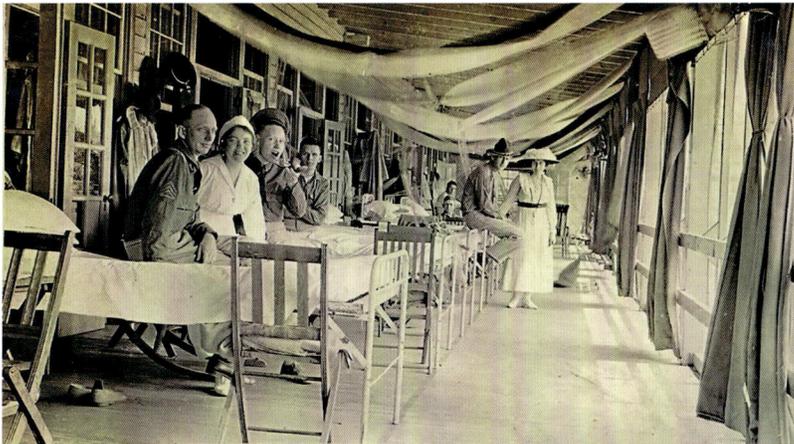

The death certificate seems curiously unaware of several facets of Mackain's life. His marital status was originally typed as 'single' (Mackain had remarried only a year before entry into the hospital) and his birthplace and details of his father and mother are given as 'unknown'. It is surprising that these details had not been logged upon Mackain's entry to the hospital.

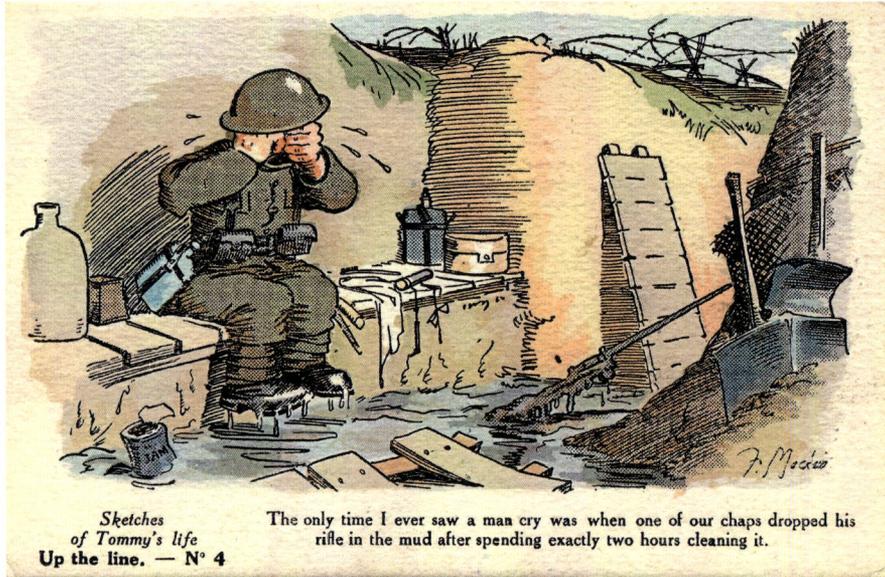

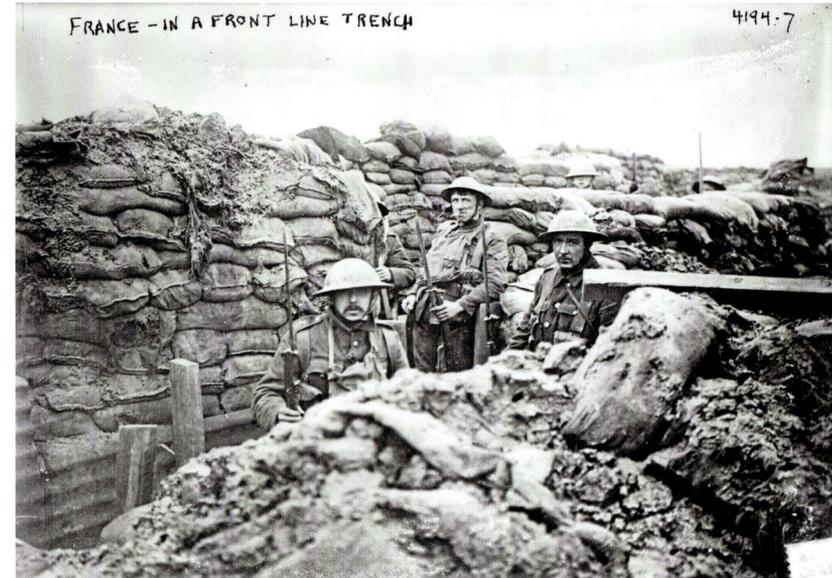

Above left: 152a. Possibly the saddest card of all: it suggests not just a man crying for dropping his rifle, but at the very end of his endurance. (Authors' collection)

Above right: 152b. The reality of the trenches. (Courtesy of the Library of Congress)

Opposite: 153. Mackain's tombstone. (Authors' collection)

... once an hour a bullet missed its aim
And misses teased the hunger of his brain.
His eyes grew old with wincing, and his hand
Reckless from ague. Courage leaked, as sand
From the best sandbags after years of rain.

Wilfred Owen

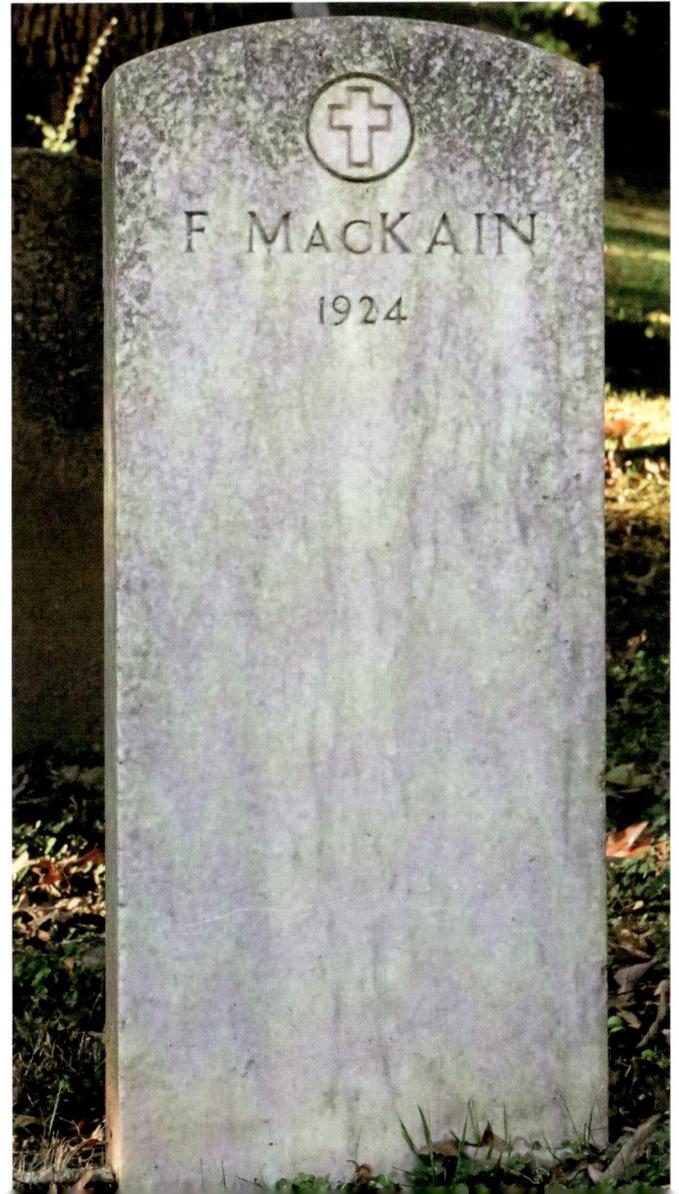

REFERENCES AND ACKNOWLEDGEMENTS

Bibliography

Brown, M., *Suffering from Cheerfulness: The Best Bits from the Wipers Times*

Bryant, M., *World War 1 in Cartoons*

Buckle, H., *A Tommy's Sketchbook*

Clarke, B., *A History of the British War Horse*

Doyle, P., *Postcards of the First World War; British Postcards of the First World War*

Doyle, P. & Walker, J., *Trench Talk: Words of the First World War*

Foley, M., *Hard as Nails: The Sportsmen's Battalion of World War One*

Glover & Silkin, ed., *Penguin Book of First World War Prose*

Gosling, L., *Brushes and Bayonets: Cartoons and Sketches of World War 1*

Hislop/Brown, *The Wipers Times*

Holt, V. & T., *Till the Boys Come Home*

Ivelaw-Chapman, J., *The Riddles of Wipers: An Appreciation of the Trench Journal*

Laffin, J., *World War 1 in Post Cards*

Mackain, F. E., *Buzzy*

Robertshaw, A., *24HR Trench: A Day in the Life of a Frontline Tommy*

Stinton, H., *Harry's War: Experiences in the 'Suicide Club' in World War One*

Ward, F. W., *23rd (Service) Battalion Royal Fusiliers (First Sportsman's) During the First World War*

Websites

Fergus Mackain's Wartime Sketches (http://fmsketches. blogspot.com)

CanadianSoldiers.com

Great War Forum website

Ancestry.com

Find a Grave.com

Family Search.org

military.rootsweb.ancestry.com, October 2005

Imperial War Museum
Ellis Island Foundation inc. Website
Reg Mayhew ancestors' website
WW1 Propaganda website
North Carolina City Directories
ww.collectionscanada.gc.ca
Fulton History.com, a great source of newspaper research
Canada First World War Study Group website
And many others for various pictures, not always creditable individually: every effort has been made to acknowledge sources.

And, individually and above all

Marika Pirie for her early huge and invaluable assistance towards this project);
The Mackain family for all their support, particularly to Alan Wagner for permission to print the original 'Dear Mackie' letters, Tracy Zimmerman for information on Joan Louise Poppe and Col Fergus Mackain-Bremner and William Mackain-Bremner for their huge and invaluable assistance;
Jon D'Souza-Eva for his internet research skills, time and generosity;
Pierre Brouland for his article on 'Les cartes satiriques pendant la Premiere guerre mondiale';
Annette Fulford, Canadian genealogist;
Mona Gehring of the North Indiana Genealogical Society for her huge initial help in contacting me with Fergus Mackain's surviving family – everything started here;
Ben Rymer, the First World War pupil-soldier of this book;
Old Buncombe County Genealogical Society for their research assistance;
Andrew Read for his assistance in tracking down those elusive Mackain postcards.

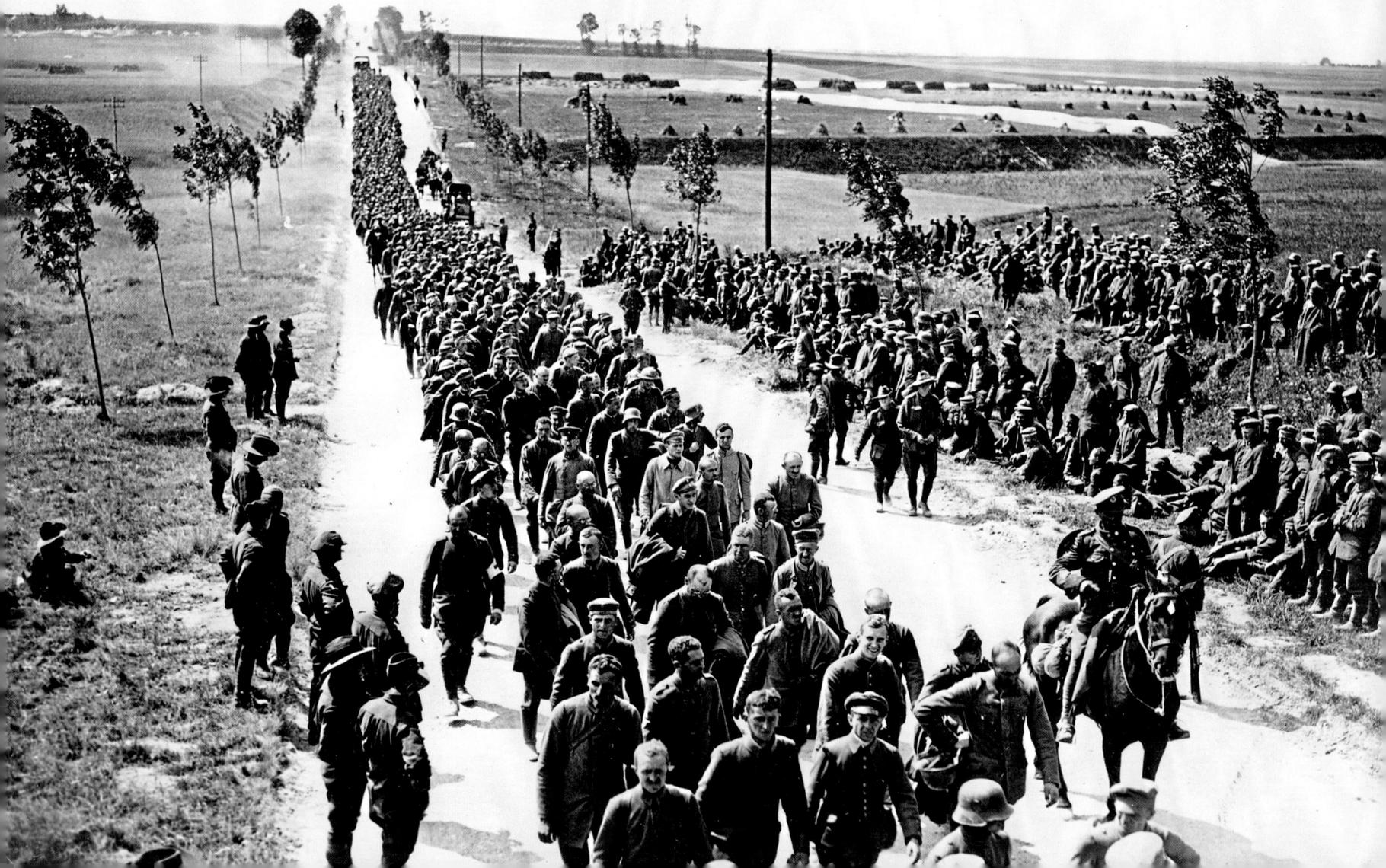

154. German prisoners arriving in batches of 1,000 at a POW camp.
(Courtesy of the Library of Congress)

INDEX

ABOUT THE AUTHORS

Fergus Mackain was born in Canada to an English father and lived in New York with his young family, working as an illustrator for an advertising agency. Demobbed in 1918, he lived in England for several years before returning to his family. He died in 1924.

William Mackain-Bremner lives in Texas and grew up in a British Army family. He was introduced to his relative's poignant illustrations at an early age.

John Place is a teacher and lives in Oxford.